# Airborne

Shaun

# White

RIZZOLI
NEW YORK

New York · Paris · London · Milan

First published in the United States of America in 2023
by Rizzoli International Publications, Inc.
300 Park Avenue South
New York, NY 10010
www.rizzoliusa.com

Interviews by: Colin Bane

Designed by: Amanda Sia and Mackey Saturday

Publisher: Charles Miers
Editorial Direction: Martynka Wawrzyniak
Copy Editor: Kim Stravers
Photo Rights and Permissions: Supriya Malik
Production Manager: Alyn Evans
Managing Editor: Lynn Scrabis

2023 2024 2025 2026/ 10 9 8 7 6 5 4 3 2 1

Distributed in the US trade by Random House, New York

Printed in China

ISBN: 9780847870950
Library of Congress Control Number: 2023936772

Image Credits:

# Contents

13    Foreword by Selema Masekela

14    Introduction

18    How It All Started

60    Japan, Korea + China

74    Silverton, Colorado

88    Vancouver, BC

112   Tignes, France

120   Park City, Utah + Breckenridge, Colorado

134   X Games

140   US Open

154   Sochi, Russia

166   New Zealand

190   Pyeongchang, Korea

204   Music

214   Beijing, China

228   Whitespace

256   Acknowledgments

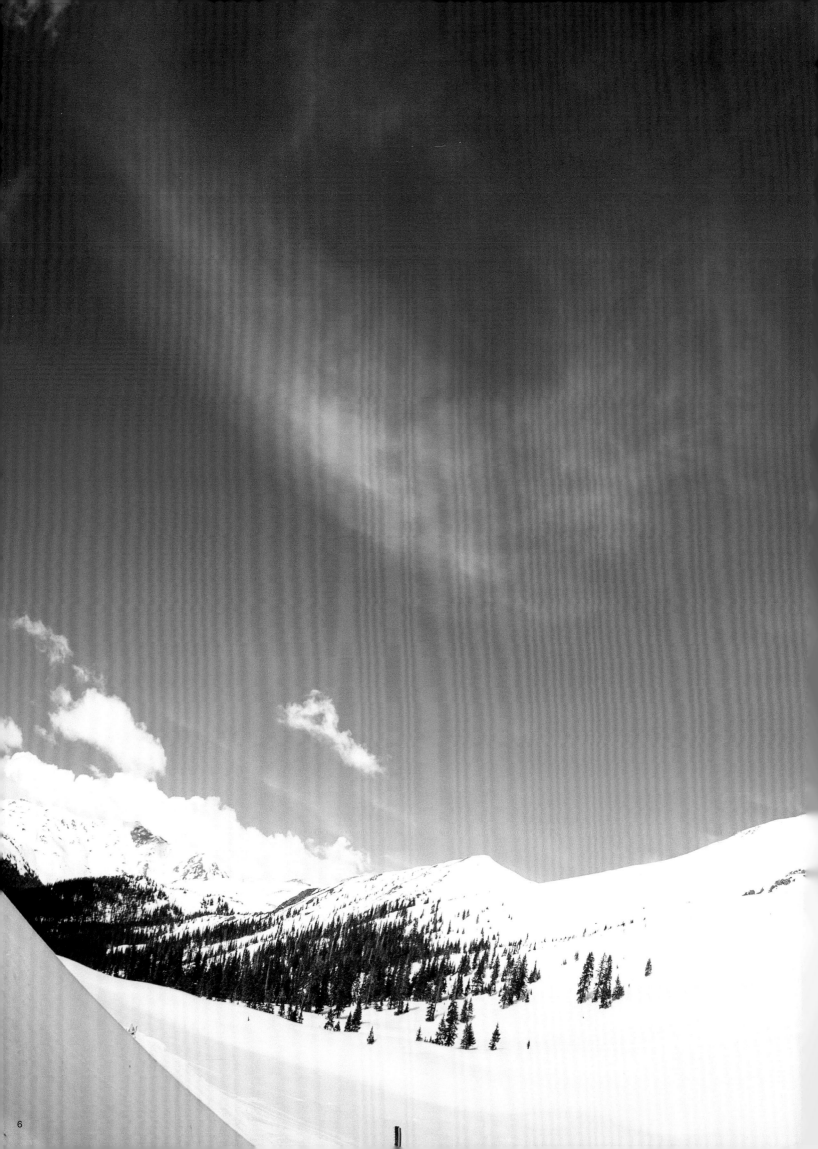

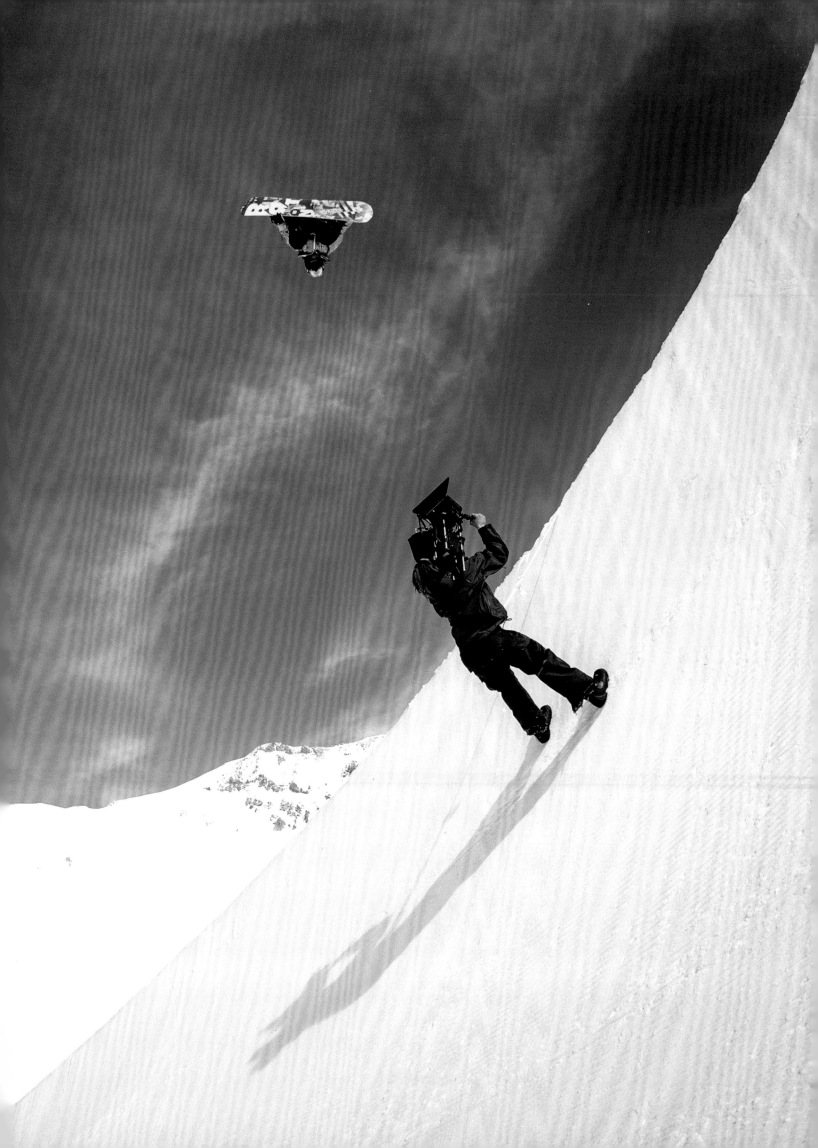

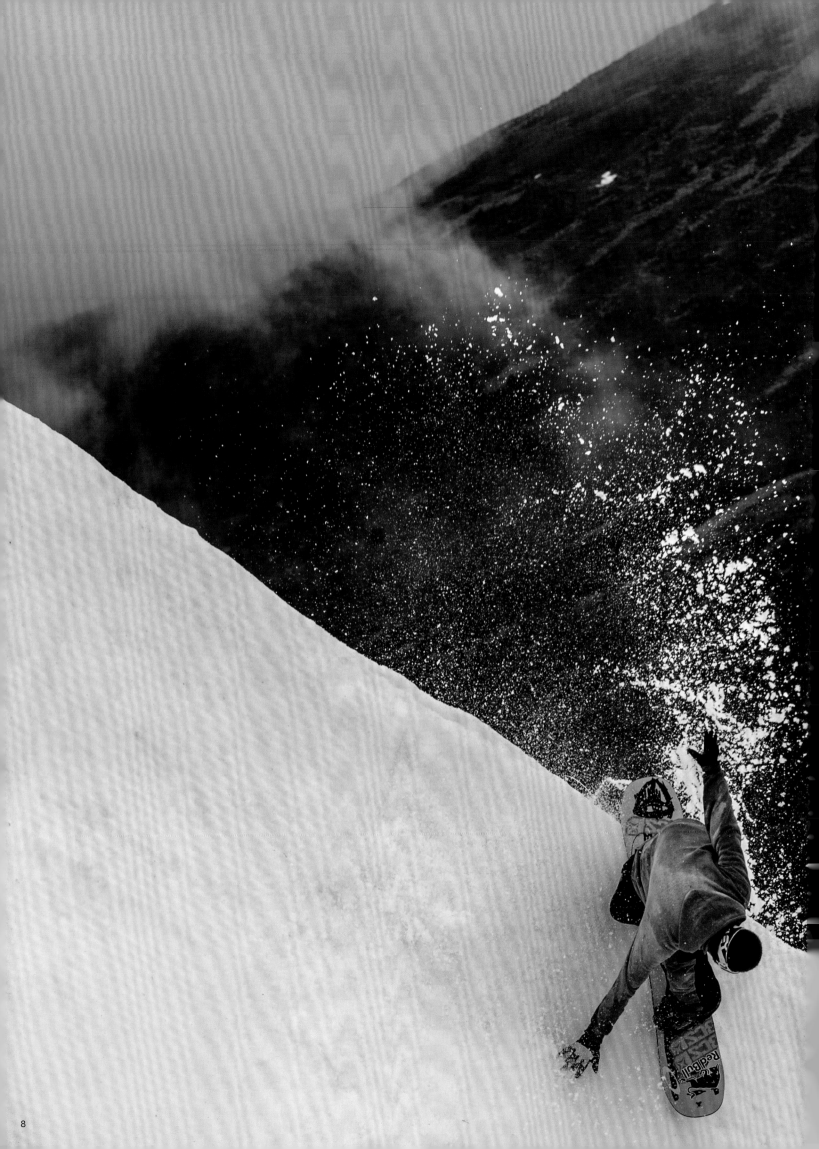

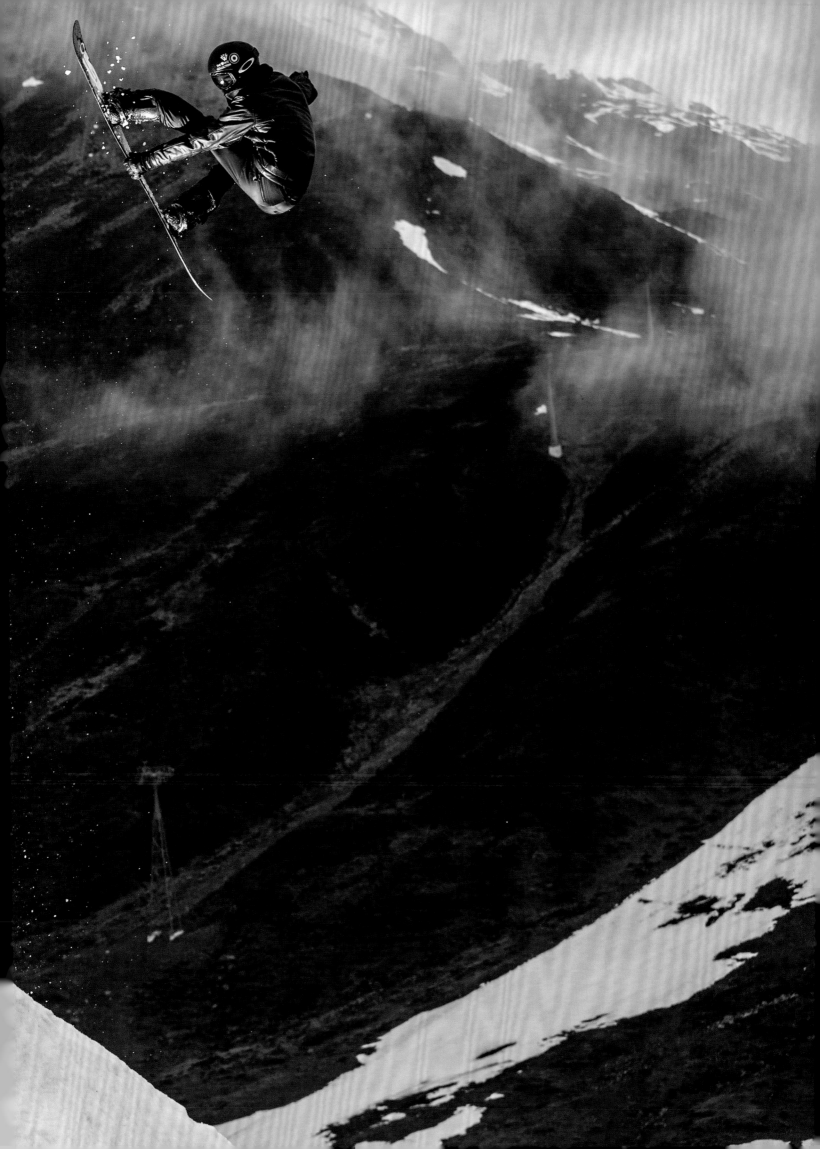

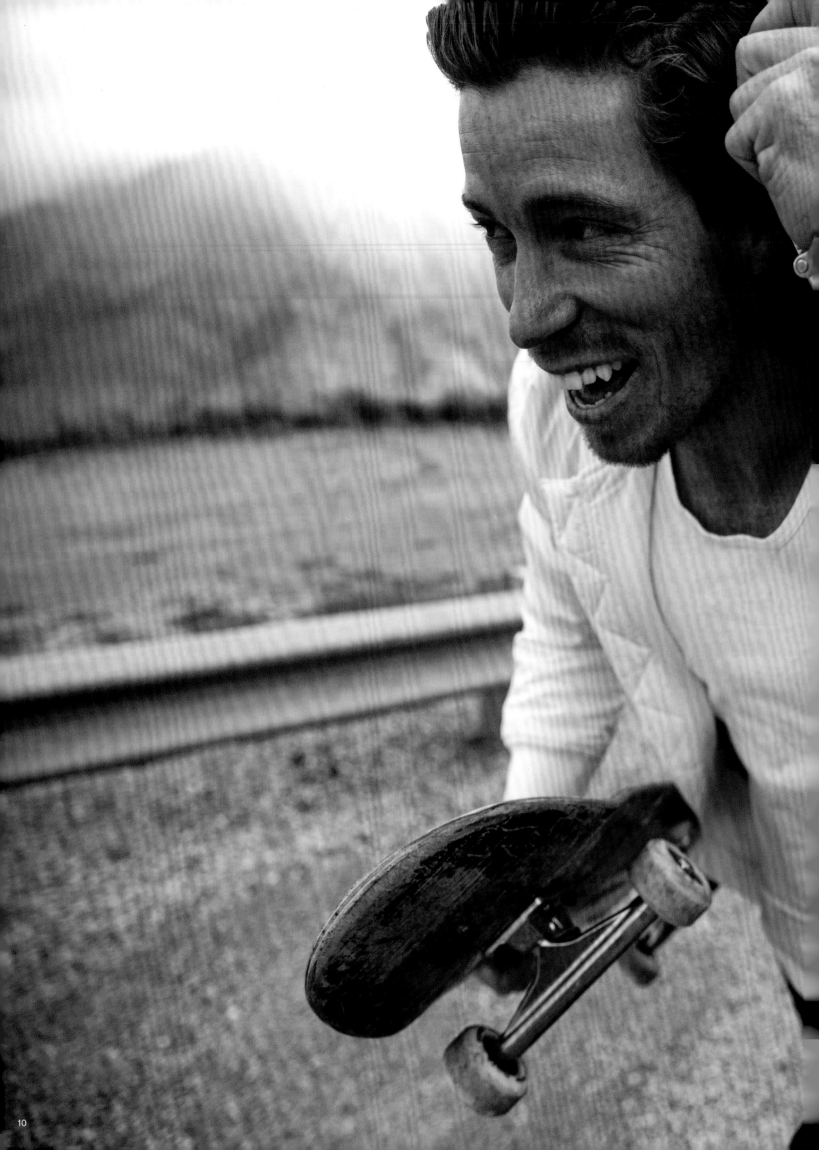

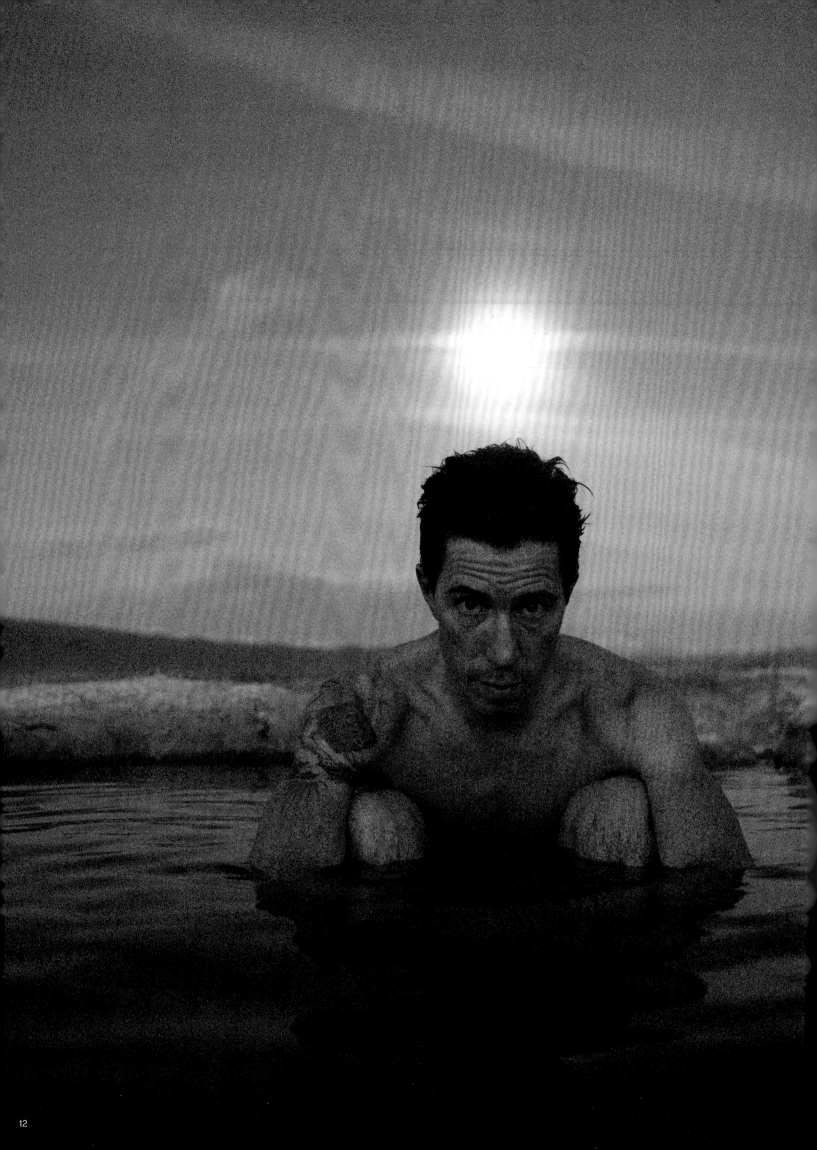

My relationship with Shaun started way before X Games. I knew him back when his parents were driving him around in the Scooby-Doo van to contests across California.

I remember hiking the old halfpipe at Snow Summit and riding with him. I was one of those people who carried him on my back up the pipe while someone else carried his board; we all took turns so this little kid could get more runs in. He was always around, and he had this little-brother energy.

It was apparent early on that this kid was beyond different. His repertoire of tricks, and the way he executed them, was ahead of his years—ahead of his time. Everyone else looked like they'd learned to snowboard; Shaun looked like he'd always been snowboarding. It was like Neo in *The Matrix*, when they plug him in and he wakes up and says, "I know kung fu." That was how Shaun would show up.

At those first couple X Games, when he was about thirteen, everybody thought he was cute. The older dudes who were making a living from snowboarding didn't take him seriously, and they didn't see him as a threat until it was too late. In 2002, Shaun got double silver in slopestyle and halfpipe (at least one of them should have been gold). The old guard just wasn't ready to give it to him.

That early incubation period uniquely endeared him to the fans. Prior to Shaun, every pro was in their twenties. Shaun was the first to show all the kids watching, "This is rad and you could live this life." He was like the Spider-Man of snowboarding—a young Peter Parker.

He won double gold the next year at X Games and kept on winning. Fans love a rock star. Practically overnight, he ascended into one.

He was incredibly disruptive in what I call the kumbaya era of action sports competition, when everybody got along and was rooting for each other, or at least was supposed to say they were. Here comes this guy whose sole purpose in life is to win, with the freakish physical ability and mental toughness to make it happen— essentially, he was like a machine, with an ability to lock

The same way that skateboarding is synonymous with Tony Hawk for the masses, Shaun White is for snowboarding, and snowboarding has benefited immensely from that. Before Shaun, no one had crossed over and taken it to the mainstream—including snowboarding's gods, legends like Craig Kelly and Terje Haakonsen. Shaun White became a god to the wider world.

Skateboarding was his base, which is why he's such a great snowboarder, and he had the opportunity to do both at the highest level from a young age while being mentored by the greatest in both sports. If he'd grown up anywhere else, none of this would have happened quite the way it did. But he grew up in Southern California, in the center of an industry that was just beginning to go from niche to mainstream.

And Shaun had the first Little League snowboard parents ever! That playbook exists now for the Sky Browns of the world and all these other super-talented kids we've seen come up. The White family started that whole movement in action sports. The first year Shaun was at the Burton US Open, they drove from California to Vermont even though he wasn't competing, just in the hope that he'd get to forerun the pipe or poach some runs. They knew there would be eyeballs on him and he might get to ride with the best of the best in the world, and if he did, mission accomplished. It was crazy.

Even crazier: it worked. He did the damn thing.

—Selema Masekela

eword

Ever since I was young, I've always had cameras around me—for the family photo album, home videos, catalog shoots, magazines, newspapers, online, photos for fans, contests, interviews. I was always confident on my board. It was all the other attention that was strange to me at first. I guess, at a certain point, I just stopped thinking about how much of my life is lived in front of a camera because the cameras were always there.

The collection of photographs presented in this book makes me very grateful that my story is so well documented. The images here trace all the way back to the beginning. I've been a competitor all my life, and the big, victorious moments are what stand out the most. The moments in between, however, tell the whole journey.

When I started out, there was no Olympics for snowboarding, and X Games was just building momentum. There was no bright career path for me to follow. Snowboarding and skateboarding have given me the opportunity to travel the world many times over. This book excites me because these are some amazing images of these travels, taken by friends and family who came along for the ride, and each one has a great story behind it.

I never really thought about things like my legacy or my contributions to snowboarding while I was still competing. My focus was always, "How do I stay on top? How do I stay out in front?" But rounding the corner of my fifth Olympics and announcing my retirement have given me a different perspective.

# Introduction

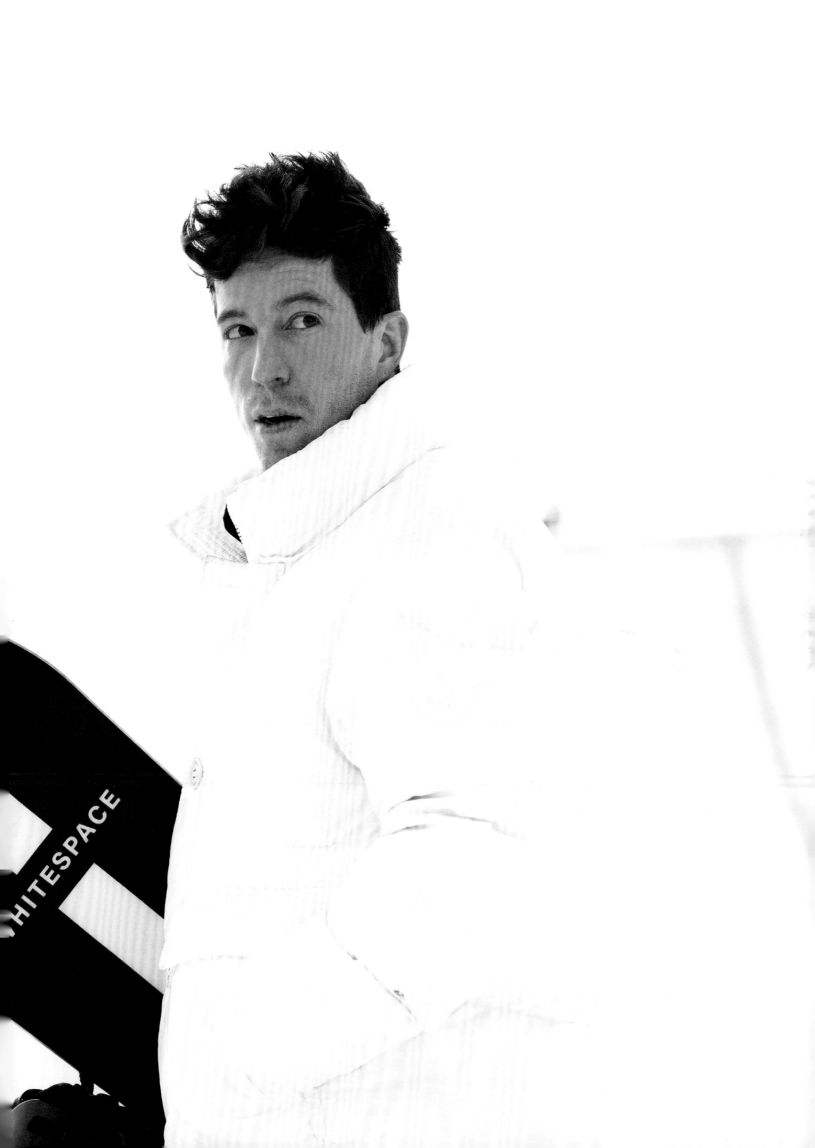

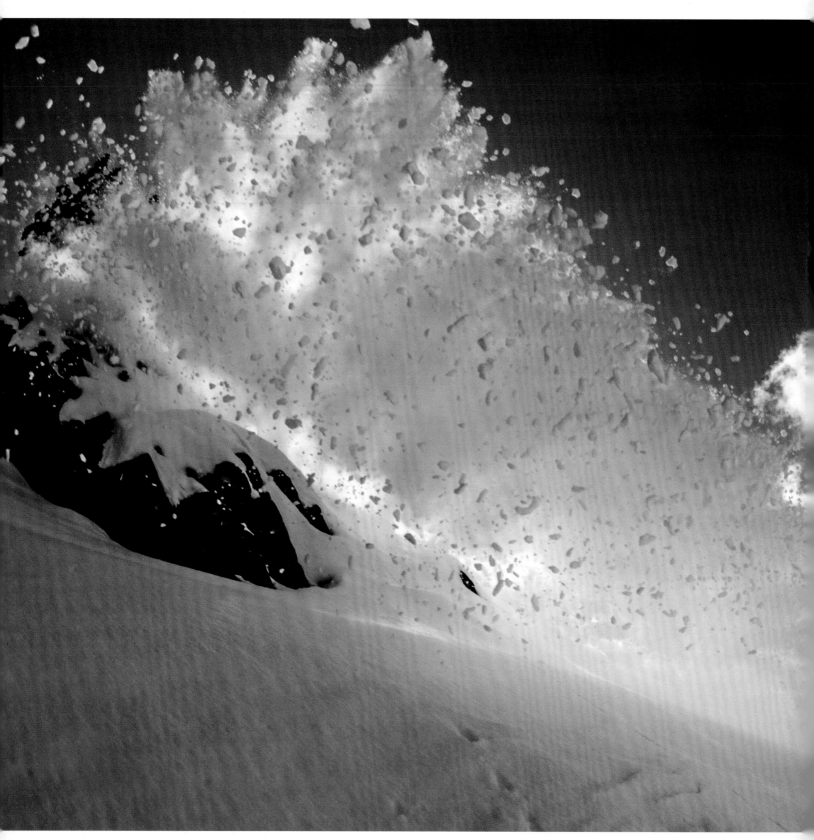

BRECKENRIDGE SKI RESORT, BRECKENRIDGE, COLORADO, 2013.

PHOTO BY GABE L'HEUREUX.

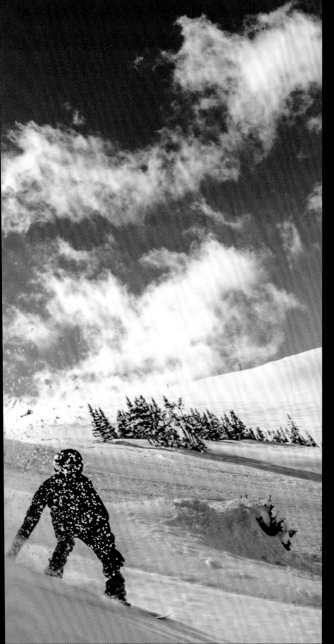

Looking back at these photographs, I am humbled to retrace the whole journey and see the boy who just wanted to snowboard. The competitor. The rebel. The son. The businessman. The friend. It's been fun to pull together these snapshots of more than twenty-three years as a professional snowboarder and to see how I've changed as a person and how the sport has changed—the faces in the crowd, the snowboards, the halfpipes, the tricks, the contests, the sponsors, and the competitors themselves. Snowboarding, skateboarding, and I shared an incredible moment in time when a spark ignited and the world took notice. I'm incredibly proud of what I'm leaving behind in these sports and the fact that my participation forever changed them.

—Shaun White

When I was first introduced to snowboarding, my dad worked at the City of San Clemente, California, in the water department, and my mom was a waitress at the Sheraton hotel in Torrey Pines. We weren't exactly struggling, but we definitely didn't have the kind of money that it takes for a whole family to buy season passes, go to the resorts, and pay for all the equipment, meals, and everything. It's an expensive sport, and the financial aspect was always looming. I remember having to pretend to be eight years old at the ticket office for a bunch of years so that we could keep getting the discounted child's lift tickets! Most years, we wouldn't get Christmas gifts; we'd all agree to just use the money on a snowboard trip to the mountains instead. We just wanted to ride together.

I think we were probably the first real suburban family who took to the slopes for snowboarding. My brother was the first to start, then I, my sister, and my dad, and finally my mom got hooked. It quickly became our thing together. Sometimes, we'd all sleep in the family van in the parking lot—anything to be on the mountain.

My career took off quickly because the sport was growing so much. At one point, my brother, sister, and I each were sponsored. Family was always our focus. We knew how special our family dynamic was, because we saw so many families grow apart as the kids got older. You know how it goes: you lose common interests, and you just don't understand each other. Snowboarding was that thing that kept our family together and kept us talking and excited to spend time together. And that's how it all started.

# How It All Started

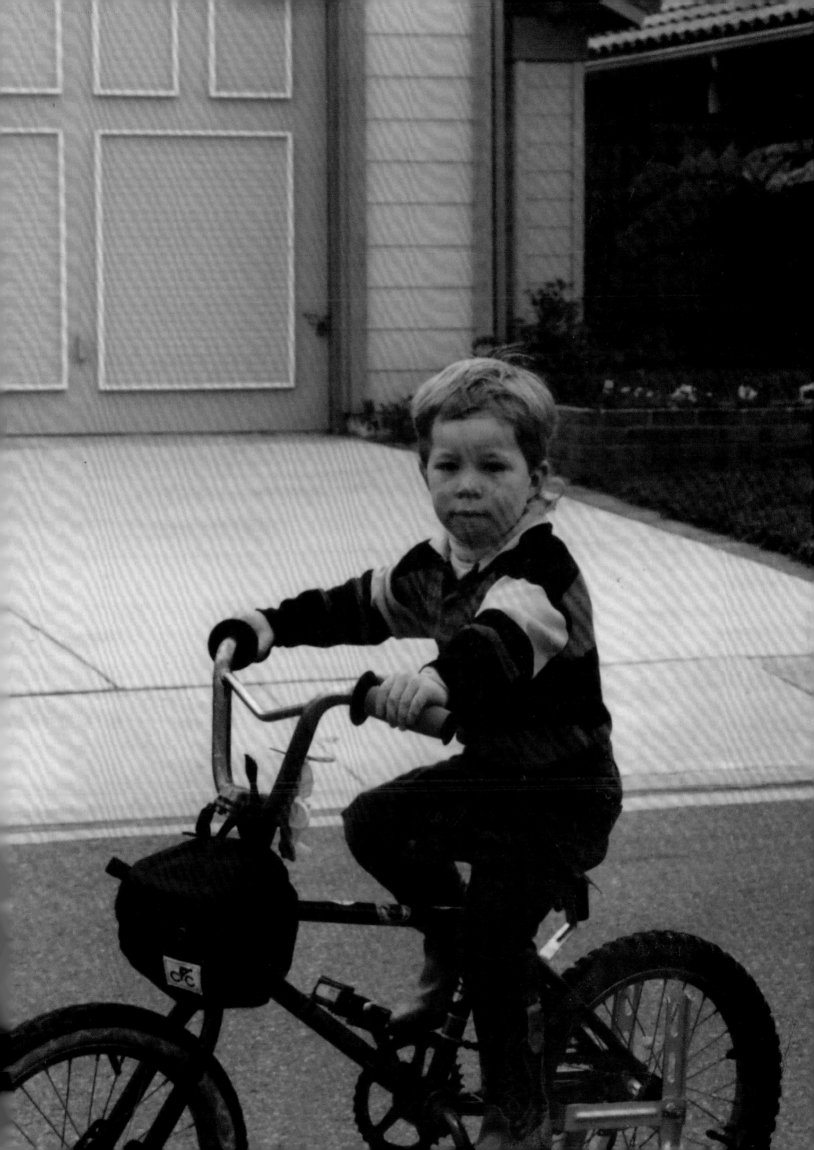

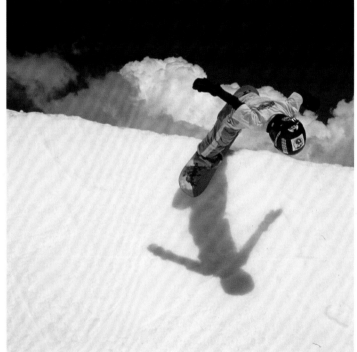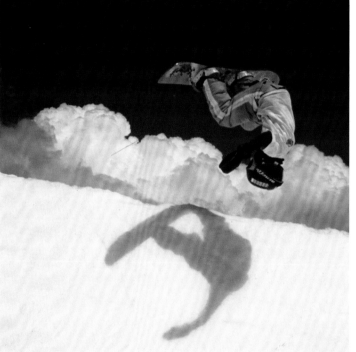

MOUNT HOOD, OREGON. PHOTOS BY DEAN BLOTTO GRAY.

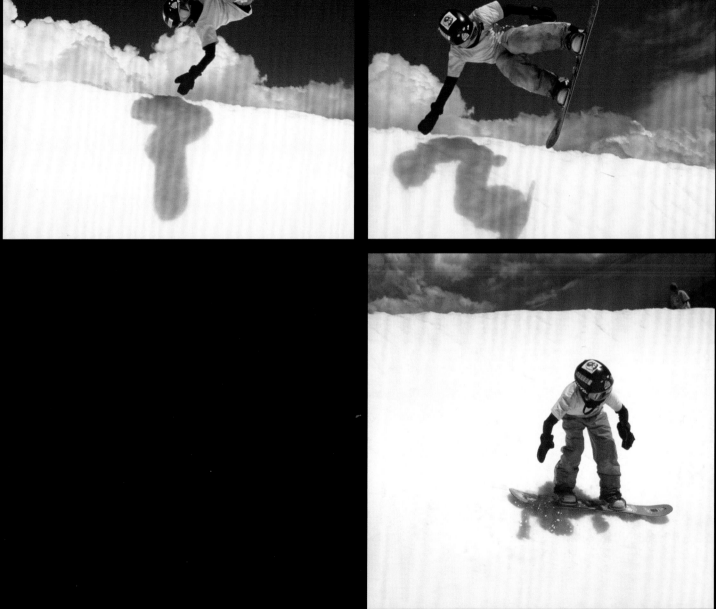

*(Below)* I was always just as into skateboarding as snowboarding. I almost think of them as inseparable. This photo is from a place that was very special to me: the YMCA in Encinitas, California. You know how other YMCAs have swimming pools, basketball courts, and stuff? Well, this YMCA was where Tony Hawk skated. He had teamed up to make an insane skatepark in one of the parking lots. And not just Tony would use it; all the skate legends would go there. When you're young, there's always somebody telling you what you can and can't do. The skatepark was the first place that had no rules and where I was set free to do whatever I wanted. Having access to those ramps and all the people I met there when I was a kid was probably one of the single biggest things to shape my life and success in both snowboarding and skateboarding.

*(Opposite, top)* This is one of my very first amateur competitions, a slalom race at Big Bear Mountain Resort, California. That's my first board ever. I'm wearing ski boots because they didn't make kids' snowboard boots my size.

*(Opposite, bottom left)* This is during a photo shoot for a Burton kids' line called Backhill. I couldn't wait to grow and be in the menswear line and be taken seriously as a rider.

*(Opposite, bottom right)* This is a little bit later, at Giants Ridge in Minnesota for the 1995 USA Snowboarding Association (USASA) National Championships. I had established myself, gotten some boots that fit me, and started winning the amateur competitions.

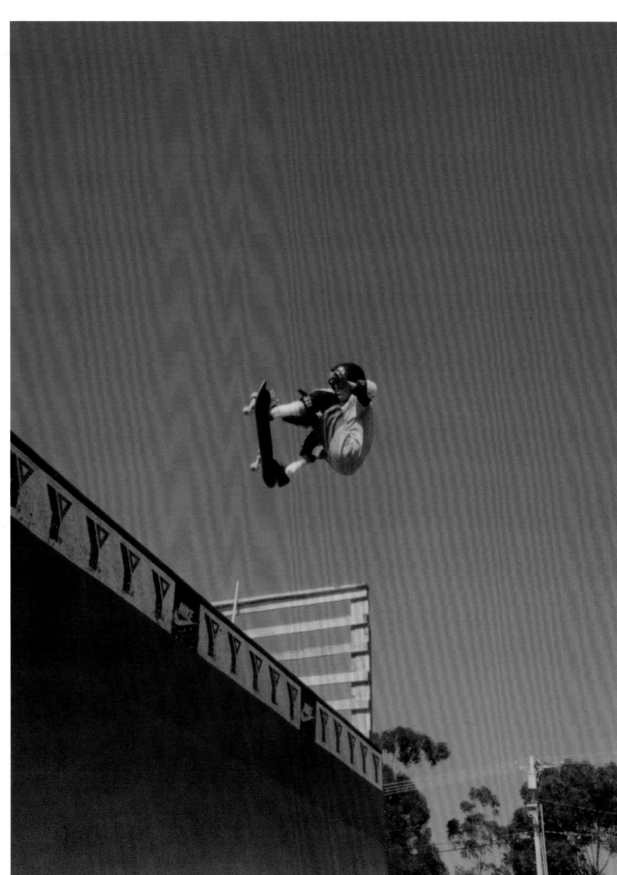

YMCA SKATE PARK, ENCINITAS, CALIFORNIA.

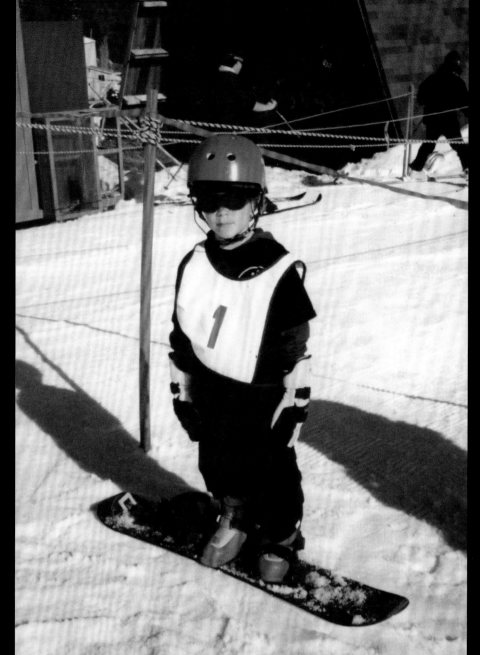

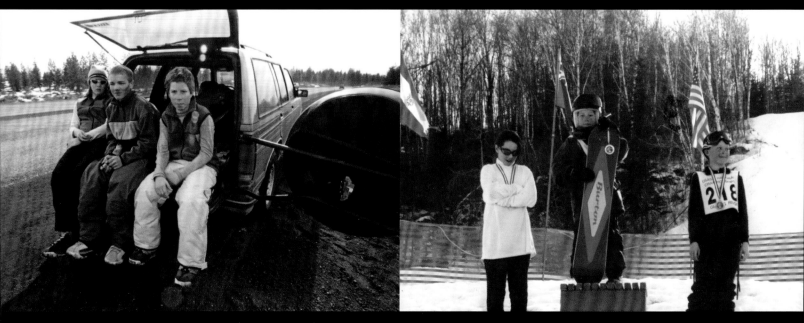

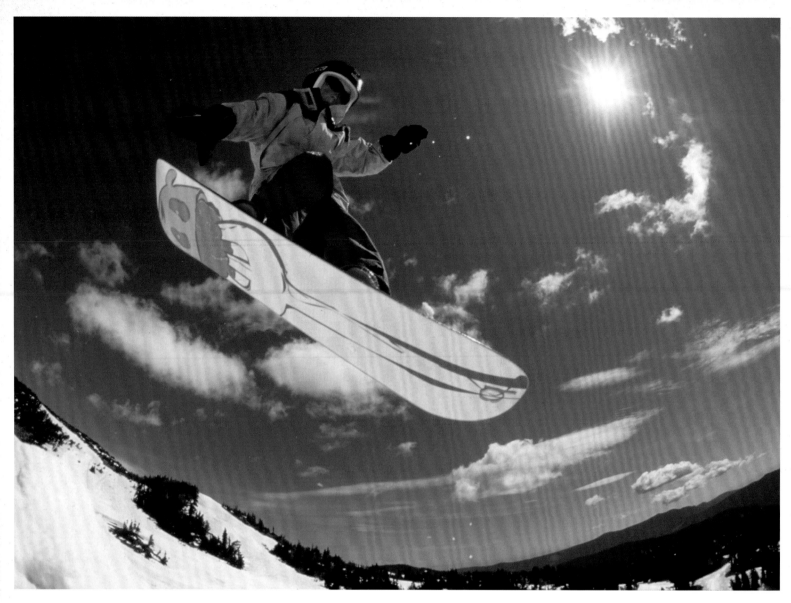

Oh, man, this is one of my favorite snowboards! Somebody at Burton said, "We're sending you a new board." For four weeks straight, I ran home from school every day hoping it had arrived. My mom was like, "It's not here. It's not here." I had just about lost all hope and then, one day, she just burst into my classroom and shouted, "It's here!" She was holding the board above her head. I was flipping out, and the classroom was cheering!

Every time I see that stupid graphic on the snowboard— that orange face with a fork in its green brains—I'm transported back to that classroom. I was so excited! The helmet I was wearing in this photo kind of became a signature look for me. It was an old-school Pro-Tec skateboarding helmet. Most helmets stopped at your temples, but this one went down around your ears. People didn't really wear helmets on the mountain at the time, and this one was huge. Shortly after this, I started wearing a face mask to protect me from the sun. People just didn't know who I was or what I looked like. I was very much like Kenny from *South Park*. You didn't know I had red hair until I took my helmet off.

Timberline

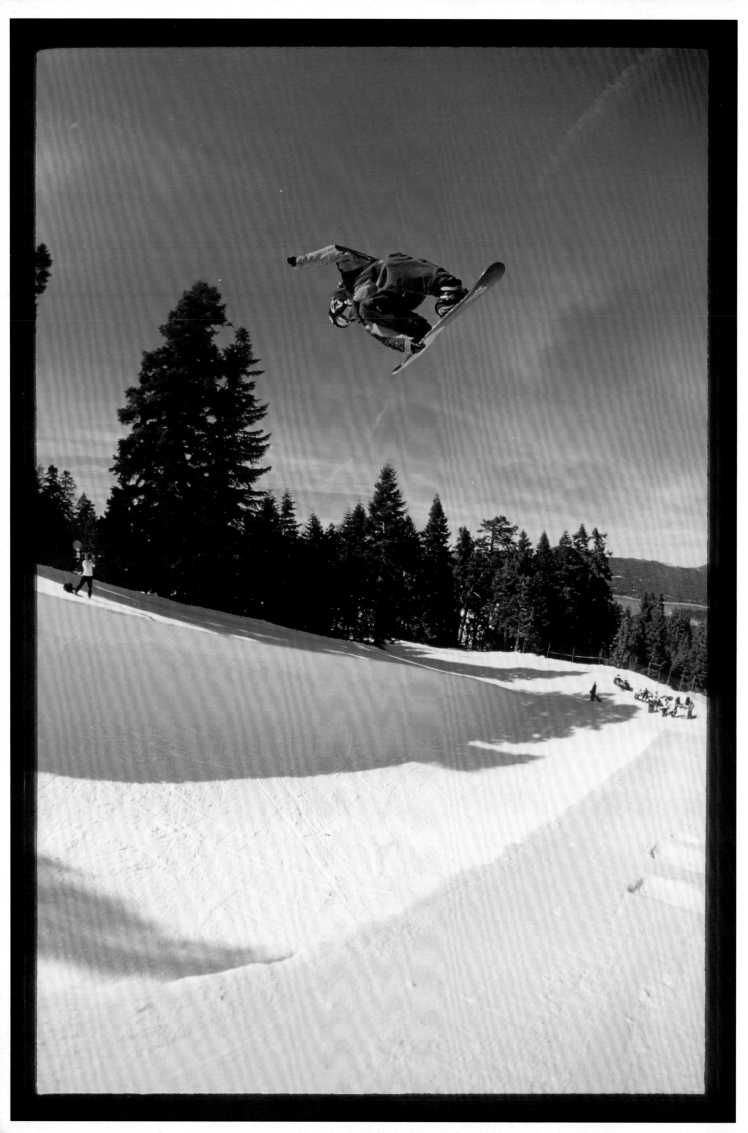

(Opposite) Snow Summit had one of the first incredible snowboard parks. Most major resorts, like Aspen and Vail, didn't even want snowboarders around, let alone build a snowboard park for them. But Snow Summit was like, "Oh, we don't care. Come on down!" and dedicated the west side of the mountain to snowboarding.

The run was called West Ridge, and it was magical. It had it all: rails, straight jumps, hip jumps, banks, a halfpipe, gaps—you name it. And it came complete with a six-person, high-speed chairlift and a tow rope at the halfpipe, so you didn't even have to go a whole chairlift lap to hit the pipe. The conditions were warm, which made the snow soft and forgiving.

Snow Summit had the perfect ecosystem for snowboarding.

PHOTO BY KEVIN ZACHER.

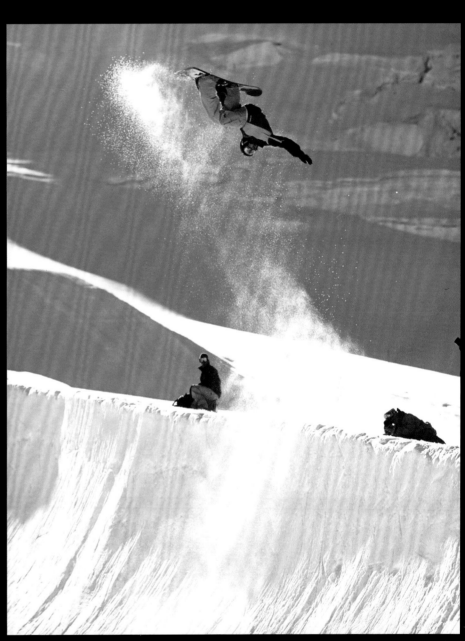

SAAS-FEE, SWITZERLAND, 2000.

(Above) This image was taken at a halfpipe in Saas-Fee, Switzerland. It ended up on the cover of *Transworld Snowboarding* magazine. If you look really close in the snowy mist coming off my board here, you can see this little face. There are eyes, a nose, and a mouth, which is slightly grinning. After this photo was published, there were a bunch of rumors floating around. People were saying things like, "It's a demon" or "It's an angel"—like that old tale of the guitar player Robert Johnson going down to the crossroads and making a deal with the devil in exchange for mastery of his instrument. "Shaun sold his soul for snowboarding," they said. To be honest, I'm not very religious, but I've always felt like there was something watching over me, keeping me on track, and keeping me safe. Who really knows? Maybe it made an appearance?

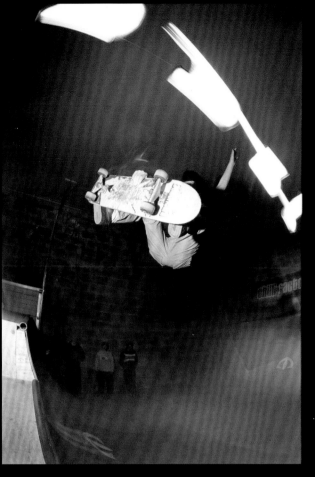

PHOTOS BY EMBRY RUCKER.

(THIS PAGE) YMCA SKATE PARK, ENCINITAS.

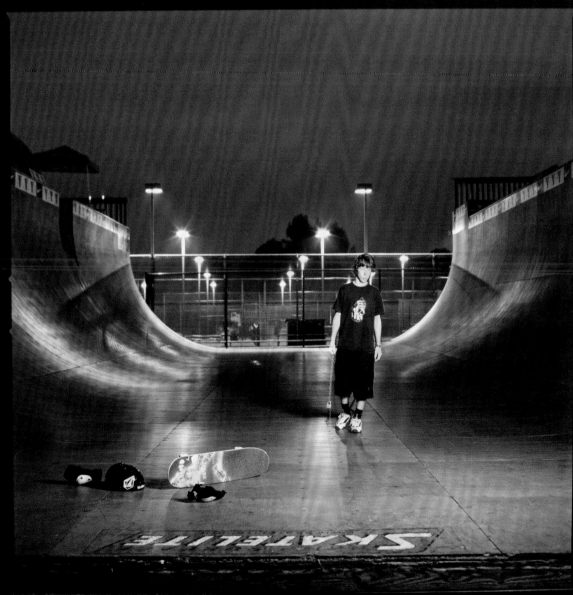

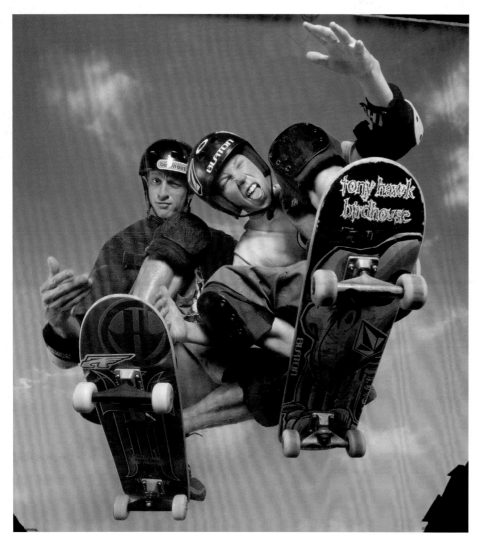

PHOTO BY TIM RUE.

WITH TONY HAWK.

*(Above)* This is a funny photo shoot that Tony Hawk and I did together for the cover of *Sports Illustrated for Kids*. I love this image because it was taken long before we became friends and equals. At this point, I was still trying to keep it under wraps that I was his biggest fan.

*(Opposite)* The Birdman, aka Tony Hawk. This photo was taken in 2001, at the Encinitas YMCA. I love this photo because the photographer asked for a doubles shot. "Can you air over Tony?" he asked. I said, "Yes, but the guy's tall!" I felt so much pressure not to decapitate my hero. But I think Tony knew that my thing was doing big airs, so having his trust in my ability to clear him was cool. Not to mention, looking down from a 15-foot air and seeing the legend Tony Hawk doing a trick under me was cool too.

WITH TONY HAWK.   PHOTO BY TIM RUE.

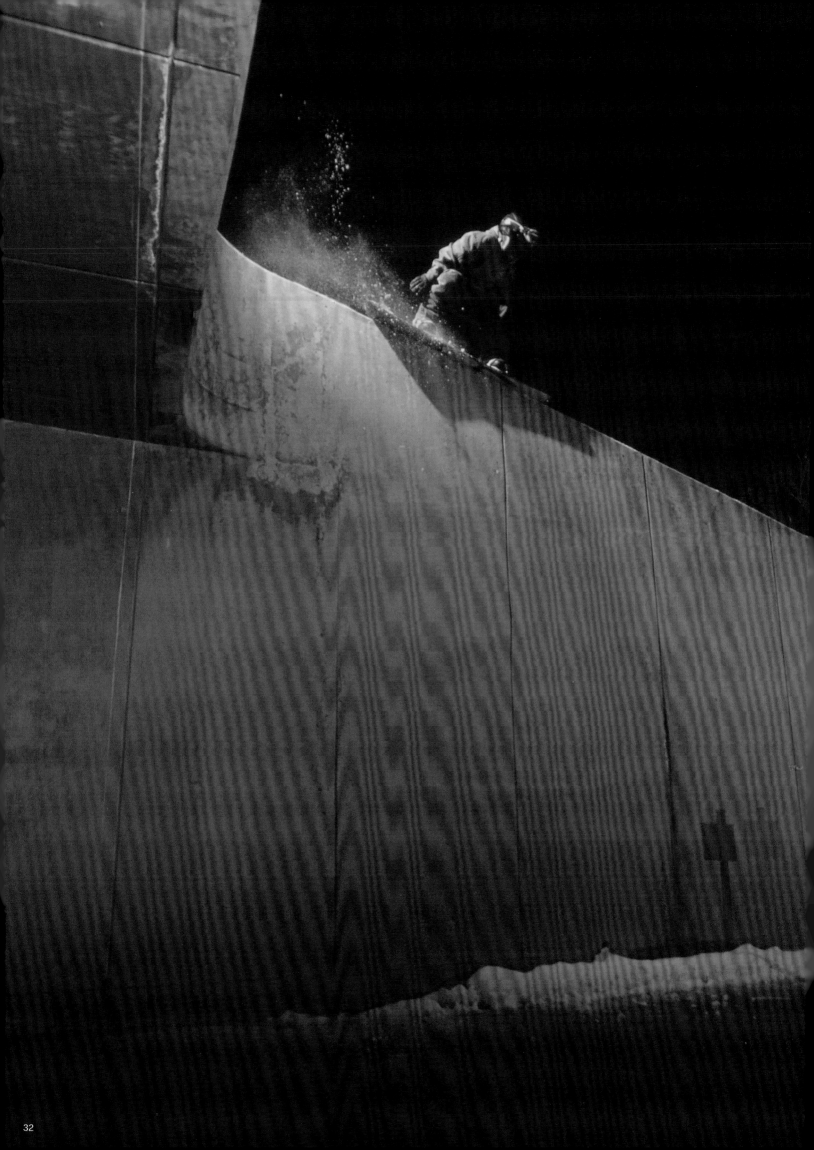

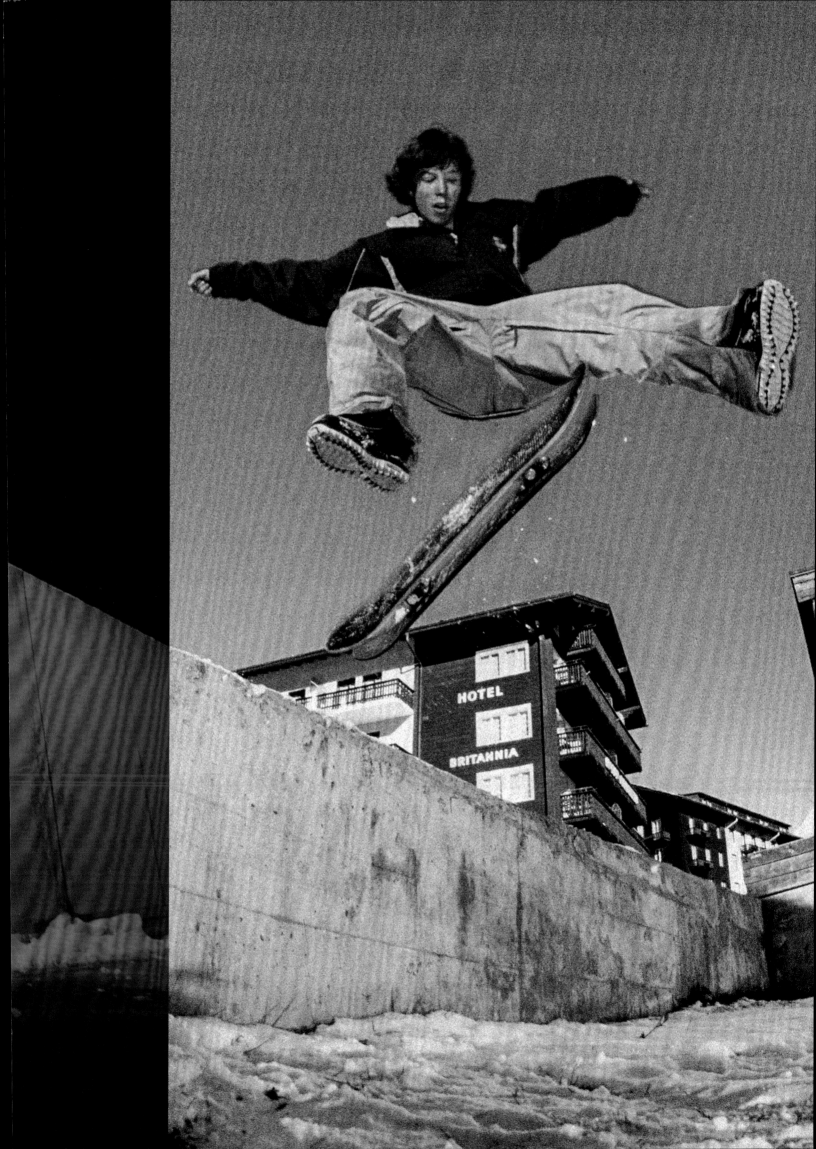

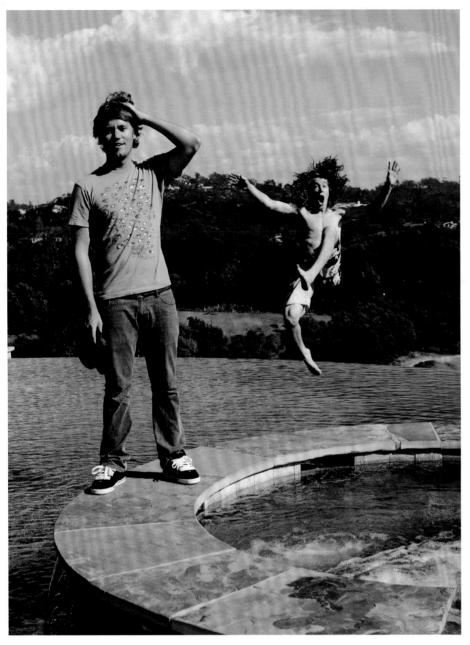

(Left) This is my brother, Jesse, and me celebrating the purchase of a home I bought after the 2006 Olympics, in an area of Southern California called Rancho Santa Fe. I did what you're "supposed to do" after you make it big: go buy a huge house and a fancy car and throw parties. It was the American dream, so to speak.

At this point, my career was going great but, to be real, I was struggling with my newfound success and recognition. I was realizing that all of my friends had gone off to college or gotten jobs, and I was alone and confused. Thankfully, I had family to help me through it. That's why I love this picture with my brother.

(Opposite) This photo was taken in New Zealand. Jesse is in the foreground, and I am above him. We did a doubles routine on a quarterpipe in which I did a big alley-oop backside rodeo and he did a lipslide below me. I love this photo because it shows how close my brother and I are—not only our sibling bond but also our ability on snow. He was incredibly talented, and I got all of my foundation of tricks from following him through the snowboard park.

Jesse was a pro snowboarder, but he gave it up to become my team manager, travel companion, and photographer. He eventually started doing the design work for all the companies I was sponsored by—my Burton Snowboards line, my kids' clothing line at Target, sunglasses, and commercials. Any artwork or product or campaign I was in, Jesse was involved. He really became this artistic and creative powerhouse for me, in addition to being my brother.

WITH JESSE WHITE. RANCHO SANTA FE, CALIFORNIA, 2007.          PHOTO BY ADAM MORAN.

(PREVIOUS SPREAD, LEFT) SALT LAKE CITY, UTAH, 2001.
(PREVIOUS SPREAD, RIGHT) CHALET BRITANNIA, SAAS-FEE, SWITZERLAND, 2000.
(OPPOSITE) WITH JESSE WHITE. SNOW PARK, QUEENSTOWN, NEW ZEALAND, 2002.          PHOTOS BY KEVIN ZACHER.

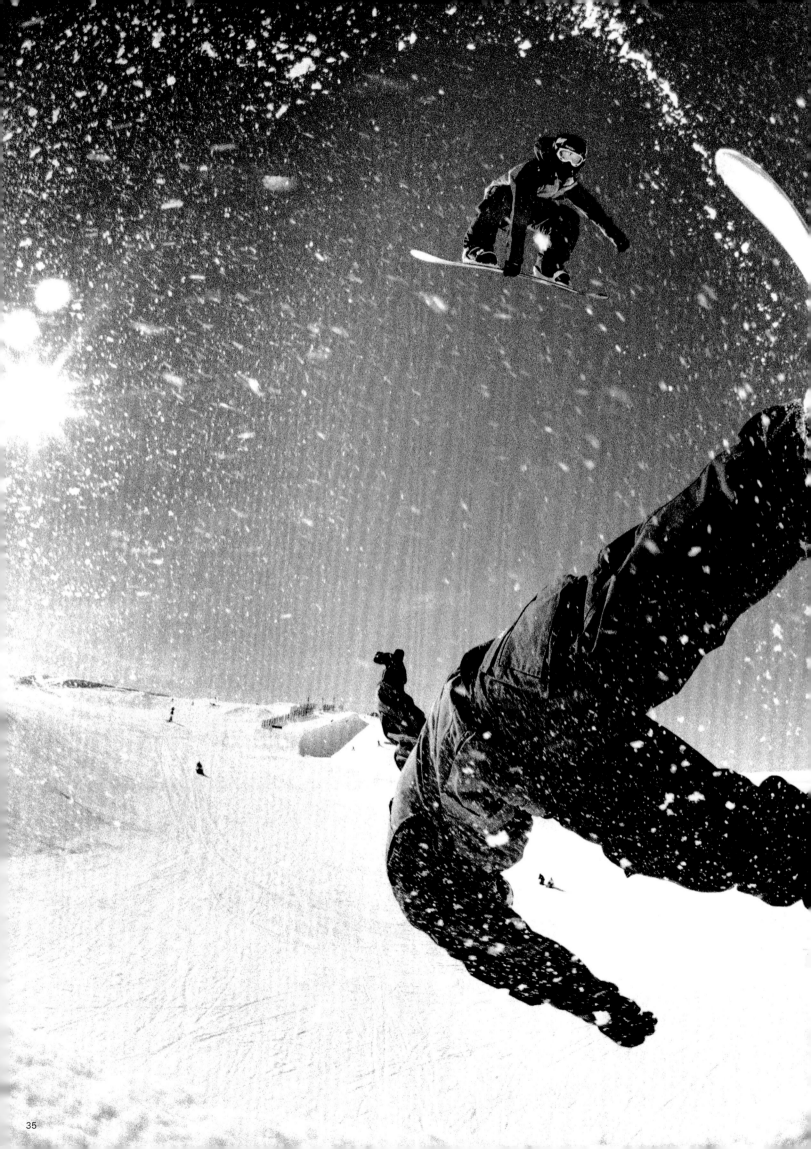

(THIS PAGE AND OPPOSITE) TRILLIUM LAKE, GOVERNMENT CAMP, OREGON, 2001.

PHOTOS BY KEVIN ZACHER.

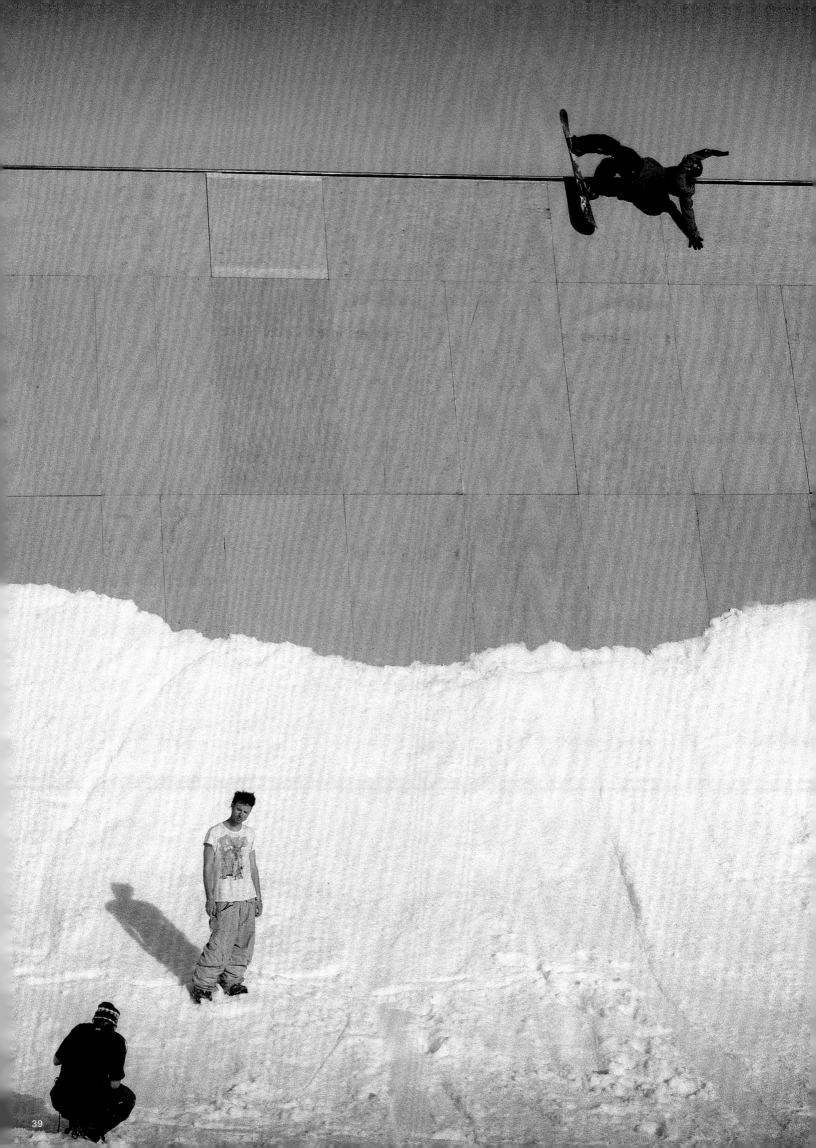

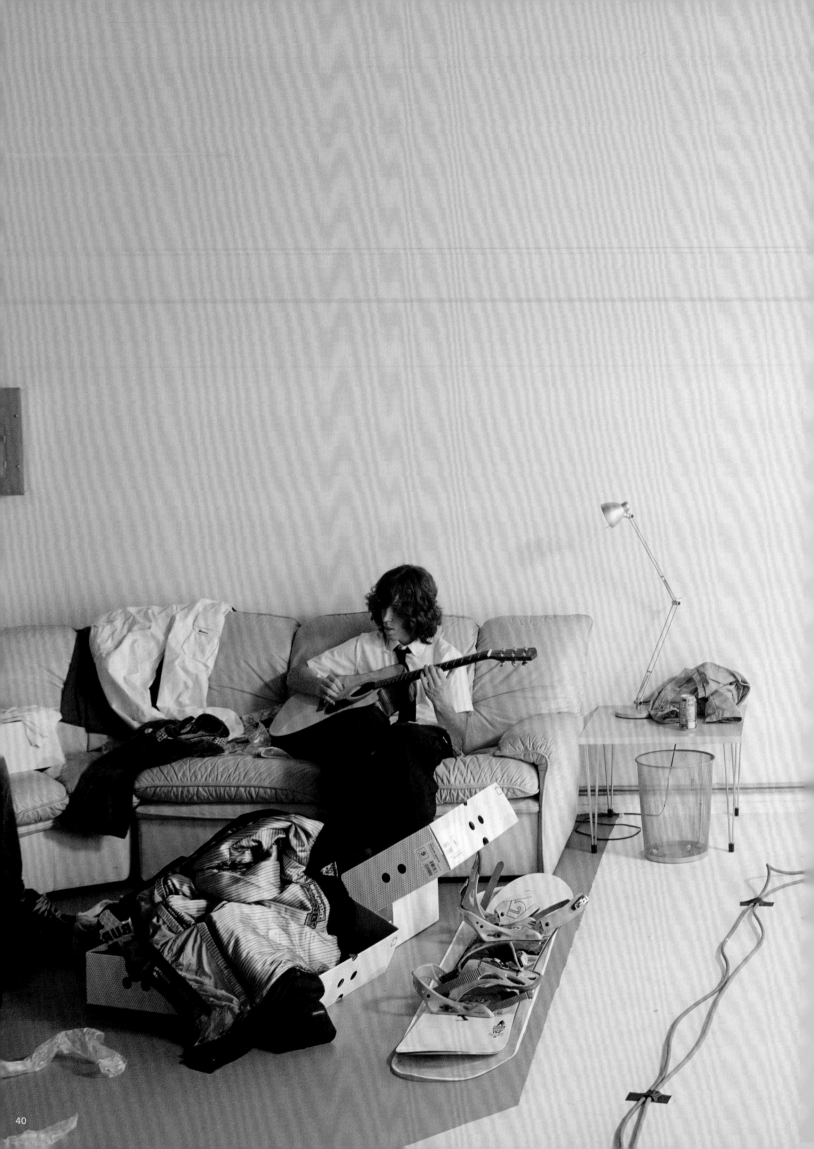

*(PREVIOUS SPREAD)* MILK STUDIOS, LOS ANGELES, CALIFORNIA, 2003.
*(OPPOSITE)* BURTON STUDIO, BURLINGTON, VERMONT, 2001.

PHOTOS BY KEVIN ZACHER.

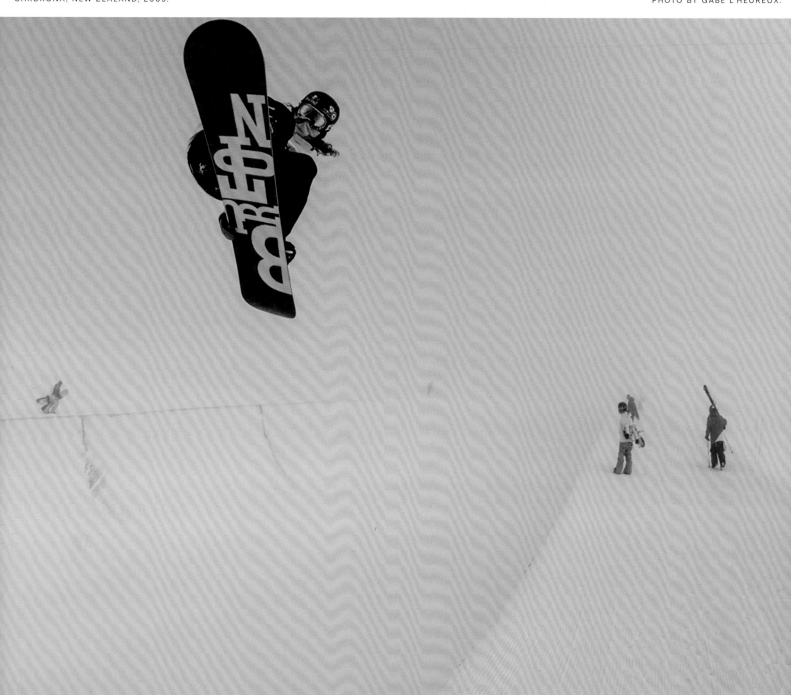

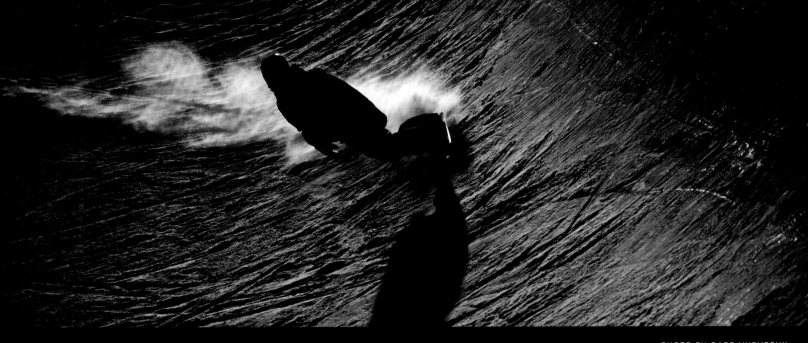

PARK CITY MOUNTAIN RESORT, PARK CITY, UTAH, 2009.    PHOTO BY GABE L'HEUREUX.

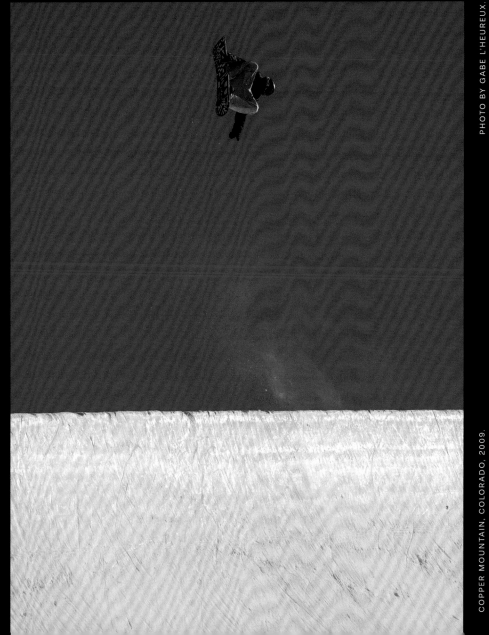

PHOTO BY GABE L'HEUREUX.

COPPER MOUNTAIN, COLORADO, 2009.

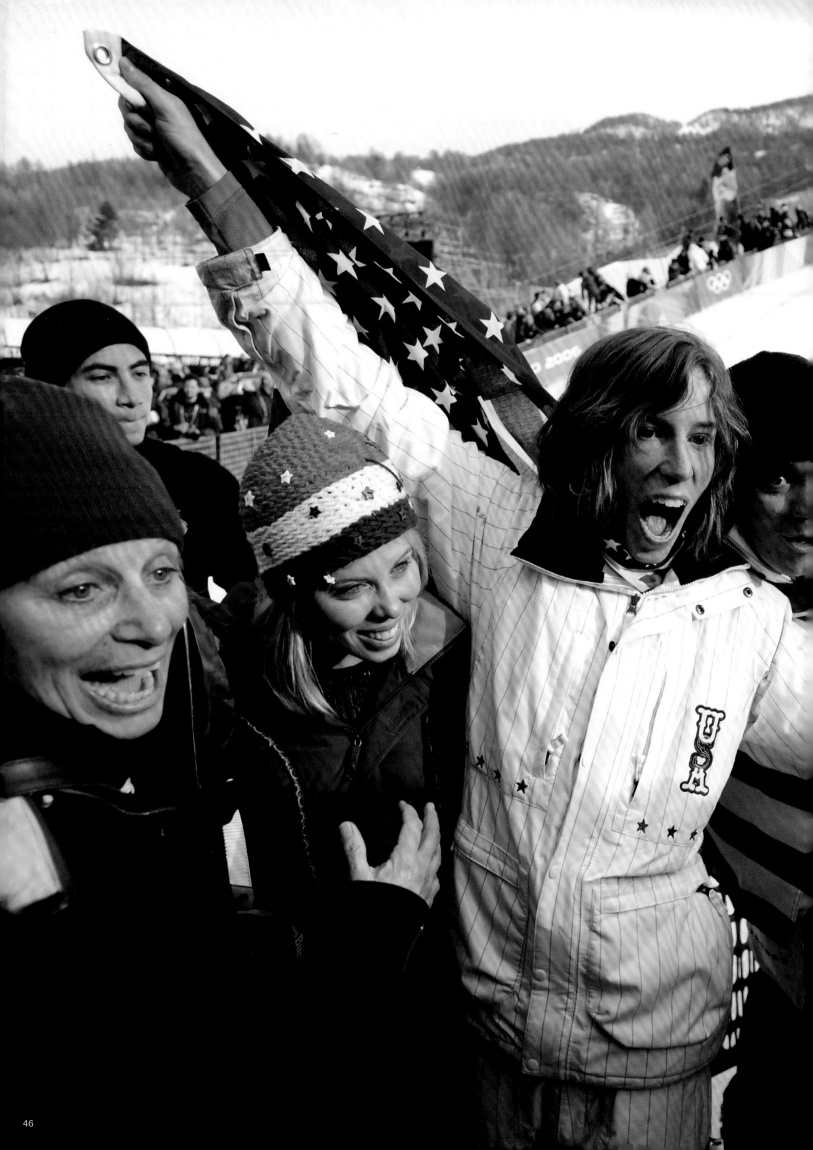

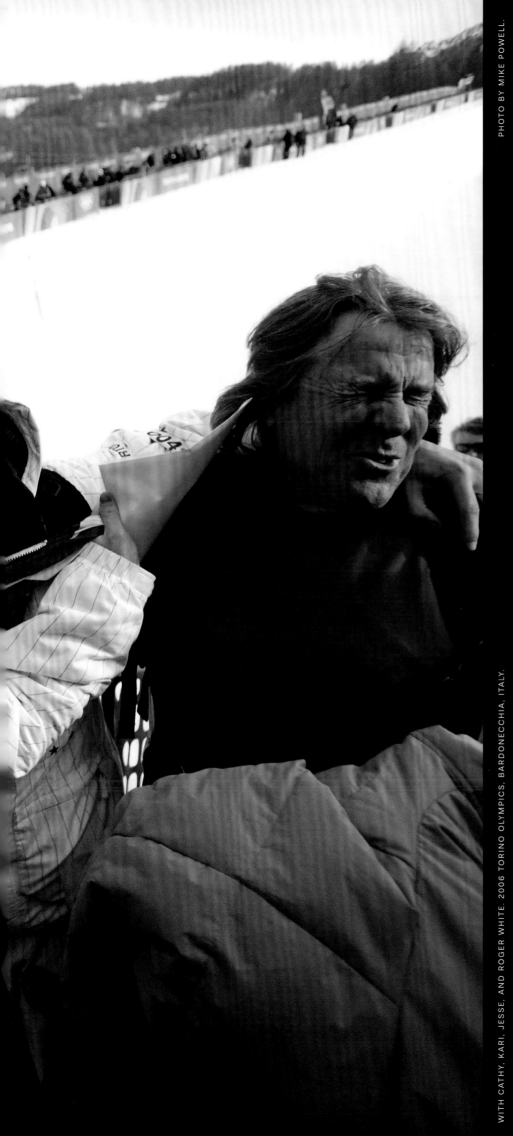

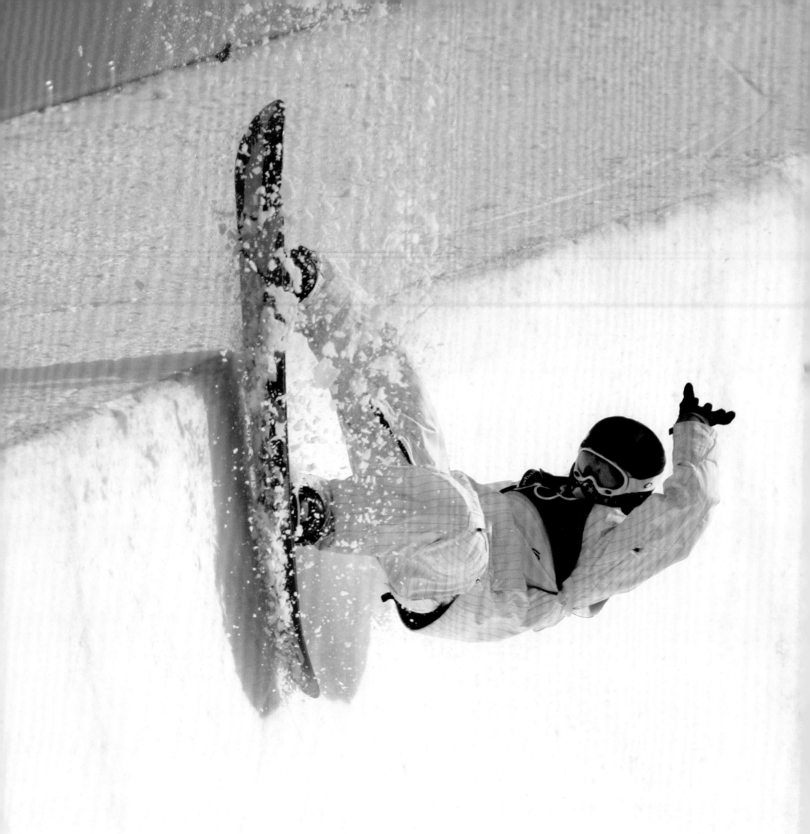

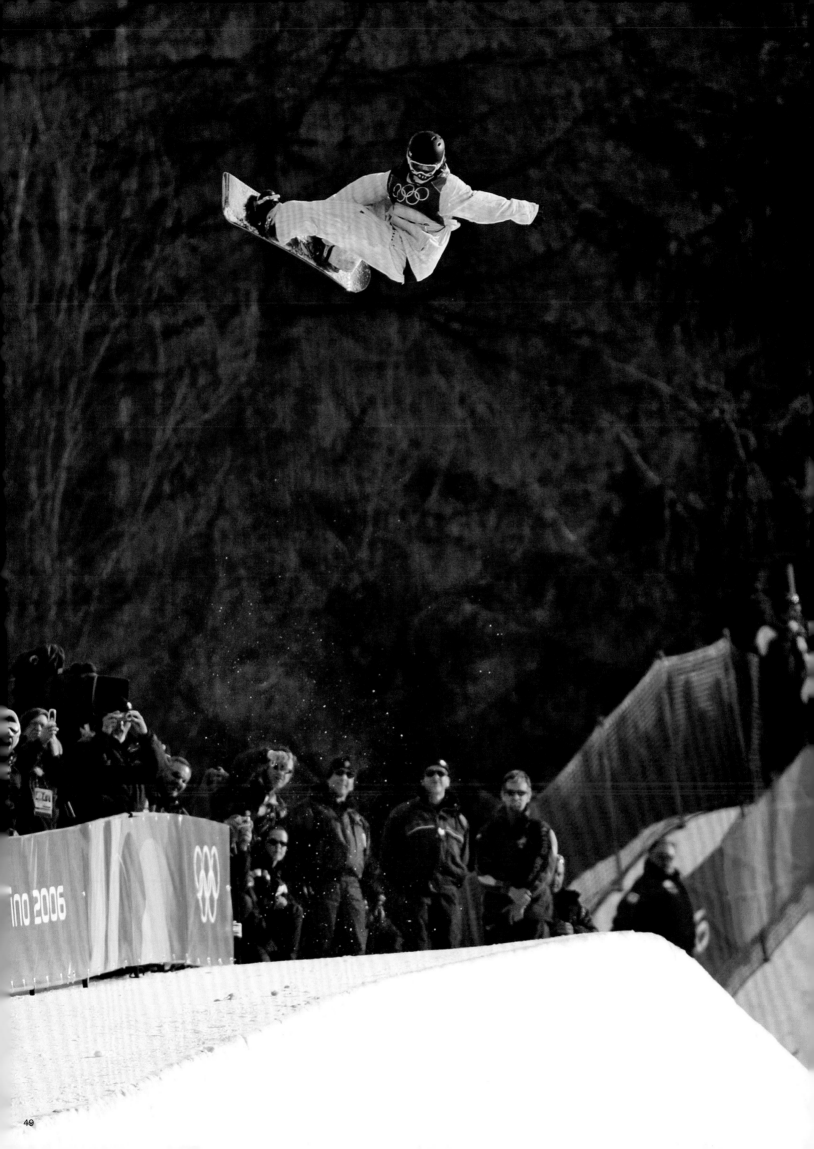

49

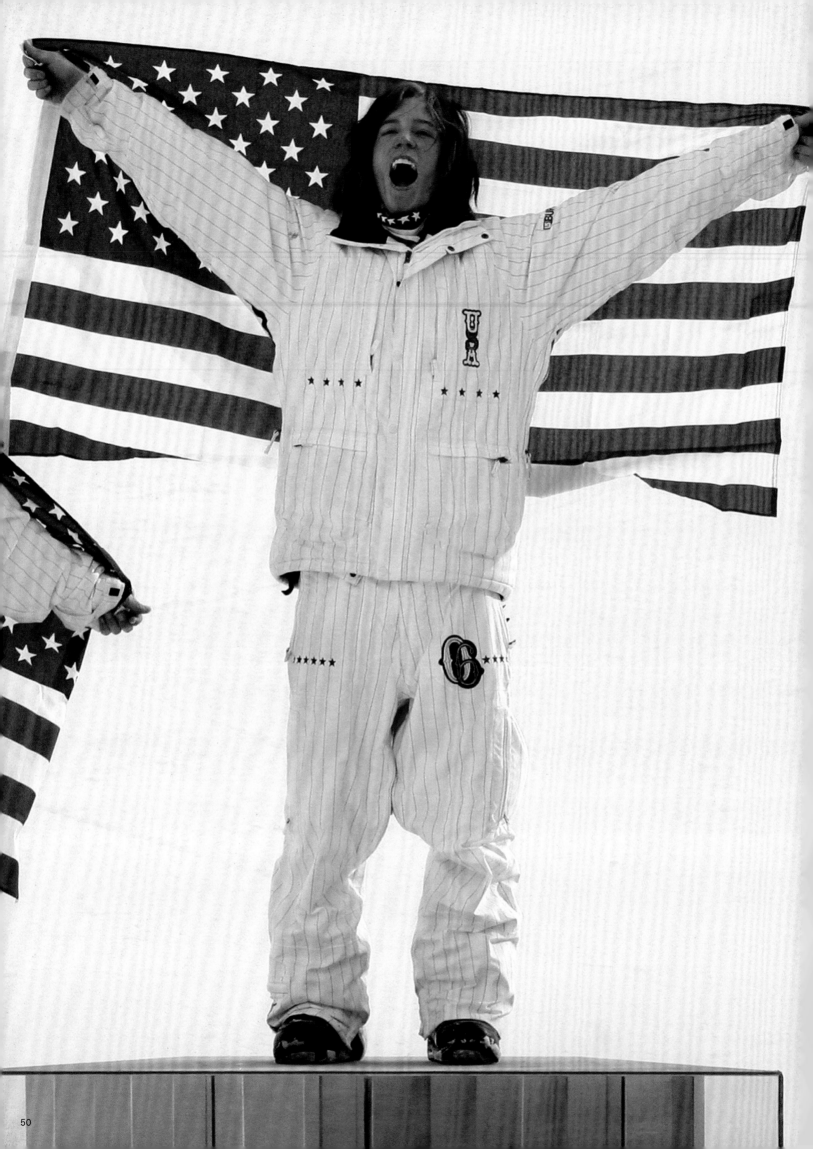

(PREVIOUS SPREAD) 2006 TORINO OLYMPICS, BARDONECCHIA, ITALY.
(OPPOSITE) 2006 TORINO OLYMPICS, BARDONECCHIA, ITALY.

PHOTO BY AL TIELEMANS
PHOTO BY JOE KLAMAR

Snowboarding first debuted in the Olympics in 1998, in Nagano, Japan. It wasn't really talked about or a big part of the broadcast. It wasn't until the 2002 Salt Lake City Olympics that the Olympics became a real goal for me. I missed qualifying for the US team for that year by one spot, to JJ Thomas, who went on to earn the bronze medal. I was devastated, but it lit a fire in me for the next season. I had never been more motivated.

The first time I went to the Olympics, in 2006, my eyes were wide open. I didn't know what to expect. Everything from getting our uniforms to taking the flight over, attending the opening ceremony, and participating in the competition felt like a daydream.

The photo of me doing a layback slash on the halfpipe wall, sending snow into the air, was part of my last run at the Games. You take two runs down the pipe and you keep your highest score. I posted a massive score on my first run and was the last rider to go for my second run. No one bested my first score, so I got to take a victory lap. This photo is me celebrating.

A lot has been written about me at the 2006 Torino Olympics, but one of the things that stands out now as I revisit these photographs is how special it was to have my family there at the bottom celebrating with me. It's a very surreal thing to accomplish something incredible and then turn around and see all the people who helped you get there. You get to hug them, thank them, and let them enjoy this moment with you. We were a family that believed in snowboarding when no one else did. So here I am, nineteen years old, and I had just won. But, really, the family had won, because we'd all believed in this thing and it panned out. I was an Olympic gold medalist.

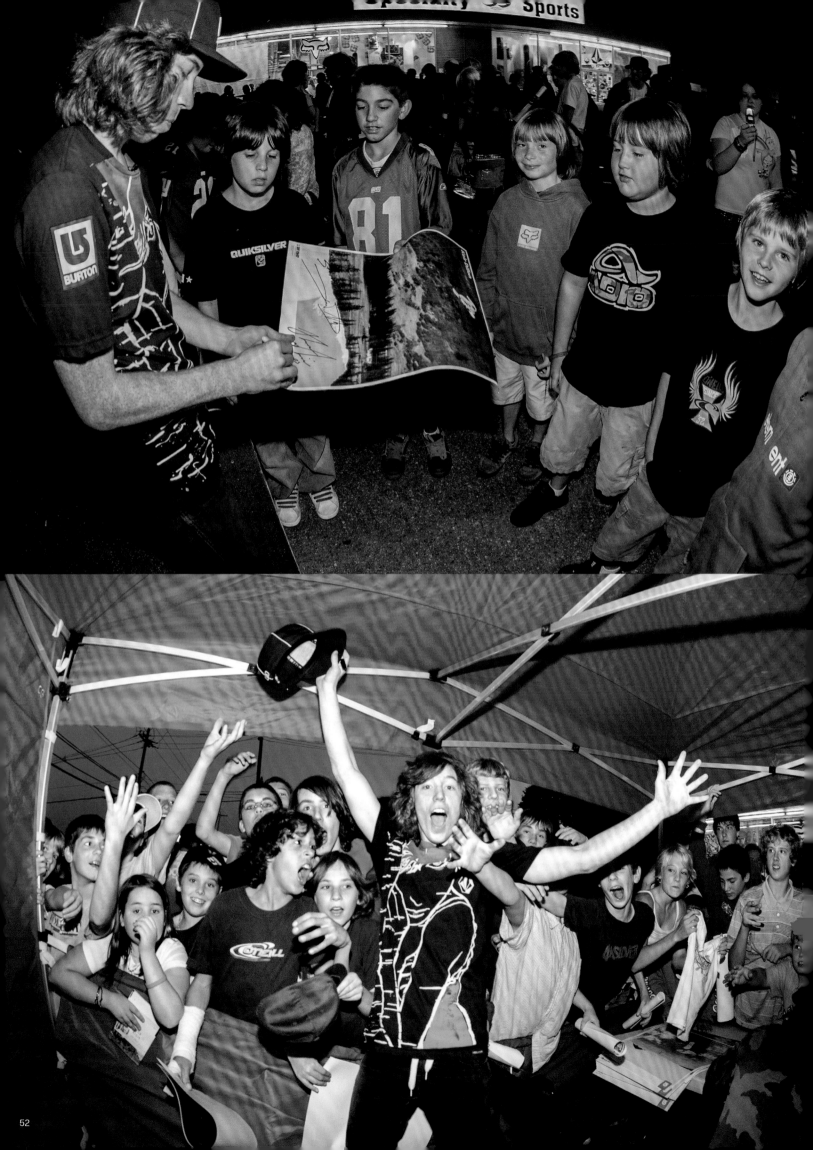

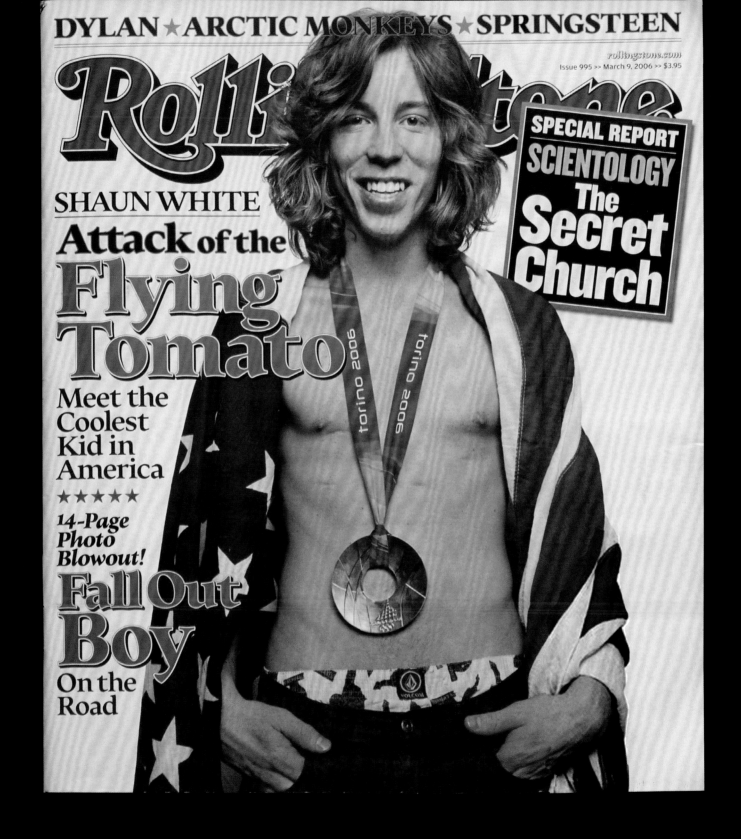

DYLAN ★ ARCTIC MONKEYS ★ SPRINGSTEEN

# Rolling Stone

rollingstone.com
Issue 995 >> March 9, 2006 >> $3.95

SPECIAL REPORT
SCIENTOLOGY
The
Secret
Church

SHAUN WHITE
**Attack of the**
**Flying**
**Tomato**

Meet the
Coolest
Kid in
America

★ ★ ★ ★ ★

*14-Page*
*Photo*
*Blowout!*

**Fall Out**
**Boy**

On the
Road

*(ABOVE) ROLLING STONE*, ISSUE 995, DATED MARCH 9, 2006.
*(OPPOSITE)* NEW YORK CITY, 2005.

COVER PHOTO BY PLATON
PHOTOS BY ADAM MORAN

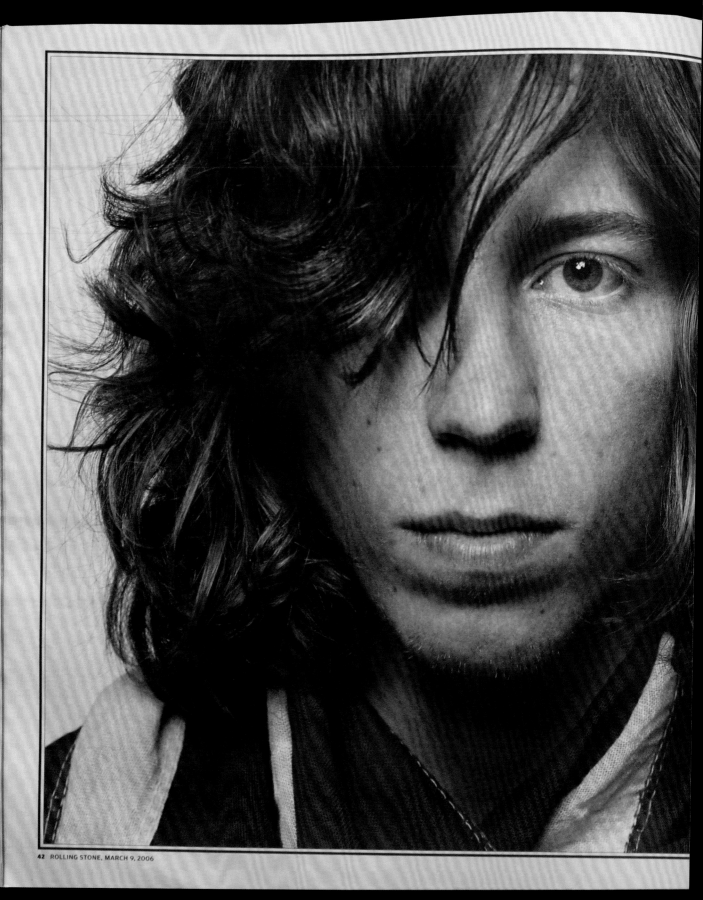

"ATTACK OF THE FLYING TOMATO" BY GAVIN EDWARDS, *ROLLING STONE*, ISSUE 995, DATED MARCH 9, 2006, PP. 42–43.

# ATTACK *of the* FLYING TOMATO

*He's an average nineteen-year-old who loves Zeppelin and "Family Guy." But snowboarder SHAUN WHITE also has something else: an Olympic gold medal he's hoping will help him out with the ladies*

**A**N OLYMPIC GOLD MEDAL DOESN'T COME WITH AN INSTRUCTION MANUAL, A TUBE of metal polish or even a box. Shaun White, nineteen-year-old snowboarder champion, earned his golden medallion with a bravura performance on an Italian halfpipe. Now he's trying to figure out: What do you do with the damn thing? • He expounds on some of the possibilities. He could never take it off, eventually developing a medal-shaped tan line on his chest. He could use it as a backstage pass for everything in life: If a waitress ever hesitated to add eggs to his breakfast order, he could whip out the medal. Then the impressed waitress, White explains, would say, "I'll see what I can do." But one option seems strongest. With a crooked grin, White says, "I could hang it from the rearview mirror of my car." • White is cool enough to enjoy the notion of bringing home a medal smeared with grape jelly and bread crumbs – but not so cool that he was able to hold back the tears at the medal ceremony. ("I wasn't crying, dude," he insists. "I had some tears come out," he explains, making a distinction so subtle as to be nonexistent.) In his nineteen years of life on this planet, he's seen snowboarding evolve from outlaw sport to extreme-athletics juggernaut. Not long ago, it seemed like an awkward, pandering idea for the Olympics to have snowboarders at all. Now snowboard events are a highlight of the schedule.

Snowboarding, once a good way to get ejected from ski resorts, has gone mainstream. In no small part, that's because of White's shaggy charm and the amazing feats of twisting airborne ballet he can perform with a plank of wood strapped to his feet.

White is a master of the 1080, meaning he can do three full rotations of 360 degrees after launching himself into the air. He concedes that "1080s are cool, but they're not that fun to do. They're hard and pretty technical. What's most fun for me is really big jumps and long, slow spins." That's not how one wins professional events, but it's what the sport is really about for White. He says, "I can have fun if there's a little snow bump, and me and my friends, we're just trying back flips and landing on our heads, you know what I mean? Honestly, I think that the way to become the best is just to have fun."

When White walks into a room, he barely seems to be expending any energy at all. His gait is halfway between a graceful professional athlete's and a slouching teenager's. (Even standing up straight, he's only five foot eight and around 140 pounds.) But when he thinks something's funny – an episode of *Family Guy*, or his brother, Jesse, clowning around with an oversize cowboy

## By *Gavin Edwards* · Photograph by *Platon*

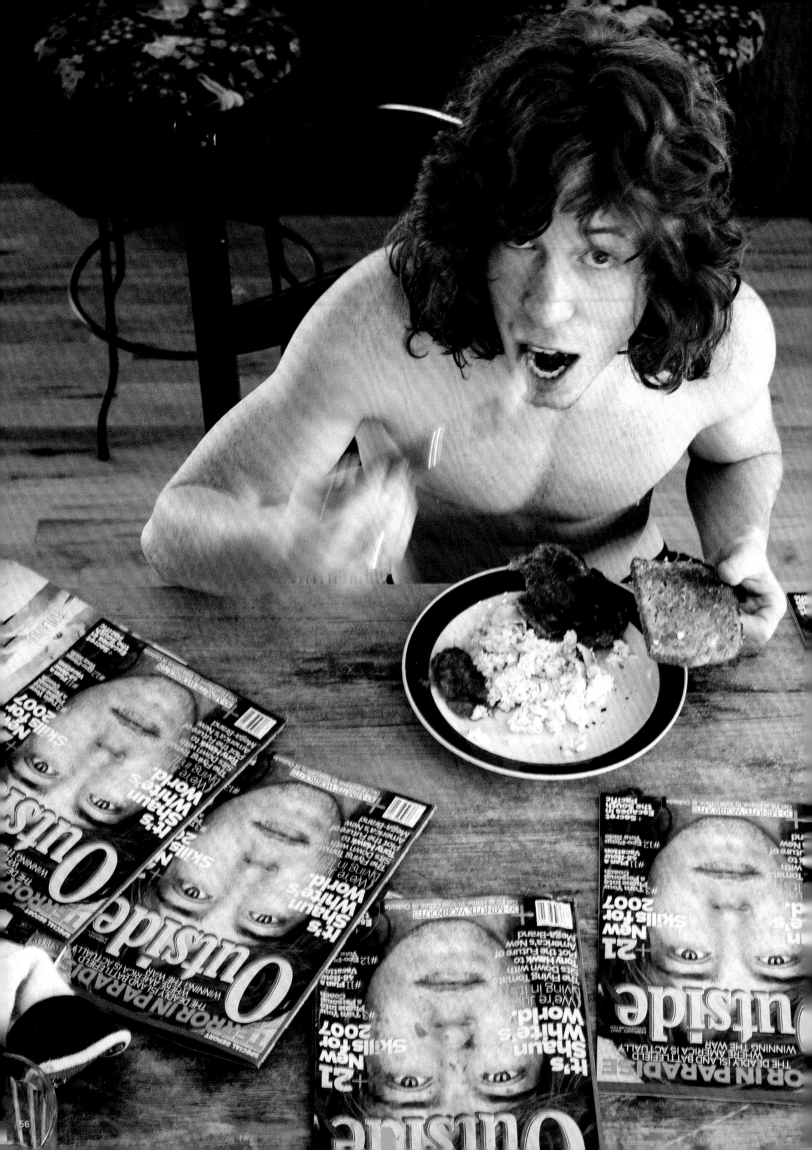

MY SISTER KARI *(LEFT)* AND AND MY GIRLFRIEND
AT THE TIME, SUMMER SPIRO.

You can prepare to win gold at the Olympics, but
nothing can prepare you for what happens after
you win gold at the Olympics. I had tasted some
fame and media attention going in, but this was
a new level. I couldn't walk through the airport
or the grocery store without getting recognized.
I remember watching the movie *Almost Famous*.
I had always been a huge fan of rock music,
so when *Rolling Stone* called to put me on the
cover, I pretty much fell out of my chair. At this
point, only two other athletes had ever been
on the cover of *Rolling Stone*—Muhammad Ali
and Michael Jordan—and I became the third.

This is a great snapshot of my life after the
Games. I think I was supposed to autograph
these covers, but I decided to have breakfast
first. I remember, for a little bit, I couldn't walk by
newsstands without seeing my face on the covers.

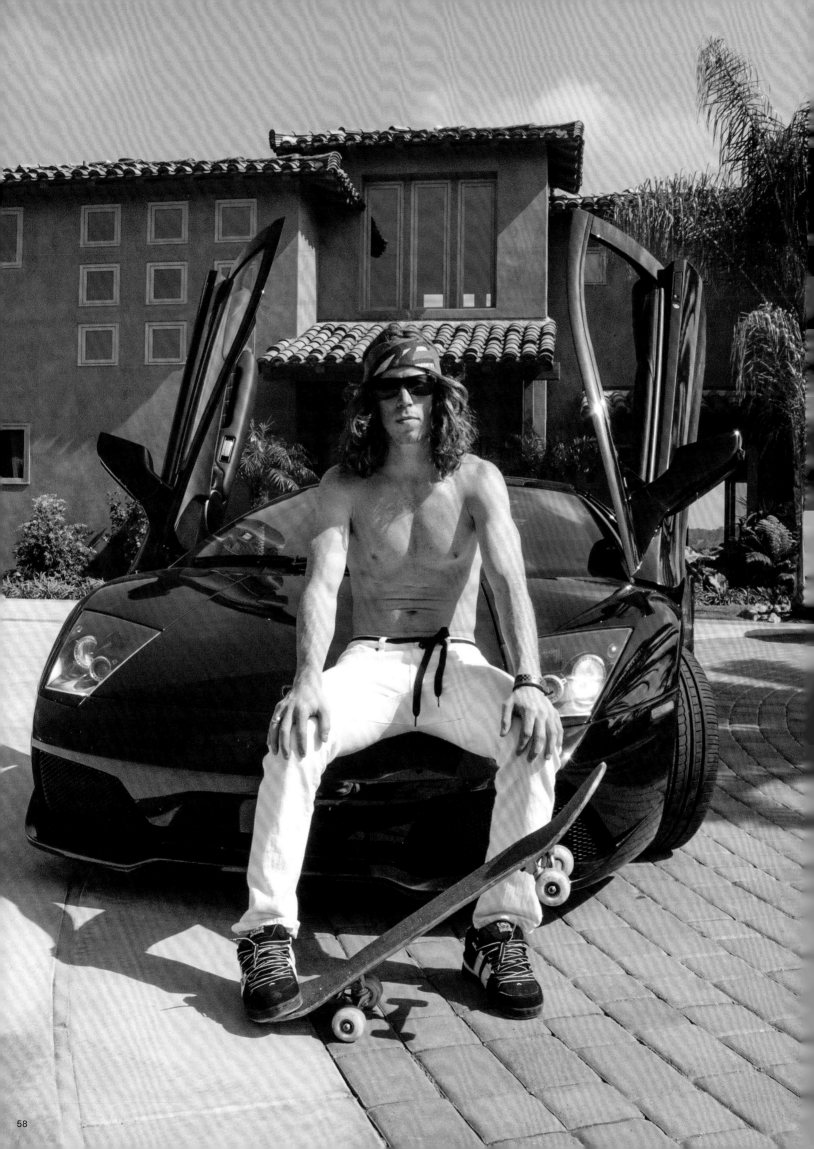

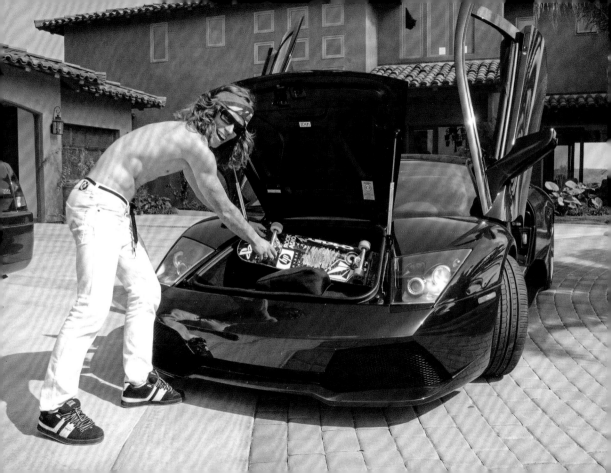

Japan was the first place that really blew my mind as a kid. The lights and the language and the culture and the clothing—everything was so interesting. But the craziest part was learning that I had Japanese fans. As the only person there with long red hair, I stood out. I was amazed that people this far across the world knew who I was.

I love Japan for its contrasts. I love being in the big cities and the cool, chaotic arena events we did. Japan would host these giant indoor snowboard competitions with massive jumps, fireworks, and huge crowds. We would go up to the mountains—places like Hokkaido, which has beautiful, serene mountains and amazing snow.

(Opposite) At a certain point, if I wanted to see Tokyo or go shopping, I had to be fast and skateboard through the city so I wouldn't get recognized and stopped by fans.

# Japan, Korea + China

(OPPOSITE) TOKYO, JAPAN, 2006.

PHOTO BY ADAM MORAN.

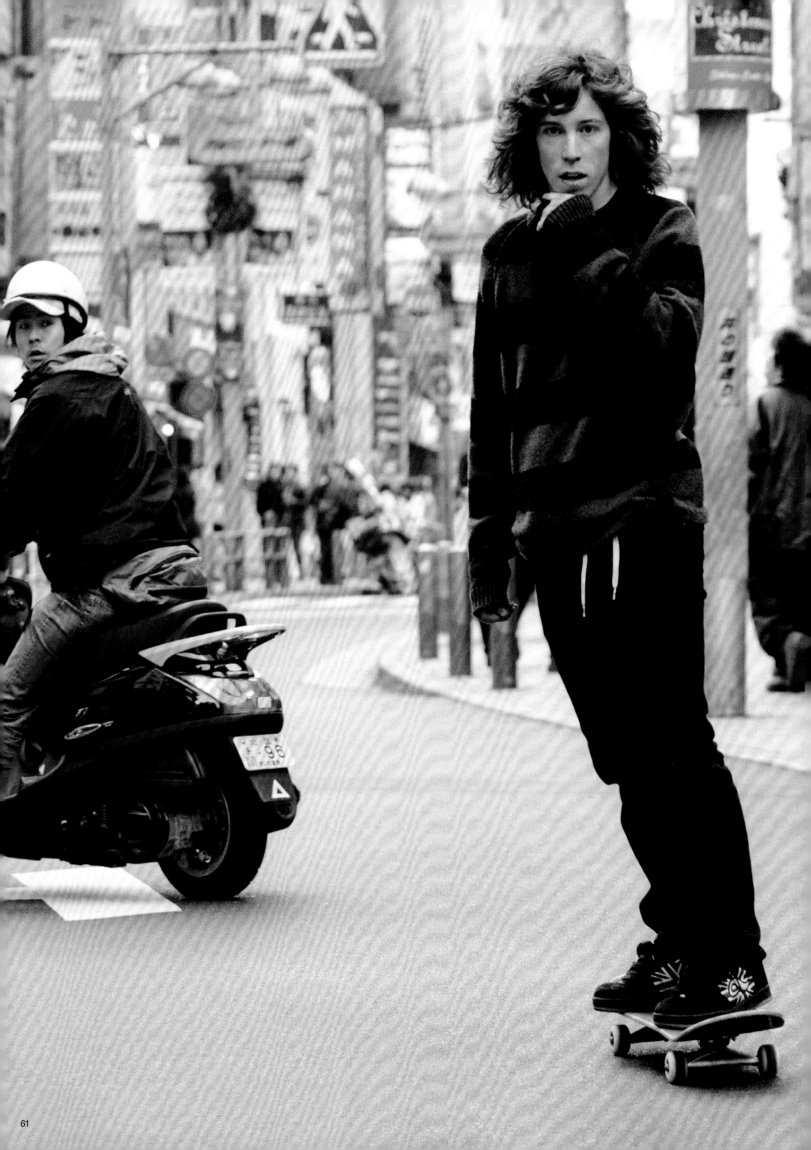

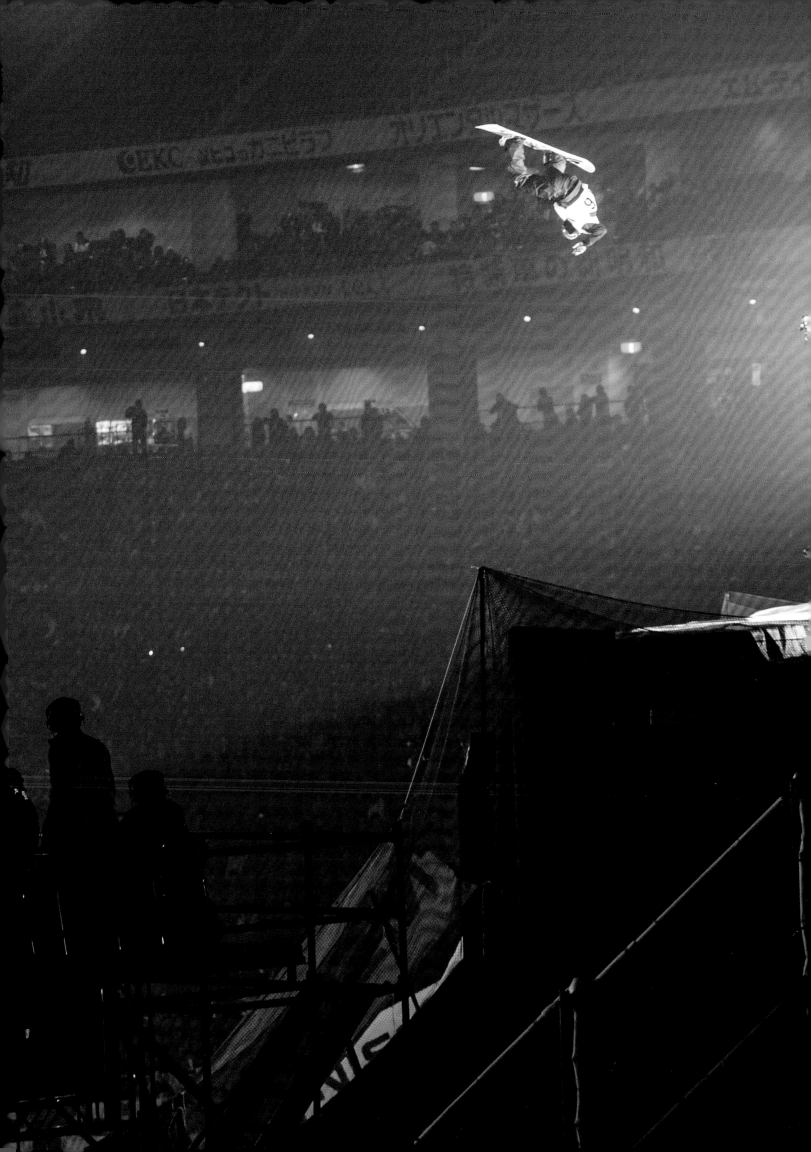

PHOTO BY ADAM MORAN.

TOKYO, JAPAN, 2006.

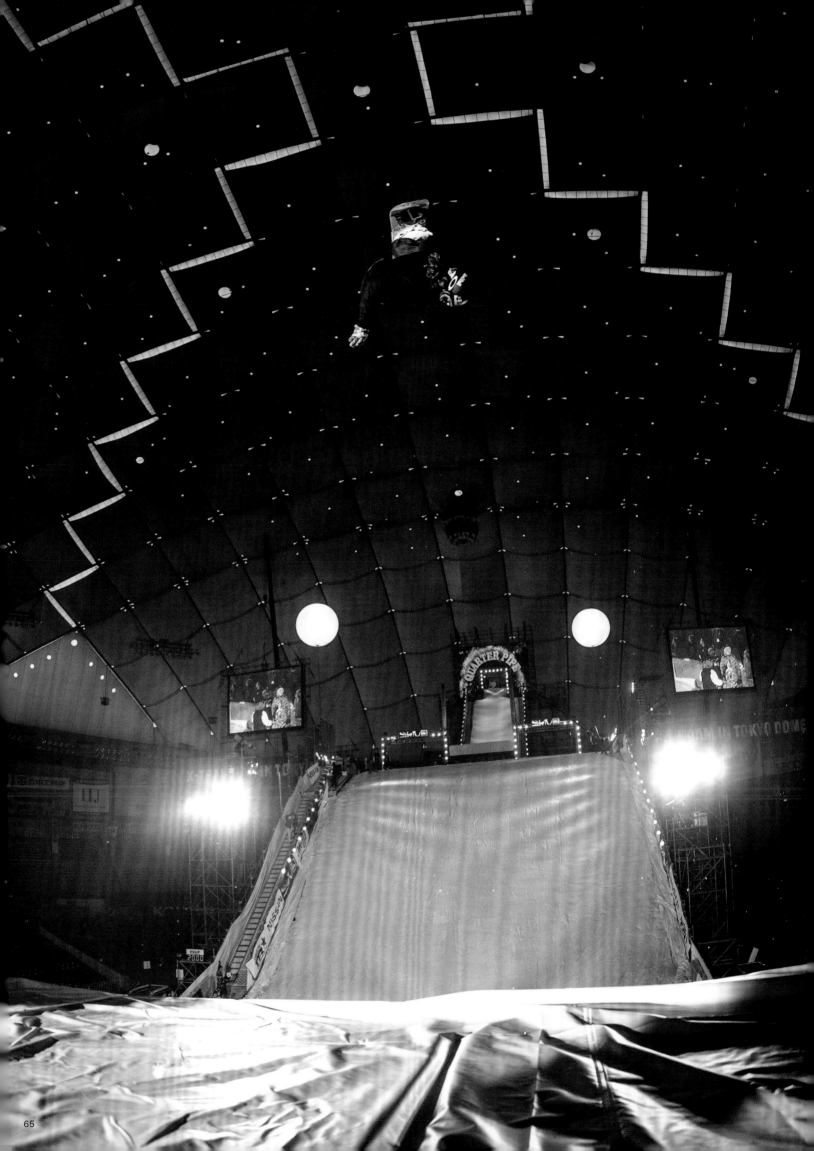

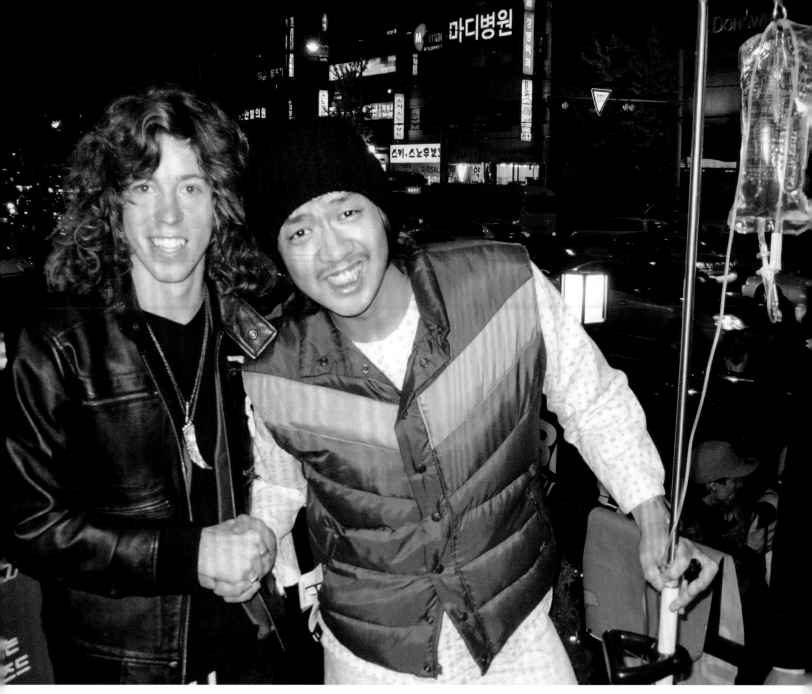

In 2006, I visited South Korea for the first time. We were on a shop tour where we would meet fans and promote a video project that we had done. During the autograph signing, one of my people came up and whispered in my ear, "Hey, we have this guy that we think should cut the line. He's got a hospital gown on!" The man had convinced his buddies to break him out of the hospital so that he could come meet me and get an autograph—IV drip in hand.

SEOUL, SOUTH KOREA, 2006.

PHOTO BY ADAM MORAN.

TOKYO, JAPAN, 2008.                    PHOTO BY ADAM MORAN.

I love this photo because the person hired to help me get around without signing autographs asked me for an autograph.

PHOTO BY ADAM MORAN.

TOKYO, JAPAN, 2008.

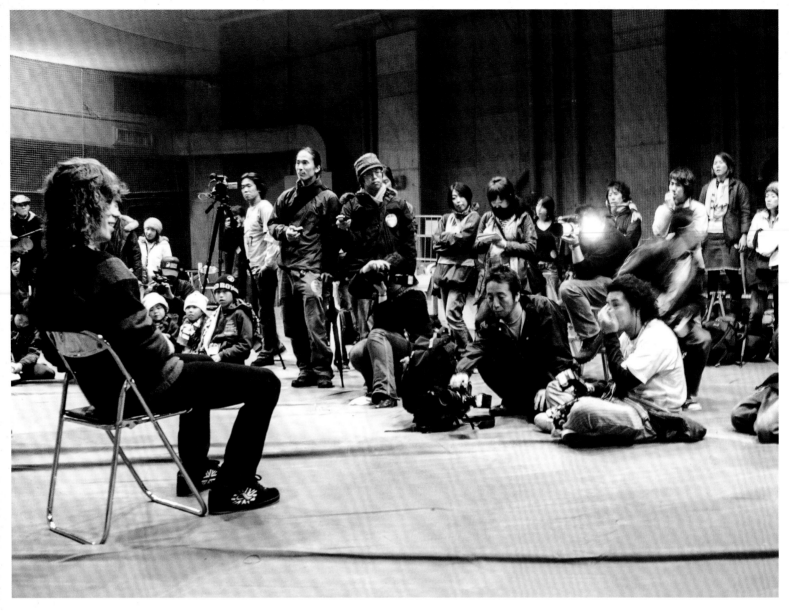

TOKYO, JAPAN, 2006.

*(Above)* This photo is from a press conference for the
X-Trail Jam in Tokyo. I like seeing all the faces in the crowd.
You always see the interview, but you rarely see this angle.
I like that here you get a little bit of my perspective.

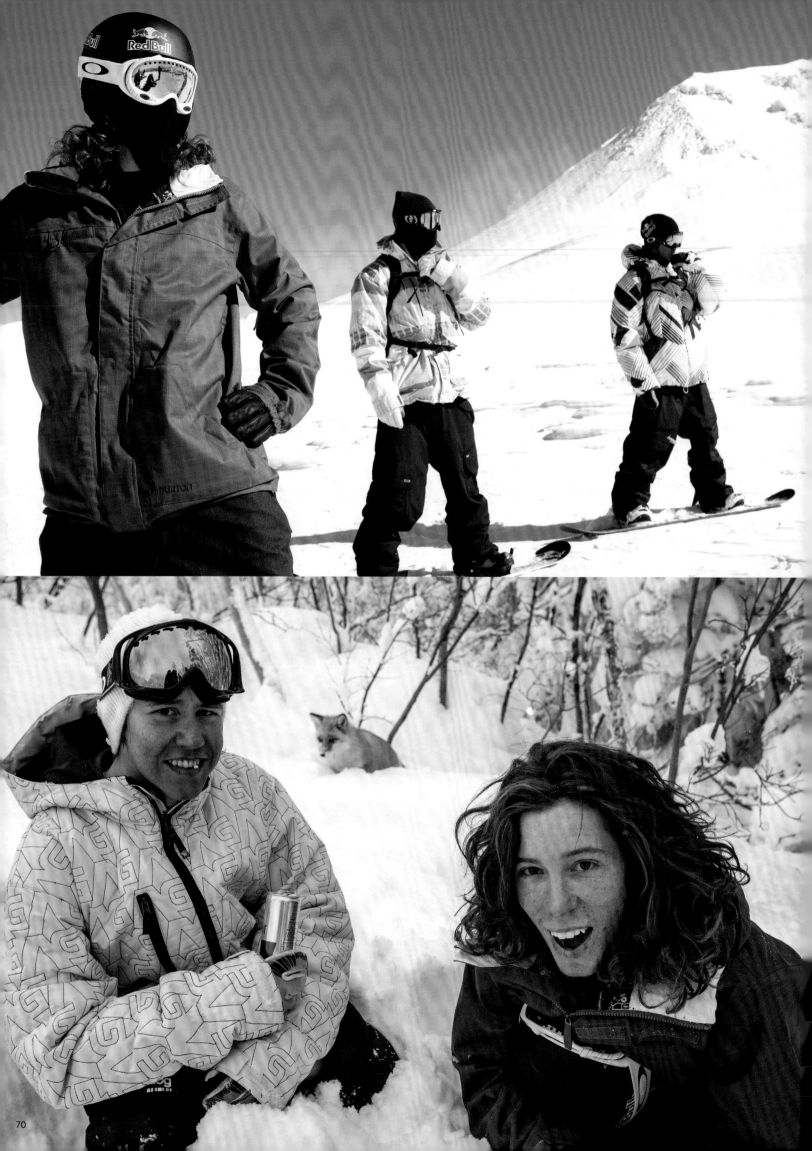

PHOTO BY ADAM MORAN.

WITH SEAN AARON AND TIM MANNING. JAPAN. 2008.

(*Above*) The competitor in me has been the most prominent story told about my life, which I understand because I'm crazy competitive. People love to paint this picture of me as an island, or as a machine with the sole purpose of winning.

But it's not true.

There was always a solid foundation of people and friendship around me. I always had people traveling with me, which made life incredibly fulfilling. It's a beautiful thing to invite people into your world and let them in.

(*Next spread*) I would always try to add an extra day or two on the front end or the back end of my trip to really take in the sights and enjoy the places that I was visiting. Walking along the Great Wall in China really made me think to myself how incredible my journey had gotten.

I had only seen pictures of this place in textbooks and movies. But to be here in person and touch the stones, smell the air, and take it in was just surreal. And the best part was I couldn't wait to see where snowboarding would take me next.

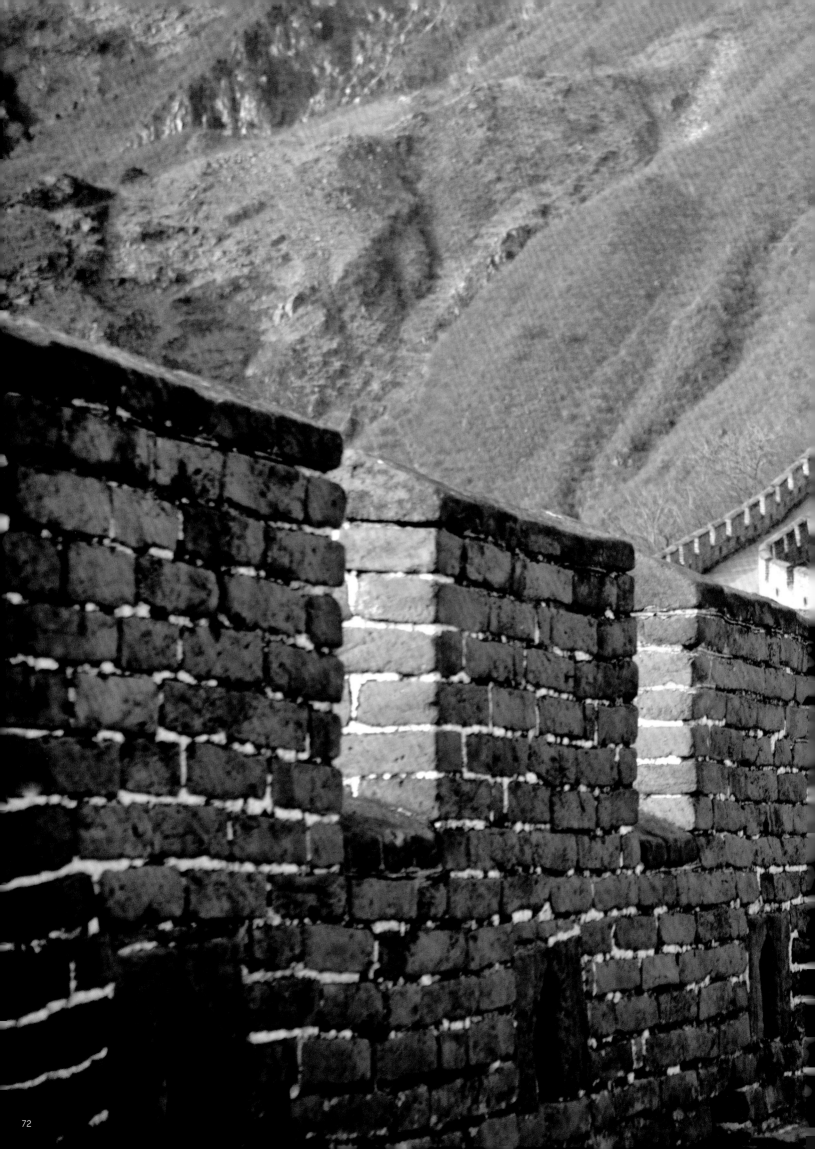

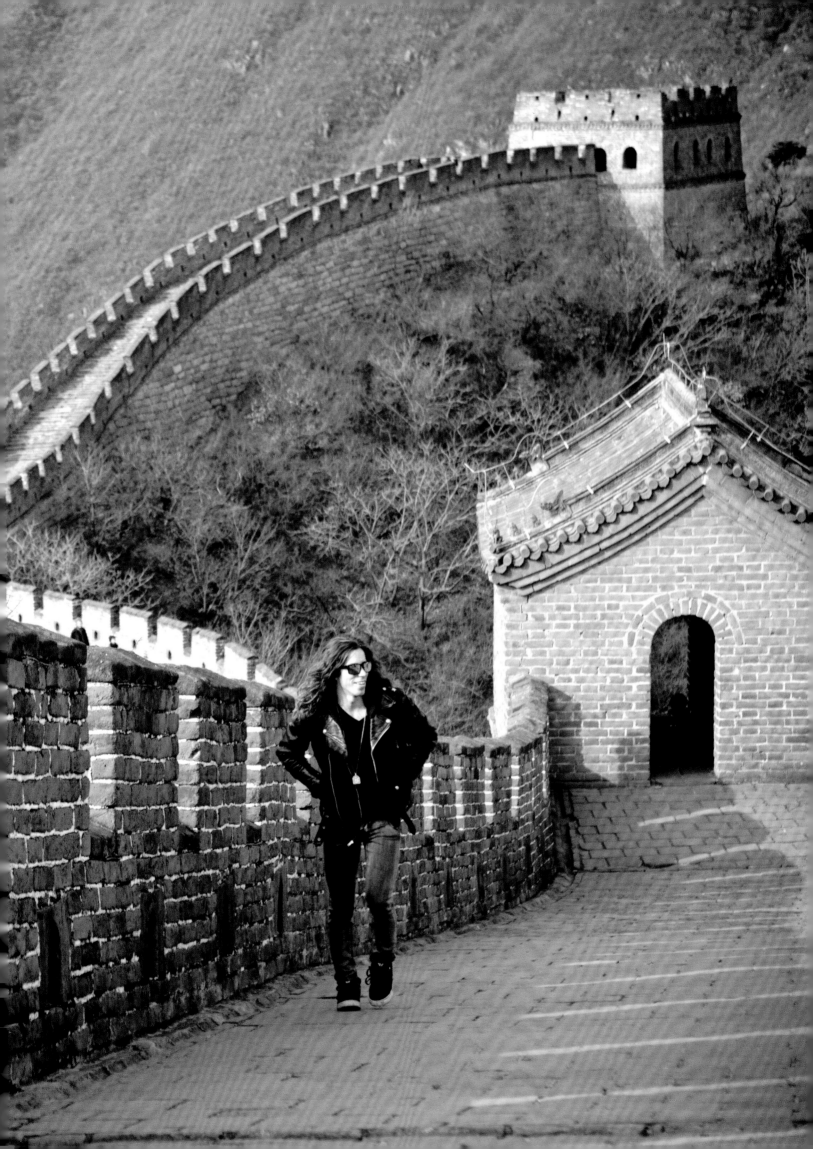

The photos on these pages are all from a project I did to train for the 2010 Vancouver Olympics by building a top-secret private halfpipe in Colorado.

The idea for a private halfpipe came out of necessity, because riding at the local resorts became difficult. People would recognize me, and word would spread. Before I knew it, there would be crowds lined up at the halfpipe to watch and film me. I love interacting with fans, but it was hard to practice with all that happening. It would be like the Lakers doing every single practice at the basketball court at the local recreation center, or Lewis Hamilton trying to train for Monaco while the road is open to the public. My team and I realized we needed a private facility. We found the perfect setting in the backcountry of Silverton, Colorado, where we could use the snow runoff from avalanche blasting to build the perfect halfpipe.

(Opposite) This is a powder day we had while scouting the backcountry to find where the halfpipe would go. Every day, we would have to helicopter in and helicopter out. I said, "Just drop me off at the peak there, and I'm gonna snowboard down to it." The snow was just incredible!

(Overleaf) That's me on a nearby peak, looking over at our creation. You can see the halfpipe in the lower right corner. I didn't tell many people about the project. The invite list was small—only the film crew and two other pro riders—but word got out and a Google Earth satellite image revealed the location and it spread all over the snowboarding blogs. The images getting posted were very blurry, kinda like any photo you've ever seen of Sasquatch. People were like, "If you look right here, you can see these lines on the mountain. That's not natural! That's a halfpipe!"

# Silverton, Colorado

(OPPOSITE) SILVERTON MOUNTAIN, SILVERTON, COLORADO, 2009.

PHOTO BY ADAM MORAN.

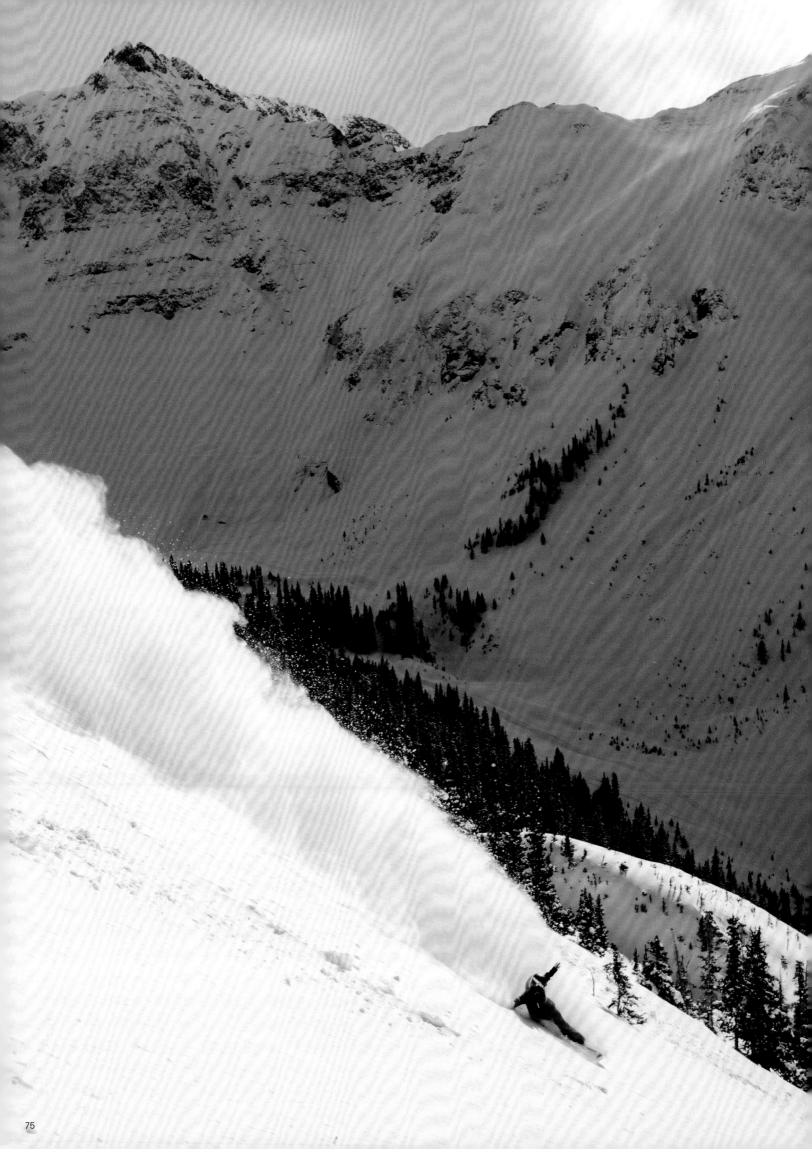

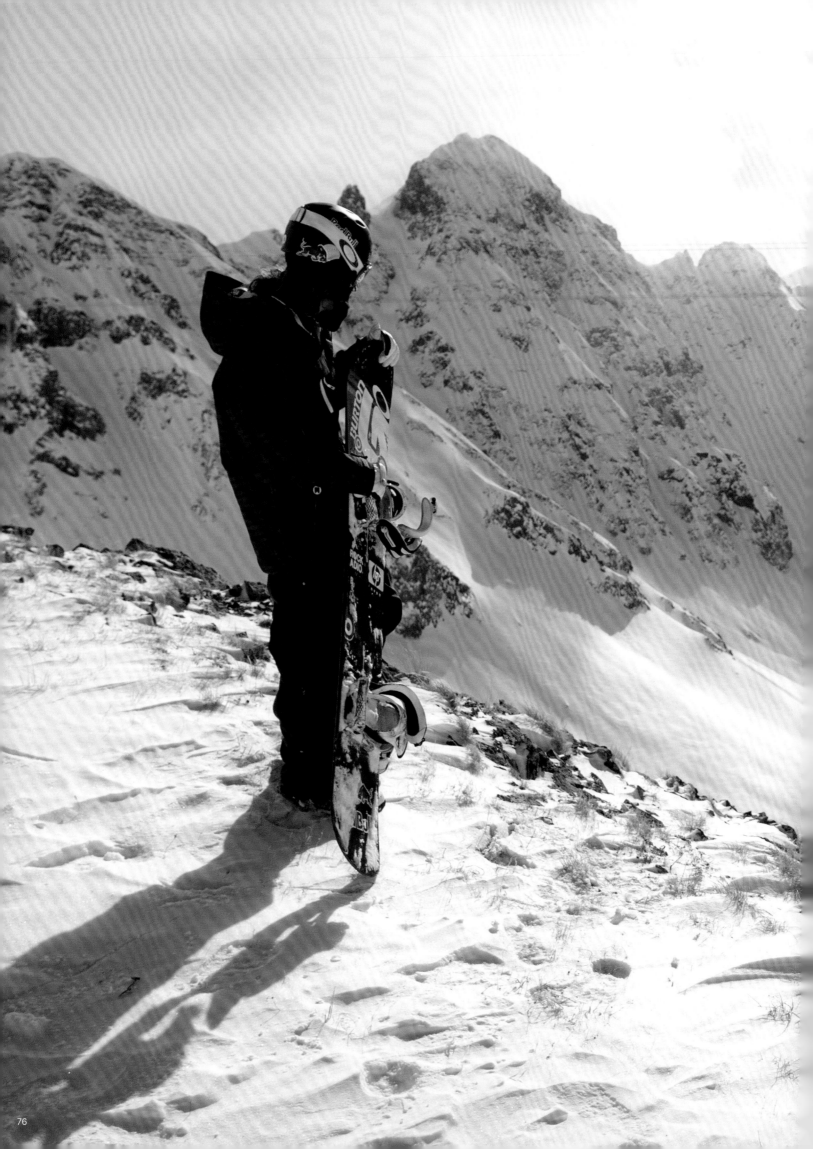

The goal of the whole project was to invent new snowboarding tricks. At this point, new tricks in the halfpipe were created by having an idea in your head and tightening your gut and just sending it. If you weren't injured, you could try it again. After seeing snowboarders attempt new moves off jumps in the backcountry and landing safely into very deep soft powder, I started thinking about how to create that in the halfpipe. Then I thought, "What about a foam pit?" They were already using foam for gymnastics training and motocross. I told my sponsor at the time, Red Bull, about my vision, because I knew they loved doing big, crazy projects. Once they had committed to the project, we sat down and scratched out how to bring it to life. It took about two years to plan.

(Above) This is the truck bringing all the foam through the little town of Silverton. The town looked like an old Western movie set, with one main street, big wooden storefronts, and only two restaurants: the saloon and the Pickle Barrel. We definitely turned some heads in this little town.

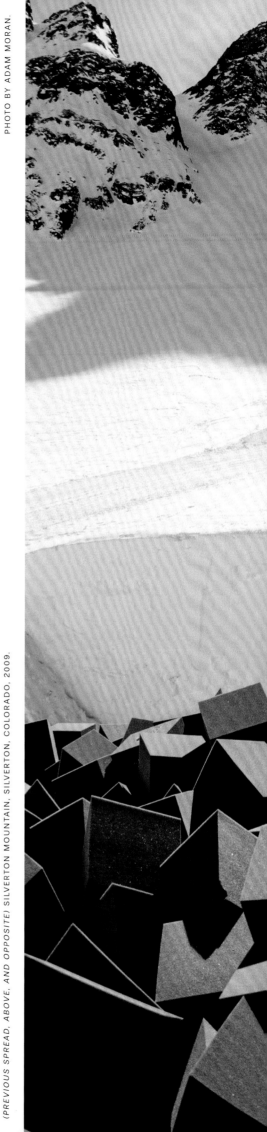

*(PREVIOUS SPREAD, ABOVE, AND OPPOSITE) SILVERTON MOUNTAIN, SILVERTON, COLORADO, 2009.*

*PHOTO BY ADAM MORAN.*

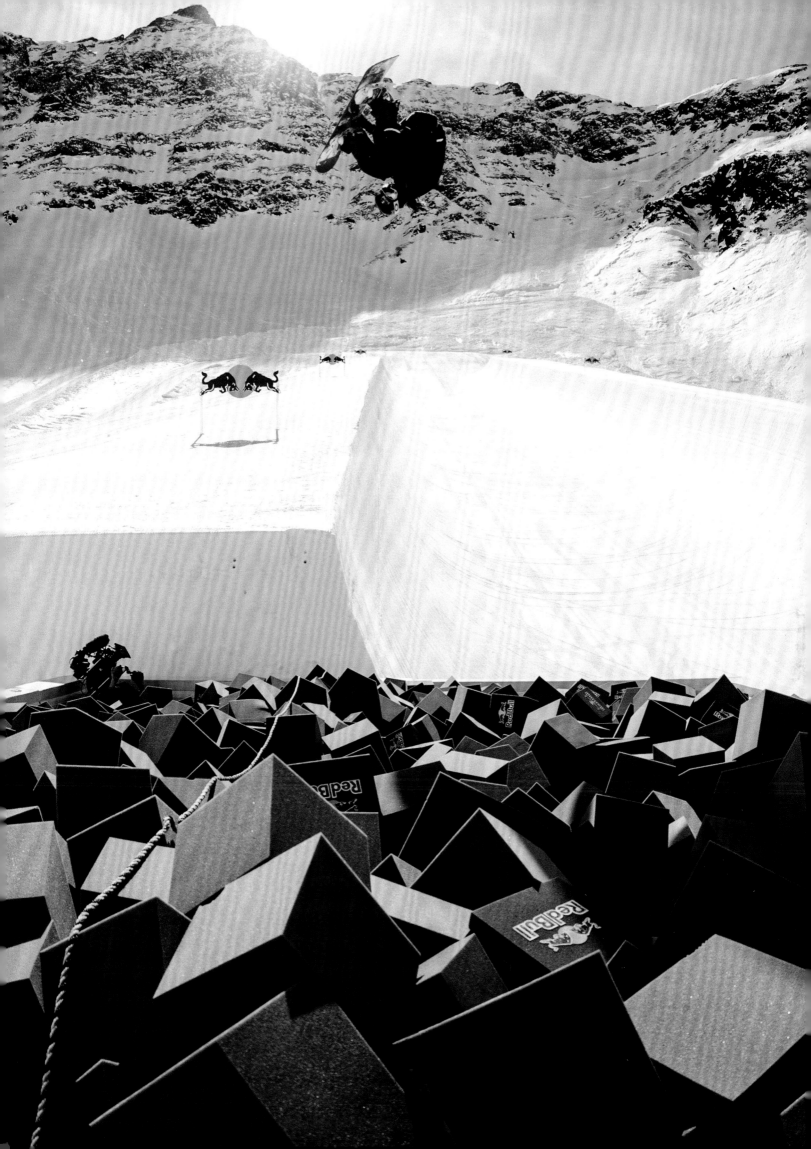

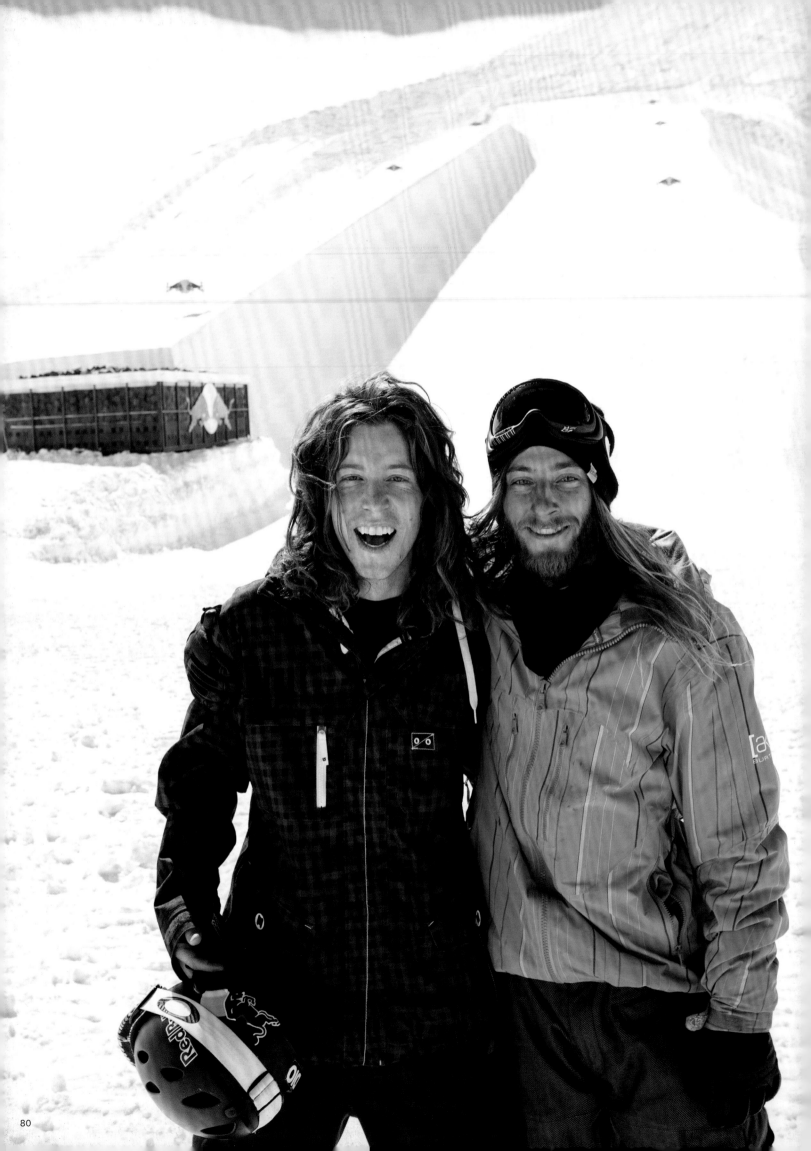

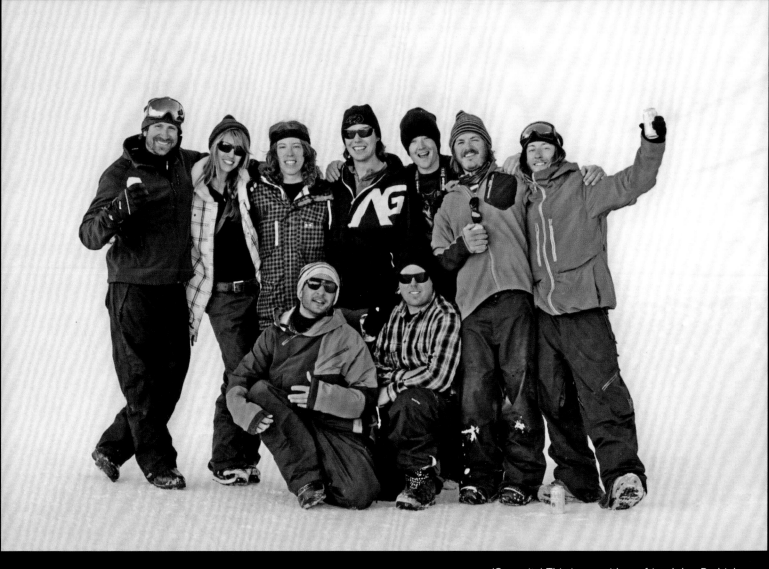

(Opposite) This is me with my friend Joe Prebich. Probably a year after the 2006 Olympics, we were surfing out in front of my house in Carlsbad. We started chatting about the future and snowboarding, and that's when we came up with the idea for a private halfpipe with a foam pit. Joe worked for Red Bull at the time, so he brought the idea into the office to see if they would support it. It was later called Red Bull Project X, and it changed the sport forever. I was able to invent four new double-cork spins: the frontside double cork 1080, Cab double cork 1080, backside double McTwist 1080, and backside alley-oop double rodeo. Those tricks all still hold up in contests today.

The foam pit inspired other riders and prompted the invention of the airbag pack shortly after. It's the same idea as the foam pit, but much easier to transport. You can see them now at every major training camp around the world.

(ABOVE, STANDING) CLAUDE MERKEL, CRYSTAL GARRETT, RYAN YOUNG, DEVIN O'BRIEN, SEAN AARON, JOE PREBICH; (KNEELING): ADAM MORAN, JIMMY FAY. (OPPOSITE) WITH JOE PREBICH. SILVERTON MOUNTAIN, SILVERTON, COLORADO, 2009.

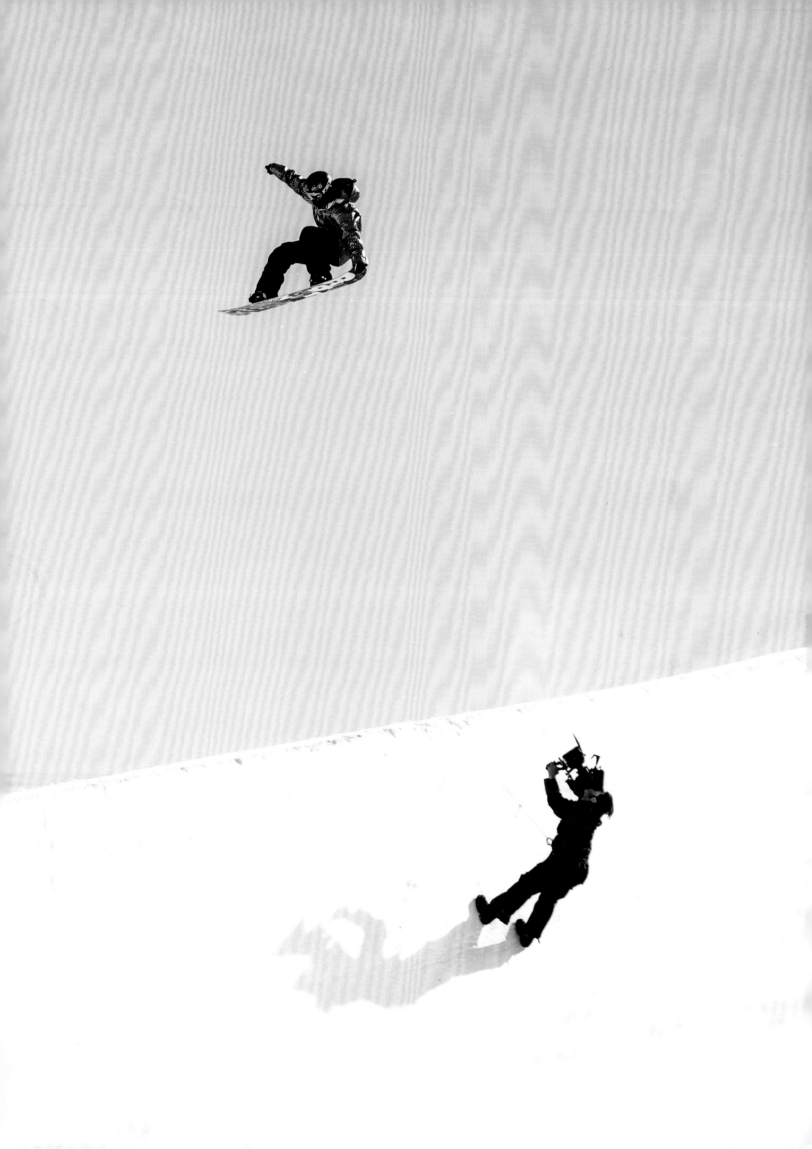

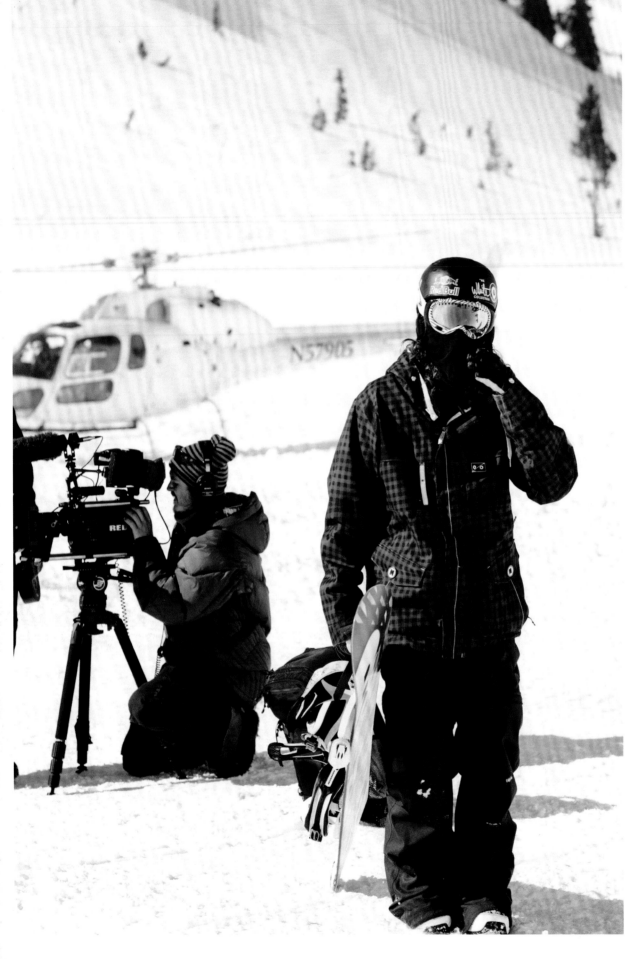

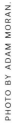

*(PREVIOUS SPREAD)* SILVERTON MOUNTAIN, SILVERTON, COLORADO, 2009.

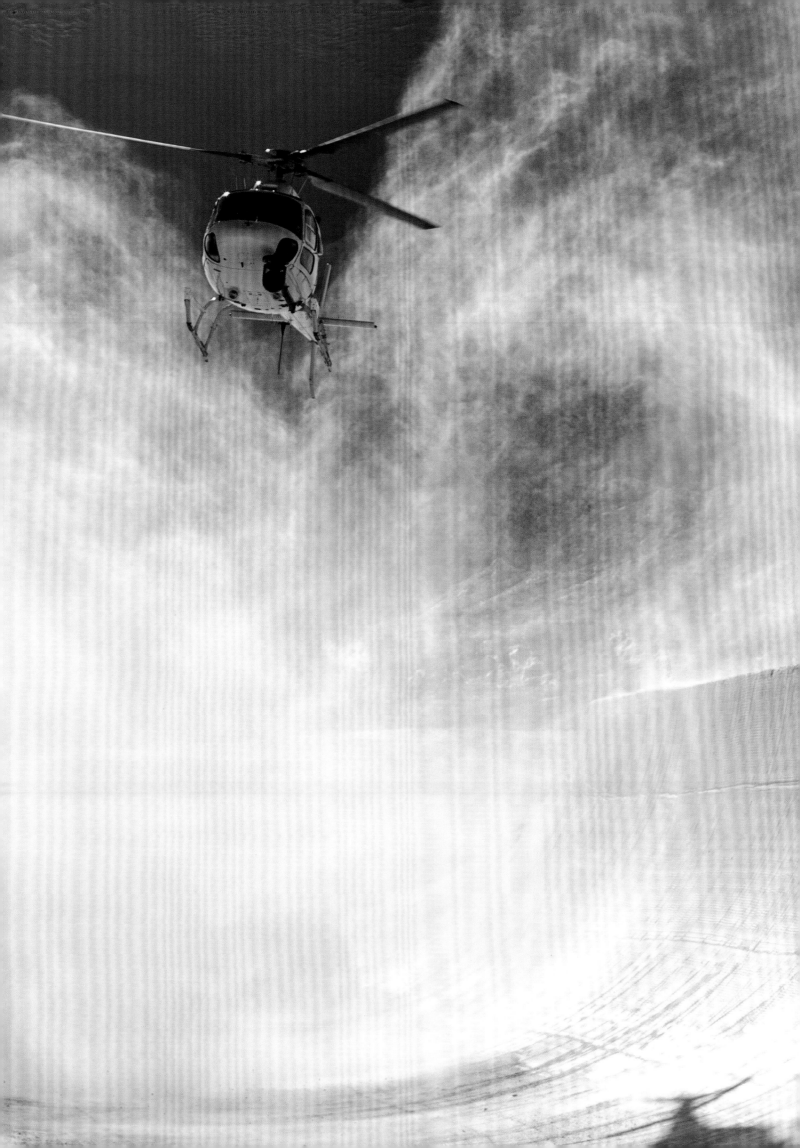

For my second Olympics, I planned every single moment out in my head—from the moment I got there to the moment I won and got the medal. It literally all went to plan. It was like being able to go back in time and relive one of the best days of my life all over again, like in the movie *Groundhog Day*. I thought to myself, "If I could do it all over again, how would I change things to make the experience even better?"

The biggest thing driving me for this Olympics was I didn't want the world and the other people in snowboarding to think of me as a fluke, a one-hit wonder. Now, there's absolutely nothing wrong with one Olympic gold medal. It's an honor to even make the Olympic team. I had just built up the idea in my head that, this time, I'd have the chance to do something even more special and leave a lasting impact, and that a second gold medal was the way to do it.

# Vancouver, BC

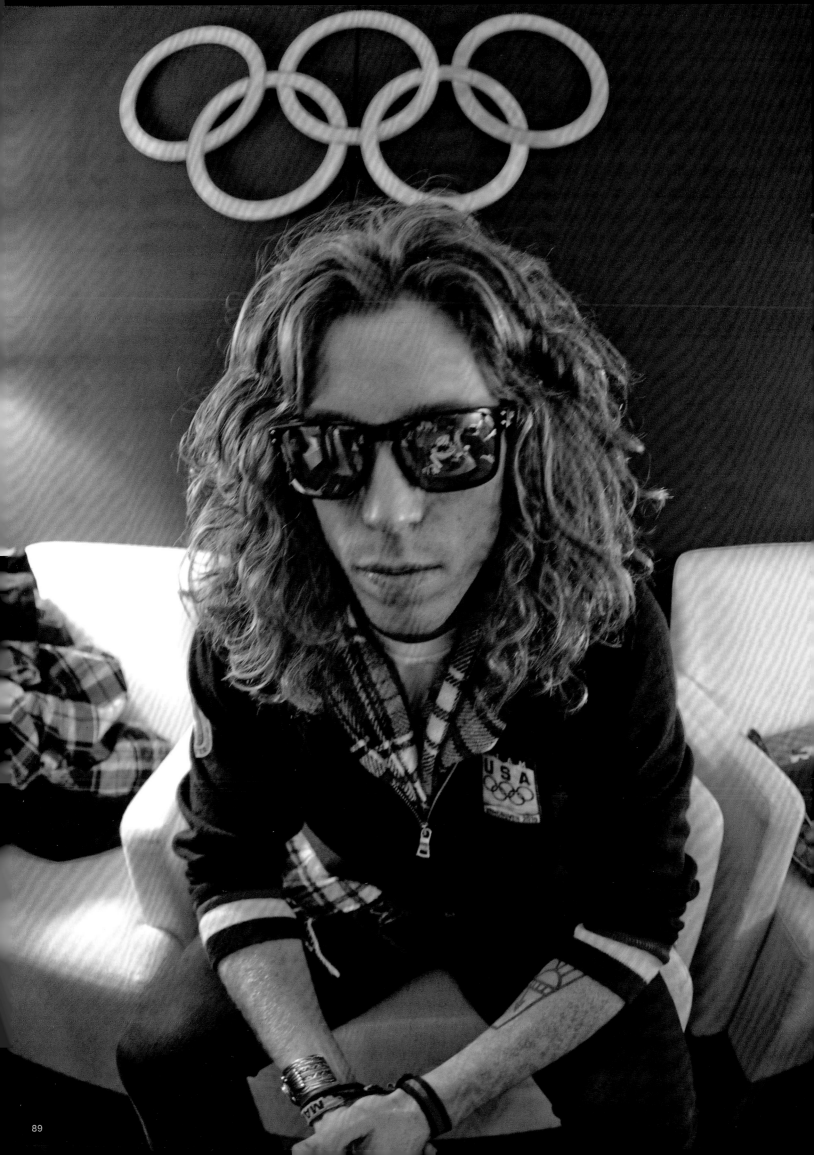

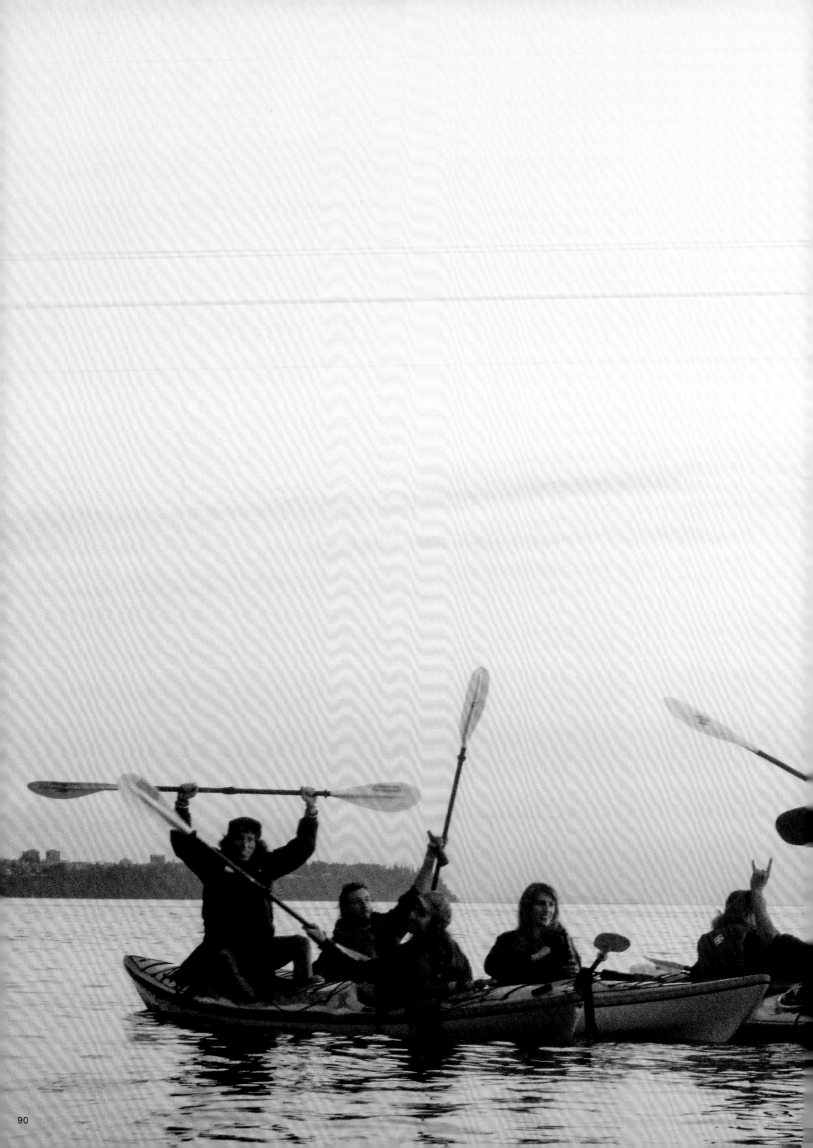

WITH JOE PREBICH, CRAIG THORNTON, CRYSTAL GARRETT, SEAN AARON, AND BUD KEENE. 2010 VANCOUVER OLYMPICS, BC, CANADA.   PHOTO BY GABE L'HEURFUX.

We had a day in between qualifying and the finals for the 2010 Vancouver Olympics. It was a scheduled practice day, but I decided to follow my tradition of skipping practice and doing something random and fun to take my mind off all the pressure. I liked the idea of all my competitors on the mountain wondering, "Where is he?" I thought it would kind of mess with their heads. I'm a firm believer that you can over-practice, and I know I'm at my best when I've had a whole day off to get ready.

This time around, we were not staying at the Olympic Village. I had rented a house near the water. I noticed a bunch of kayaks in the garage, so I talked everyone into grabbing a few beers and hitting the water. It was an amazing moment—a perfect calm before the storm.

This was the opening ceremony for the 2010 Vancouver Olympics. I had participated in the opening ceremony once before, but I want to say it was even better the second time around. Vancouver did it big with an amazing show. Ralph Lauren was the new team sponsor, so we were running the vintage ski-chalet looks, with turtlenecks and knit beanies, which I loved.

Nothing really compares to the energy and the feeling of running into a stadium, fireworks blasting, with Team USA while the whole world is watching.

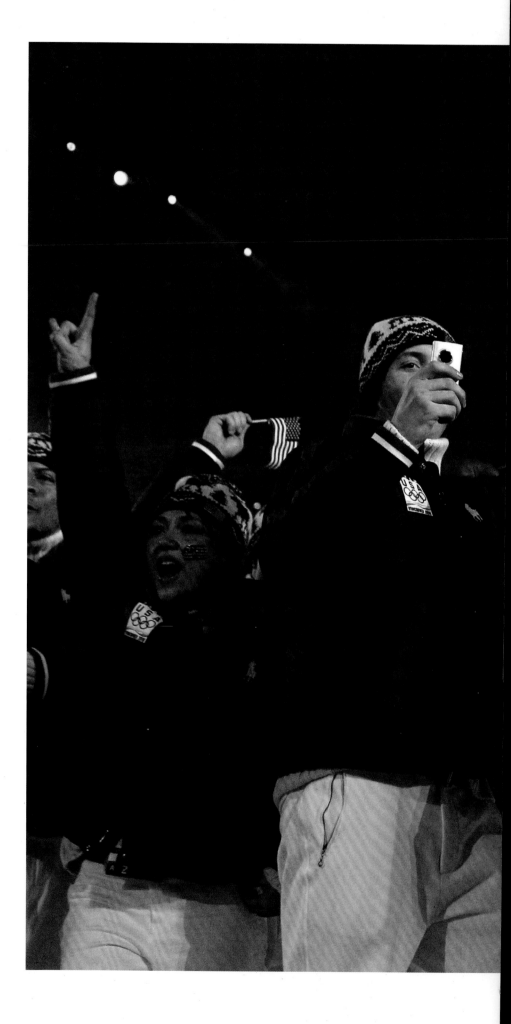

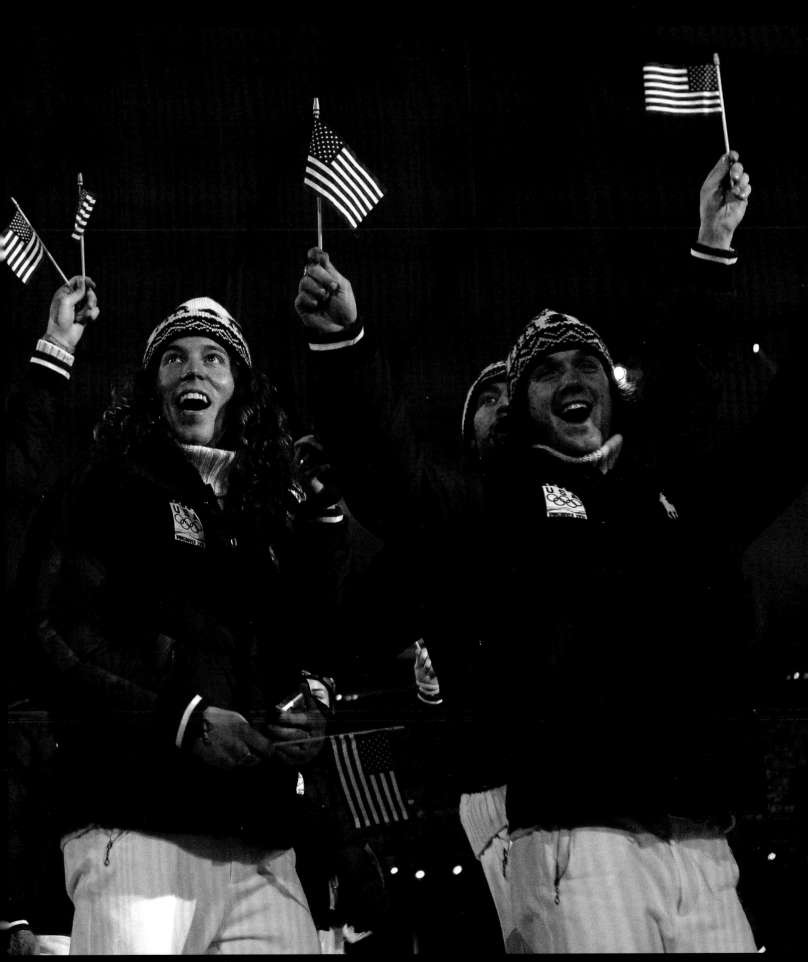

WITH LOUIE VITO. OPENING CEREMONY, 2010 VANCOUVER OLYMPICS, BC PLACE, VANCOUVER, BC, CANADA.

PHOTO BY CAMERON SPENCER.

(*Opposite*) This is my first hit at the Olympics. At this point, you could almost call this my signature trick, besides all the double flips and spins. I was known for going really high out of the halfpipe on my first hit, and that's where I would set the tempo for the rest of the run. Snowboarding is very much about style, not just the number of spins you can rack up in one run, so this kind of hit in my run would get me some style points.

And, almost like déjà vu from four years earlier, I was standing at the top of the halfpipe with one more run to go and had won the Olympics again. Nobody beat my first score, so I got another victory lap. This time, I decided that instead of spraying snow and waving to the crowd, I was going to go for an even better run than before and add a trick that I'd invented during the lead-up to the Games: the double McTwist 1260.

I had a bad crash just before the Olympics, attempting the trick at X Games. I hit my head on the wall, and it knocked my helmet clean off and my face slid down the icy wall. In the back of my mind was the fact that a friend of mine, Kevin Pearce, was in the hospital with a traumatic brain injury from hitting his head in the halfpipe, so I had my reservations about the trick. There was a lot of talk circling in the media about whether or not I was going to attempt to do the trick again at this Olympics. I had worked so hard for this trick, and I didn't want to leave anything on the table. I came to share what I was capable of with the world. So, at the top, I decided, "I'm going for it. I've already won. Now let me show you what I'm capable of."

After I landed that final run, the double McTwist 1260 became the trick heard around the world. Suddenly, people like Oprah and Jimmy Kimmel and everybody in the mainstream world knew what the double McTwist was. To win in that fashion with that trick was the impact I was hoping for.

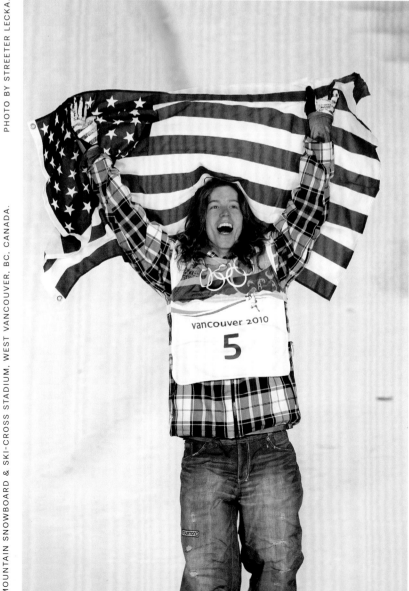

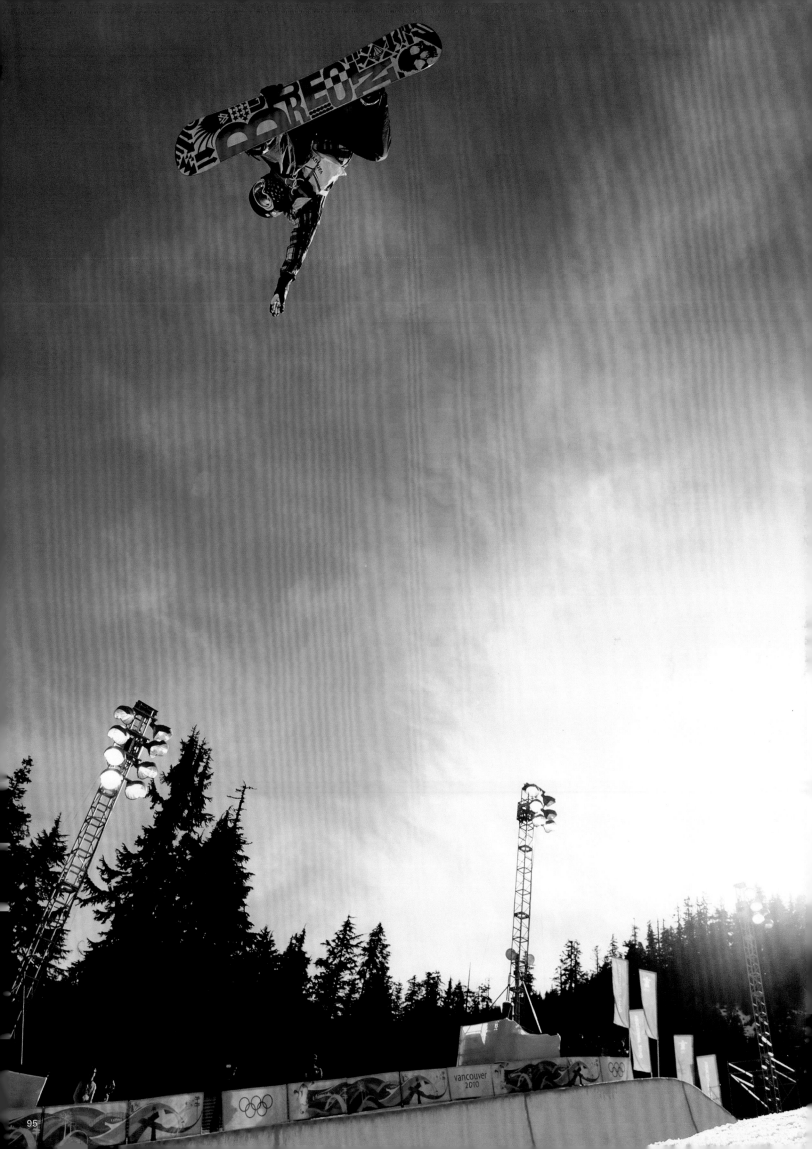

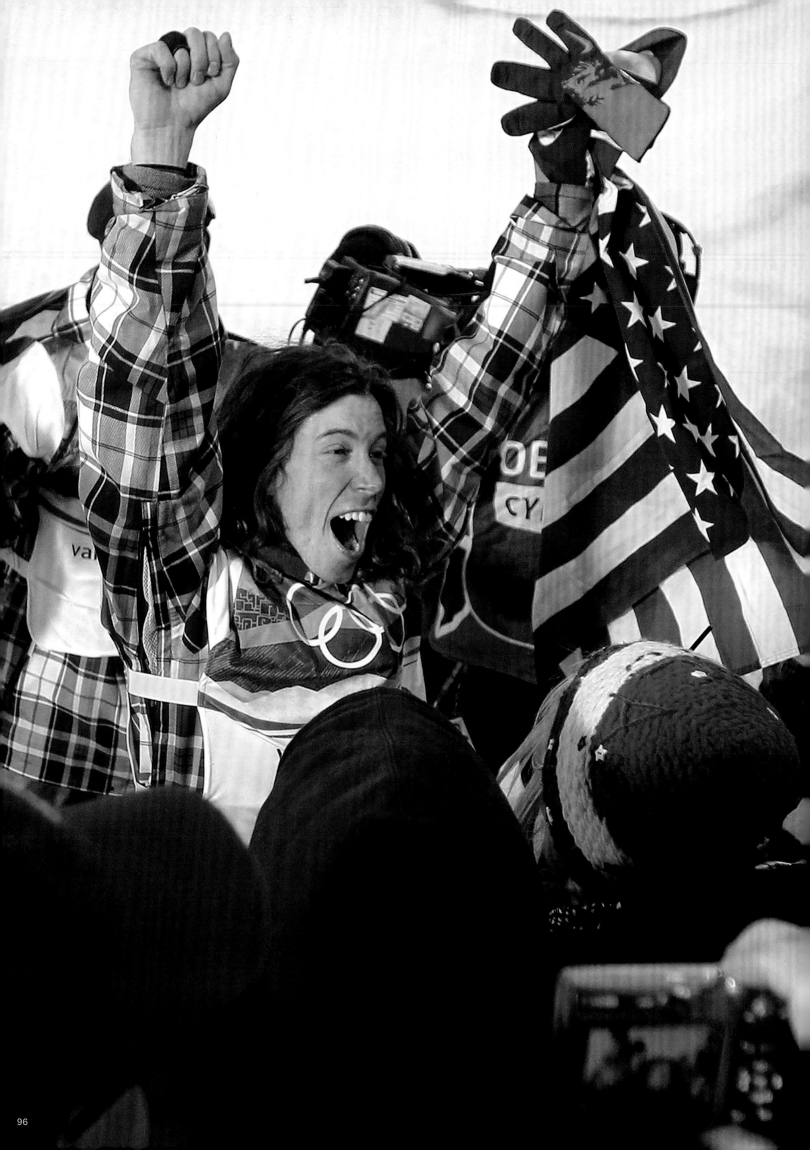

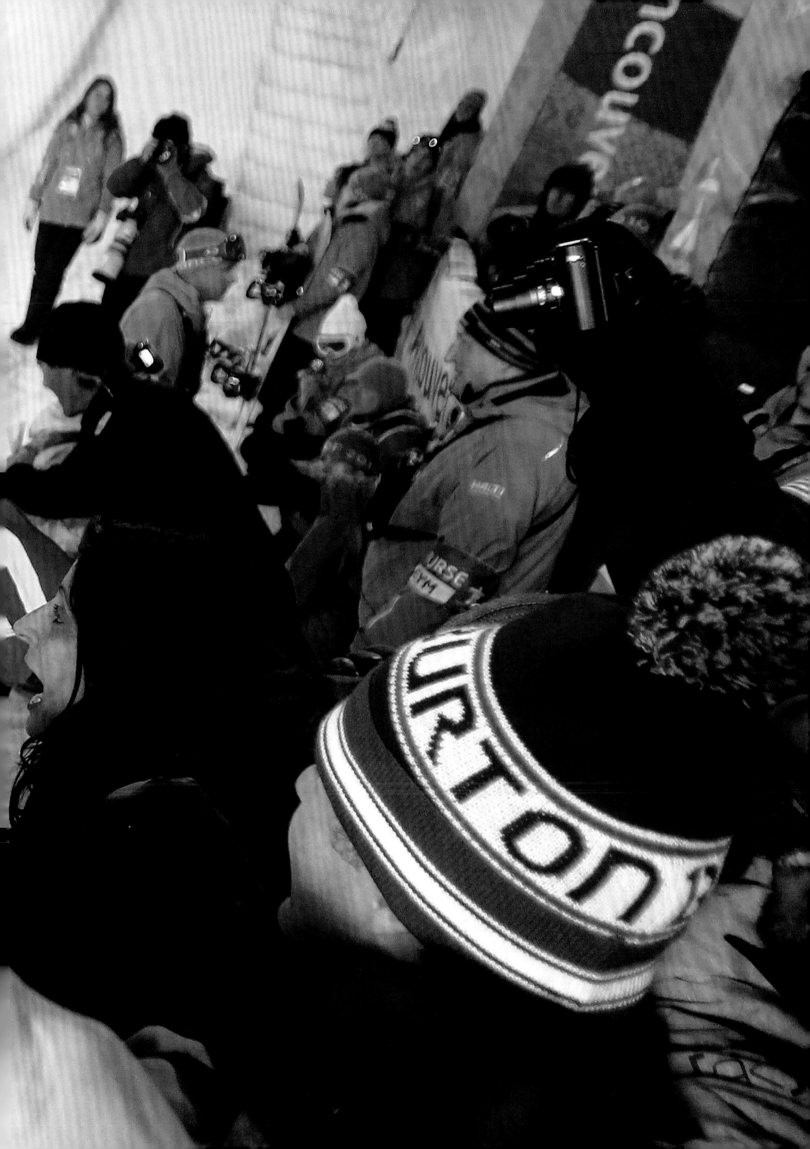

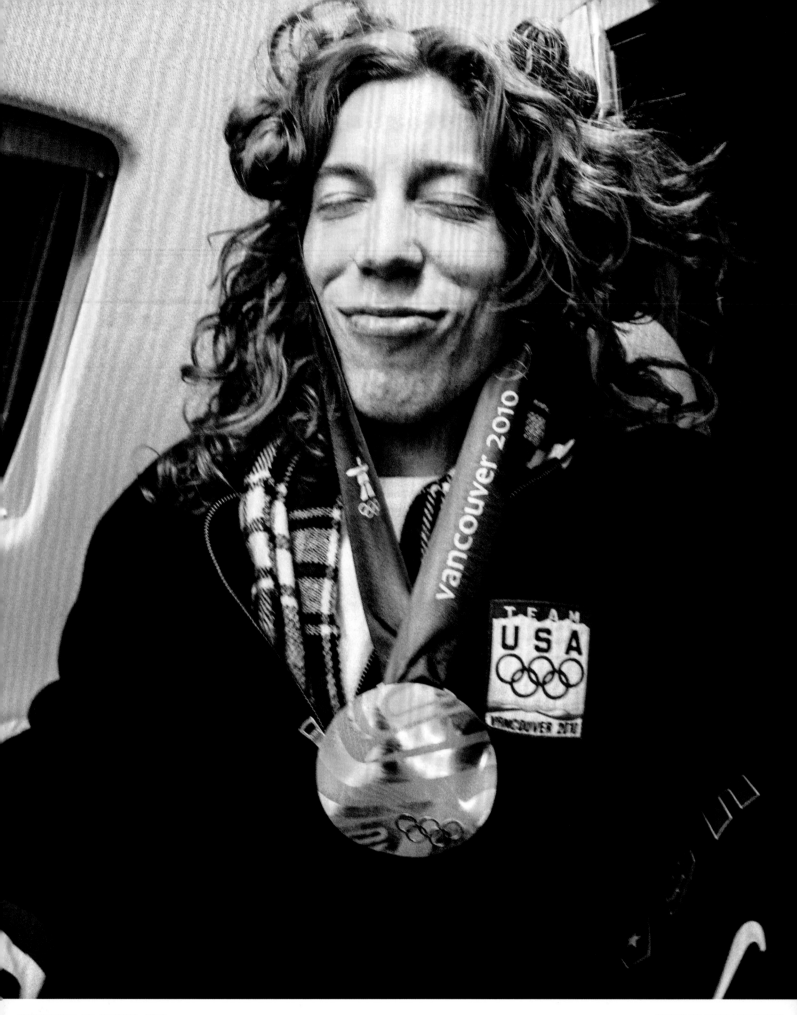

VANCOUVER, BC, CANADA, 2010.

PHOTO BY GABE L'HEUREUX.

*(PREVIOUS SPREAD)* MEN'S SNOWBOARD HALFPIPE FINAL, 2010 VANCOUVER OLYMPICS,
CYPRESS MOUNTAIN SNOWBOARD & SKI-CROSS STADIUM, WEST VANCOUVER, BC, CANADA.

PHOTO BY STREETER LECKA.

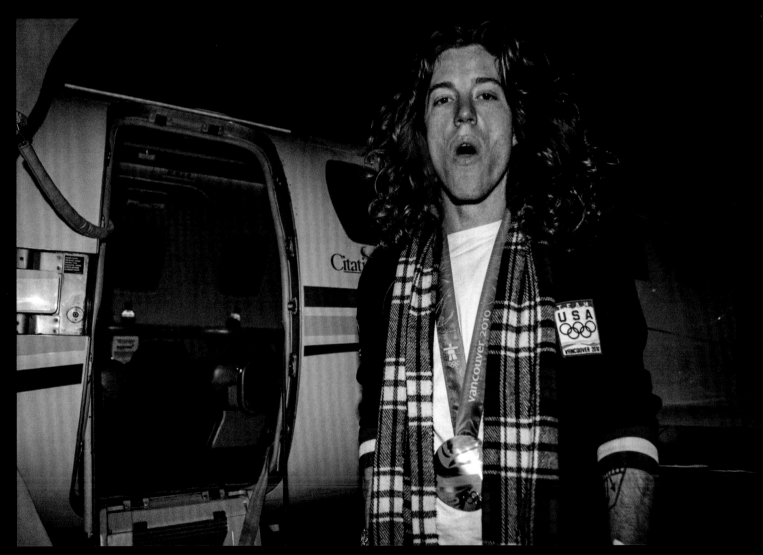

VANCOUVER, BC, CANADA, 2010.

A few years before the Vancouver Olympics, I was at the Hard Rock Cafe casino in Las Vegas, looking at the rock 'n' roll memorabilia. I saw Slash's guitar and Billy Idol's jacket on display and thought, "How can I get something on display here?" Then I started thinking, "What if I won the Olympics again? What if *Rolling Stone* put me on the cover again? Maybe they would put my outfit from the cover in here." Then I thought, "Well, what would I wear?"

I remembered watching a Guns N' Roses concert in which Axl Rose was wearing star-spangled striped short-shorts. I thought, "Well, that's a little aggressive. Maybe I can get away with some pants?" So, I had these stars-and-stripes pants made just in case. Then, I won and *Rolling Stone* did call me. I wore the pants on the cover while lighting my snowboard on fire like Jimi Hendrix burning his guitar. Jimi was supposed to be on the cover that month, but they moved him to put me on, so I wanted to pay homage to him.

A few months later, those pants, boots, and burnt snowboard were on display with the magazine cover at the Hard Rock Cafe in Las Vegas.

COVER PHOTO BY TERRY RICHARDSON.

(OPPOSITE) ROLLING STONE, ISSUE 1100, DATED MARCH 18, 2010.

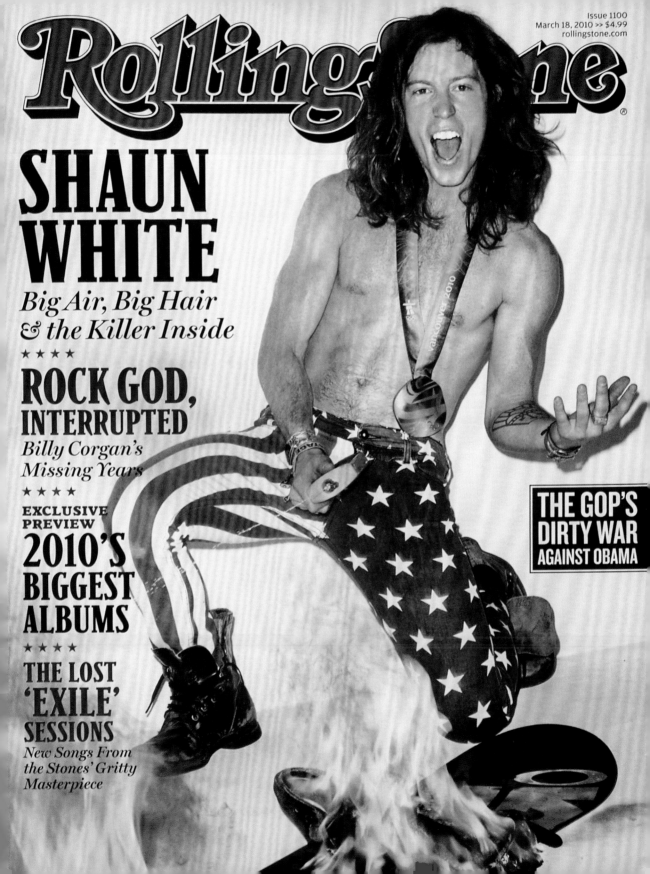

Issue 1100
March 18, 2010 >> $4.99
rollingstone.com

# Rolling Stone

## SHAUN WHITE

*Big Air, Big Hair*
*& the Killer Inside*

★ ★ ★ ★

## ROCK GOD, INTERRUPTED

Billy Corgan's
Missing Years

★ ★ ★ ★

**EXCLUSIVE**
**PREVIEW**
## 2010'S BIGGEST ALBUMS

★ ★ ★ ★

## THE LOST 'EXILE' SESSIONS

*New Songs From*
*the Stones' Gritty*
*Masterpiece*

## THE GOP'S DIRTY WAR
AGAINST OBAMA

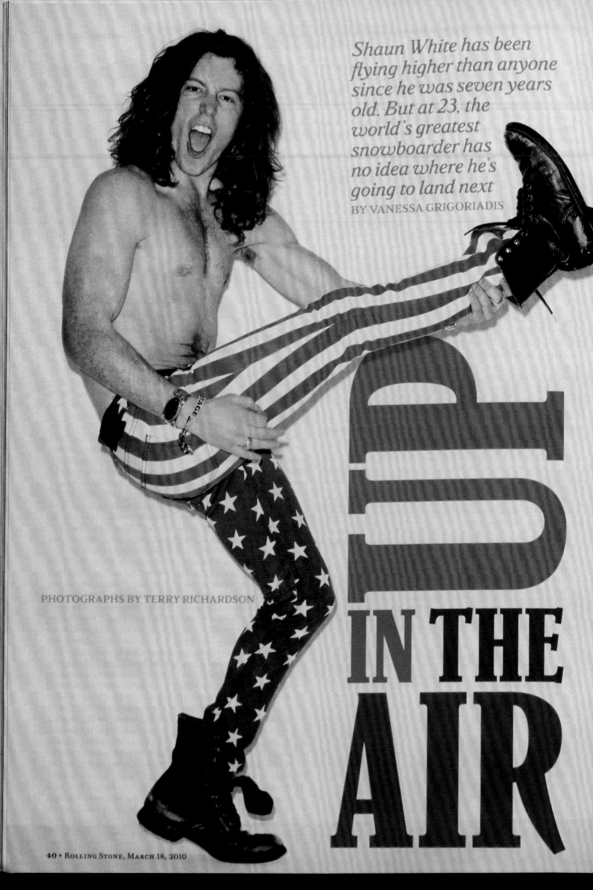

Shaun White has been flying higher than anyone since he was seven years old. But at 23, the world's greatest snowboarder has no idea where he's going to land next

BY VANESSA GRIGORIADIS

PHOTOGRAPHS BY TERRY RICHARDSON

# UP IN THE AIR

"UP IN THE AIR" BY VANESSA GRIGORIADIS, *ROLLING STONE*, ISSUE 1100, DATED MARCH 18, 2010, PP. 40–41.

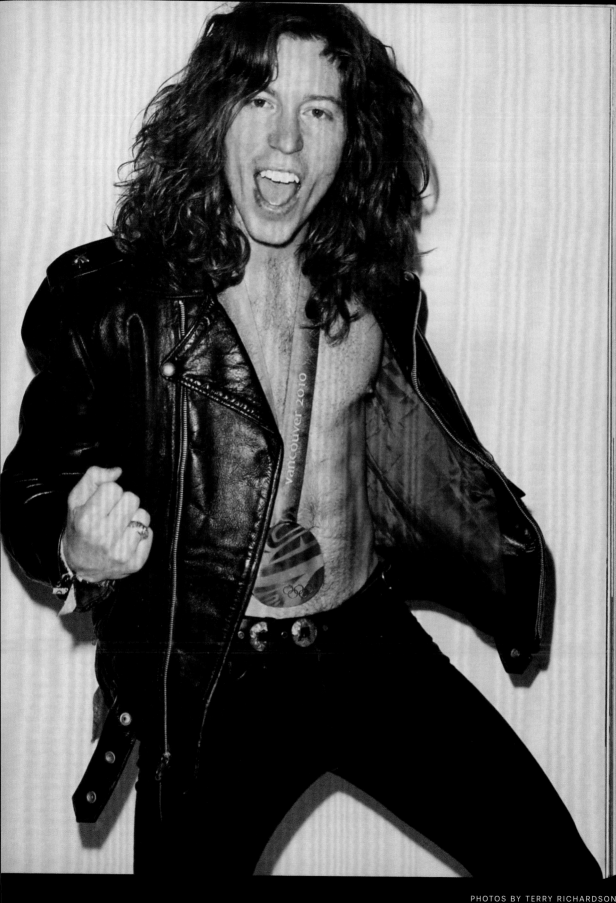

Japan was one of my favorite stops along the post-Olympic press tour. I already had a following in Japan before the Olympics, but it had drastically multiplied overnight to the point where I couldn't step outside the hotel.

A favorite memory of mine is seeing the faces of the people when I would pull the gold medal out of my pocket. The shock and awe were unforgettable. You could see clearly what my accomplishments at the Olympics meant to people around the world. Out of respect, the talk-show hosts in Japan refused to even touch the medal before putting on white gloves.

*(THIS PAGE)* TOKYO, JAPAN. 2010.

PHOTOS BY GABE L'HEUREUX.

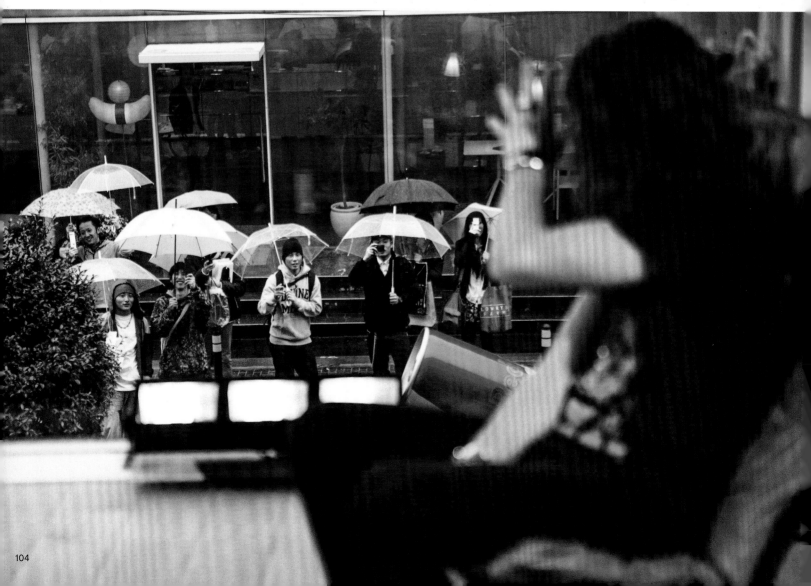

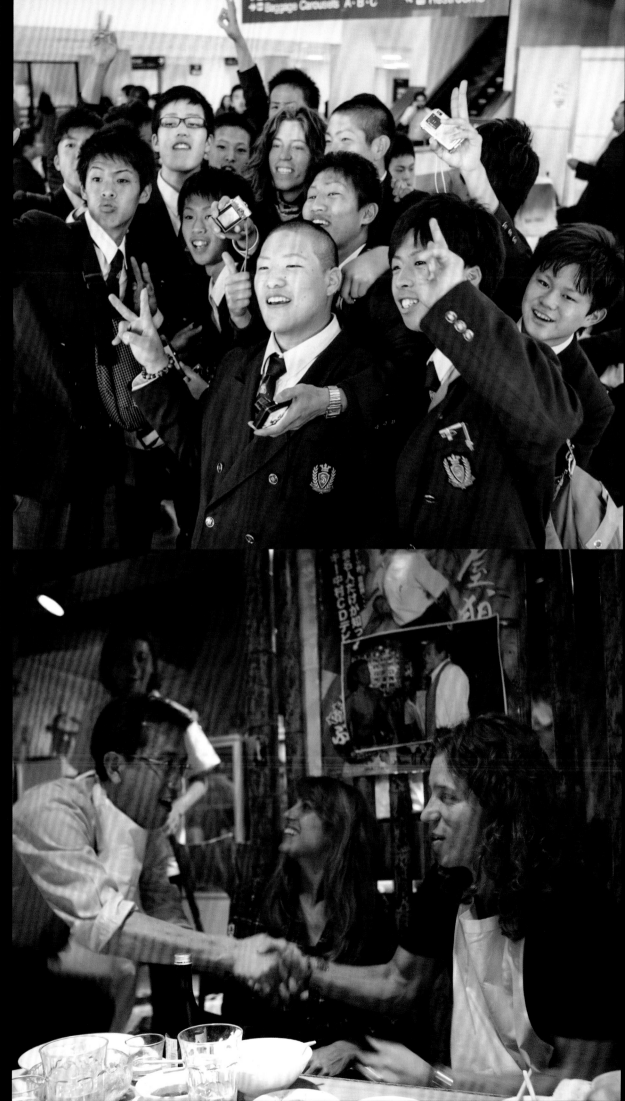

(OPPOSITE) SALZBURG, AUSTRIA, 2010.
(BELOW, LEFT) NEW YORK CITY, 2010.
(BELOW, RIGHT) CHICAGO, 2010.

PHOTOS BY GABE L'HEUREUX.

(Opposite) This was me stopping off in Salzburg, Austria, during the global post-Olympic press tour. I wanted to drop by to thank Dietrich Mateschitz, the owner of Red Bull, for greenlighting my training project in Silverton, Colorado. A documentary about the private halfpipe, Red Bull Project X, came out in 2010.

(Below, right) I became good friends with the police force out in Chicago. They would show me a really good time every time I came to the city, escorting me around with the sirens on. Chicago is a really cool city when it opens up for you.

PHOTOS BY GABE L'HEUREUX.

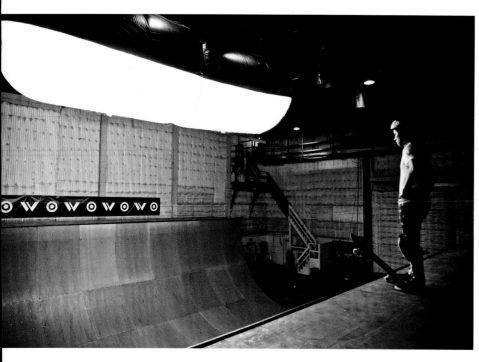

This is me skateboarding in Los Angeles. I had a portable vert ramp that I would set up in empty building parking lots and vacant film studios at the Sony and Paramount lots.

In the winter, I was an Olympic snowboarder and, in the summer, I was a professional skateboarder. One season would just blend into the other. There were no vert ramps in LA, so I had to get creative.

I remember people like Danny DeVito and the cast of *It's Always Sunny in Philadelphia* shooting nearby and peeking their heads in to watch me skate during their lunch break.

(*THIS PAGE AND NEXT SPREAD*) MY PRIVATE VERT RAMP WAS IN A WAREHOUSE AT PARAMOUNT STUDIOS IN HOLLYWOOD, LOS ANGELES, 2010.

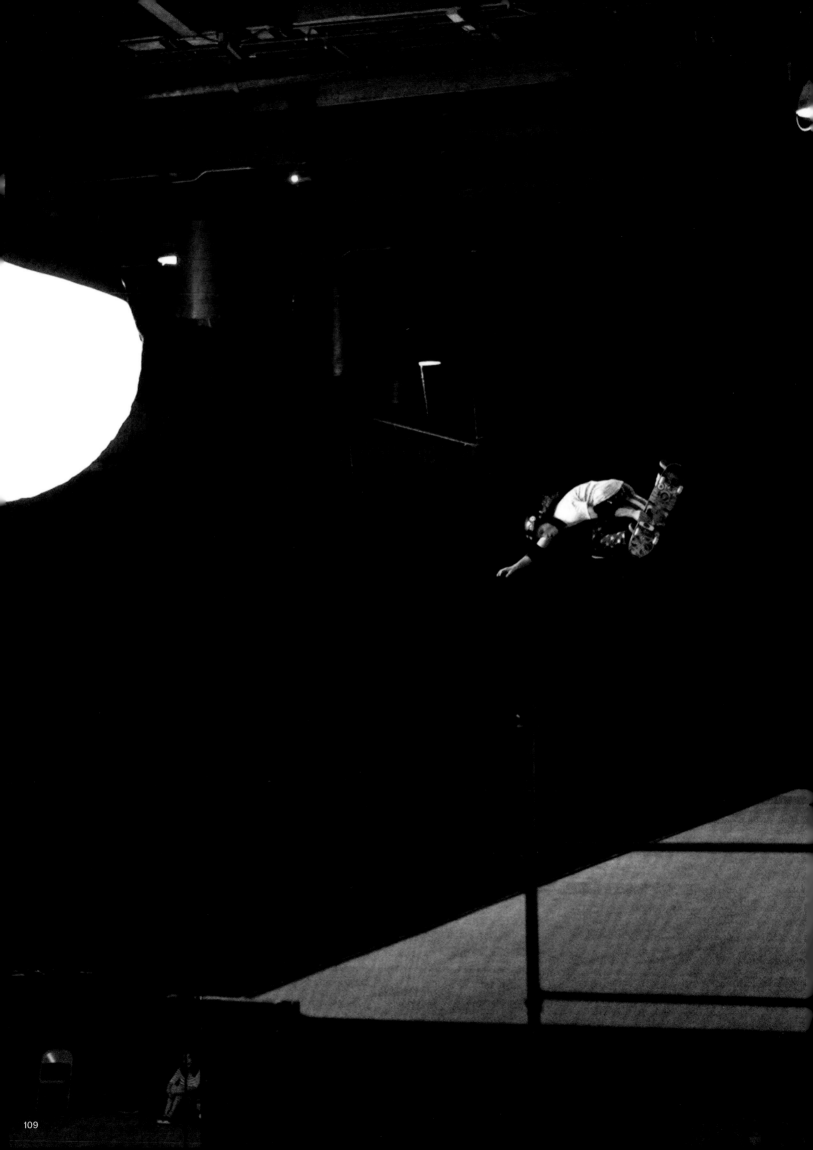

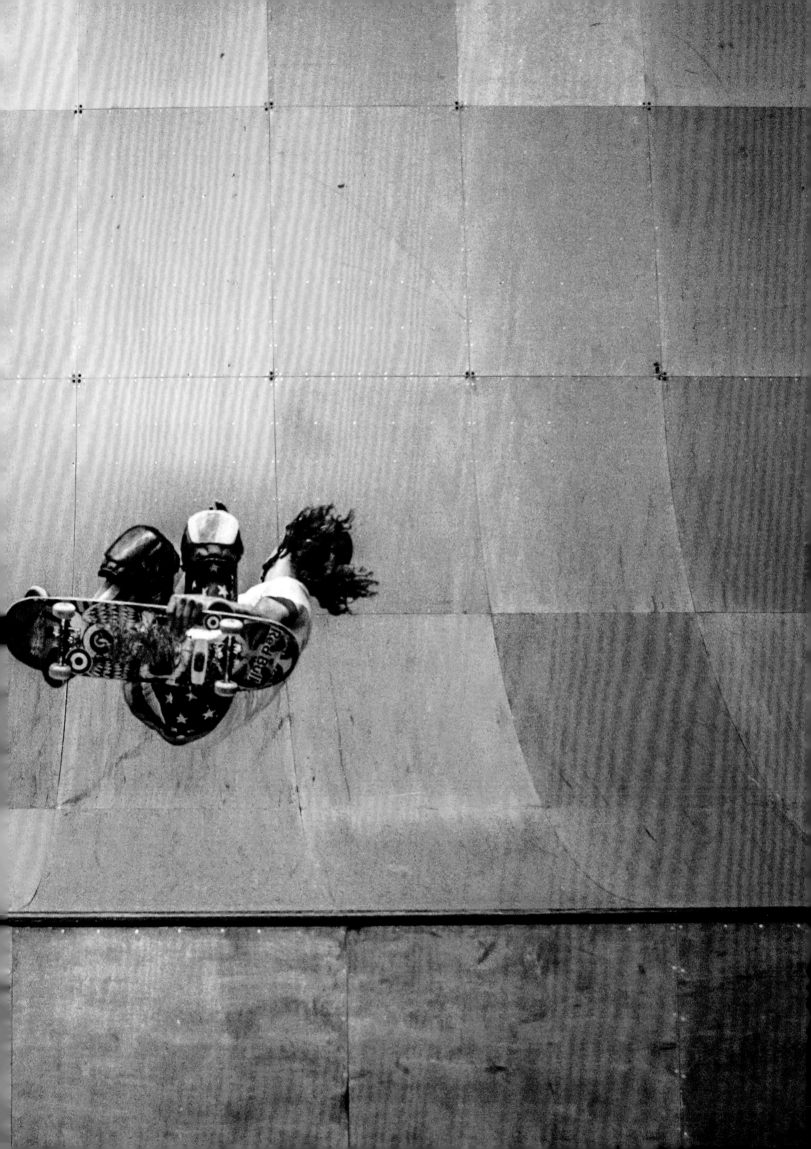

Although most of my fame came from competing in the superpipe at the Olympics, I felt just as proficient at slopestyle and, for a while, I had more medals in slopestyle than in halfpipe. Slopestyle wasn't an Olympic discipline until the Sochi 2014 Olympics, so I would take a two-year break from slopestyle every time the Games came around so that I could focus on halfpipe. I'd have to pick it back up where I left off and catch up to the riders who focused only on slopestyle year-round.

This photo is from X Games Tignes 2012 in France, a couple years after the Vancouver Olympics, where I managed to win both superpipe and slopestyle. In slopestyle, it was a big upset that I had come back, after taking two years off, to beat Mark McMorris, the rider who was winning everything at the time. I was one of the only snowboarders competing in both disciplines. As I look back on my career, being what you would call an all-mountain rider is something I'm really proud of. If you could snowboard on it, I could do it.

Competing in Europe was amazing. The people there had the best vibe. Halfway down the slope, they would just roll out a blanket, break out a bottle of wine with bread and cheese, and watch the event. It's just a different way of life, and it's really fun to experience.

Tignes, France

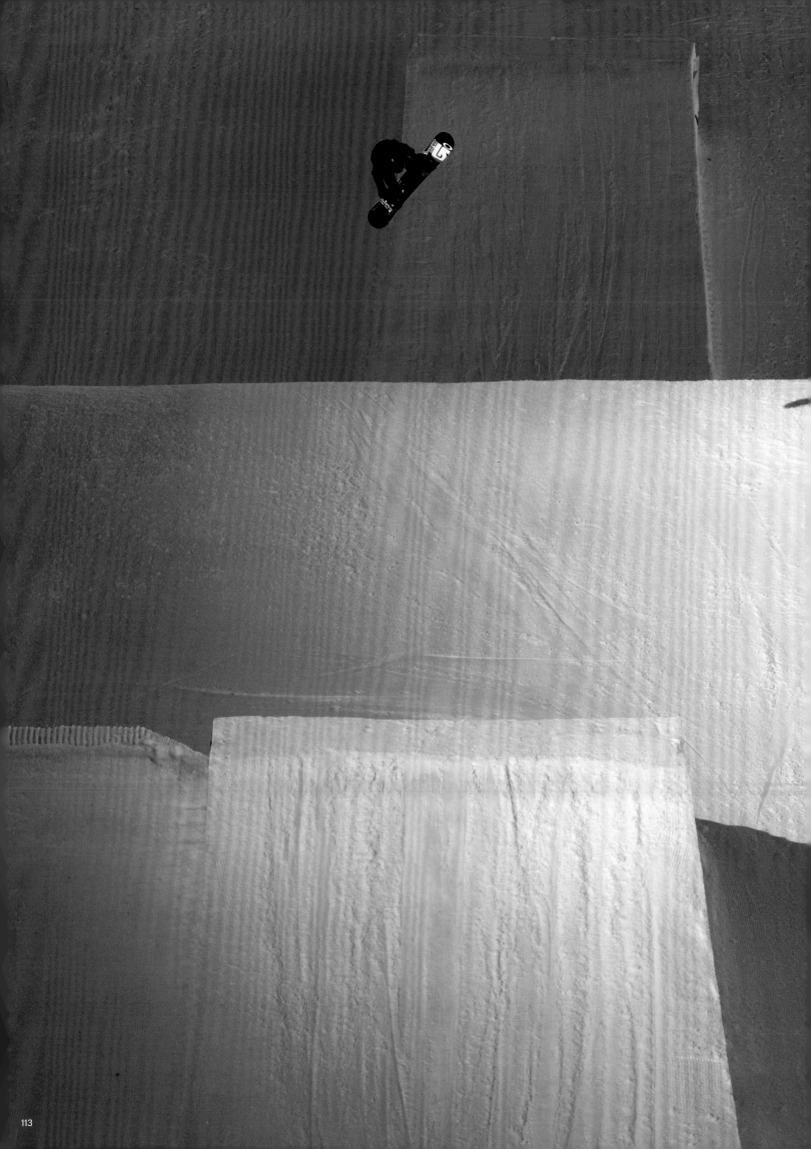

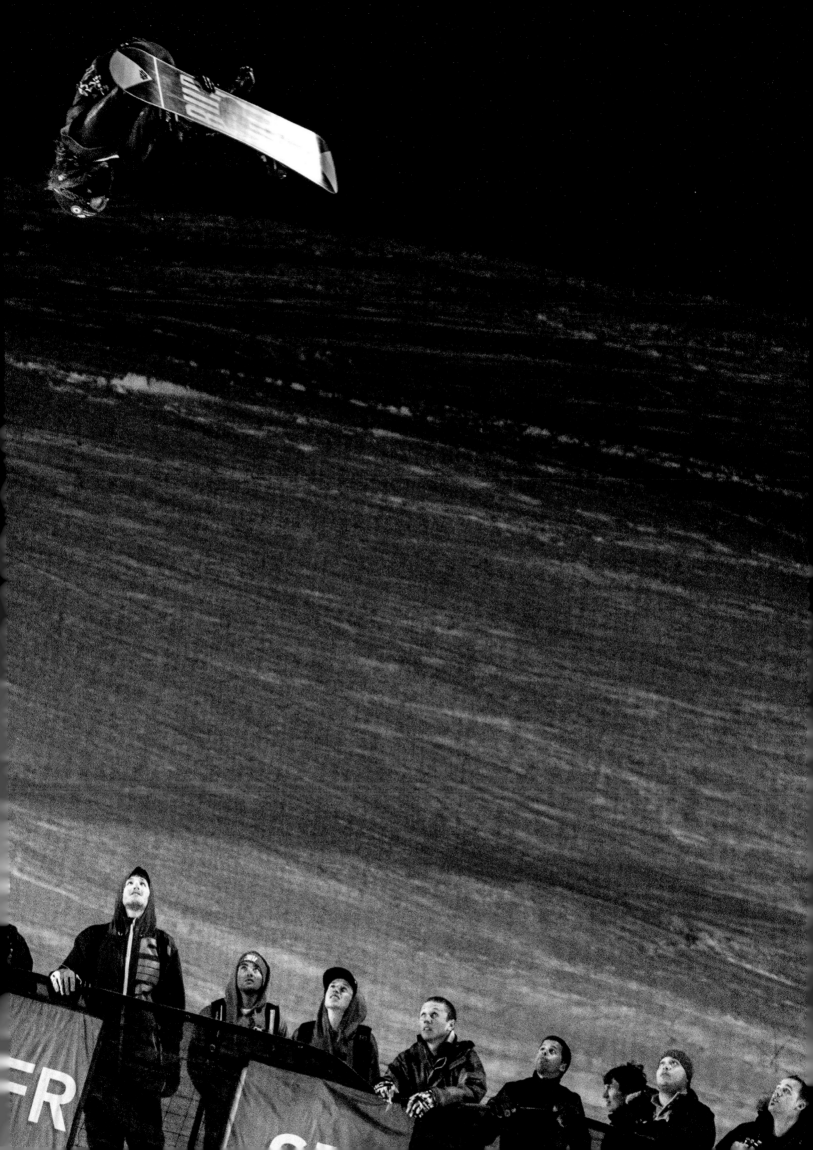

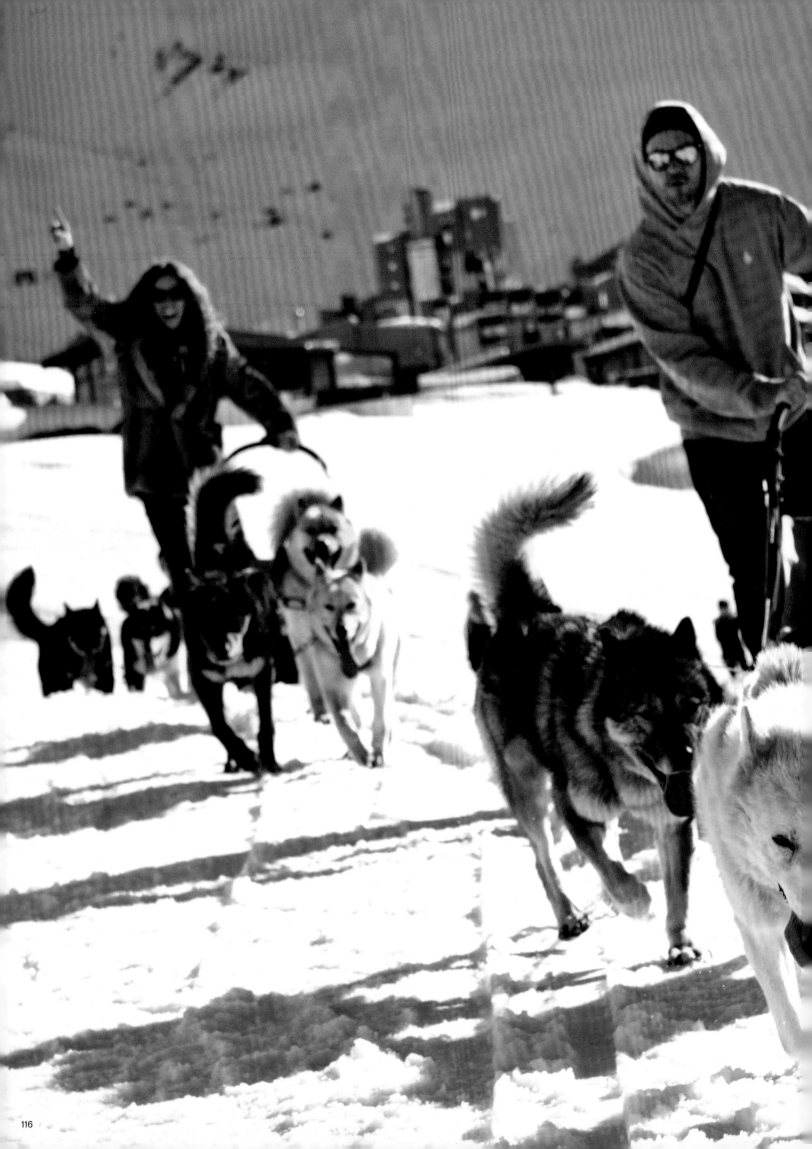

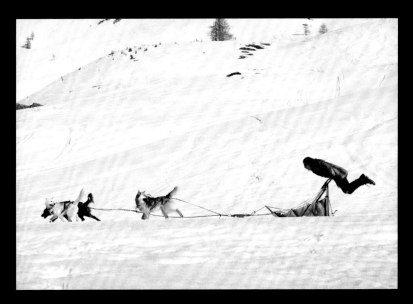

After receiving my gold medals from the event and getting back to the chalet, I noticed these big huskies running around with sleds. I was like, "Let's go dogsledding!" This is what it was all about: working hard and celebrating the moments in between. This is my brother Jesse and I ripping around on the dogsleds in the French Alps.

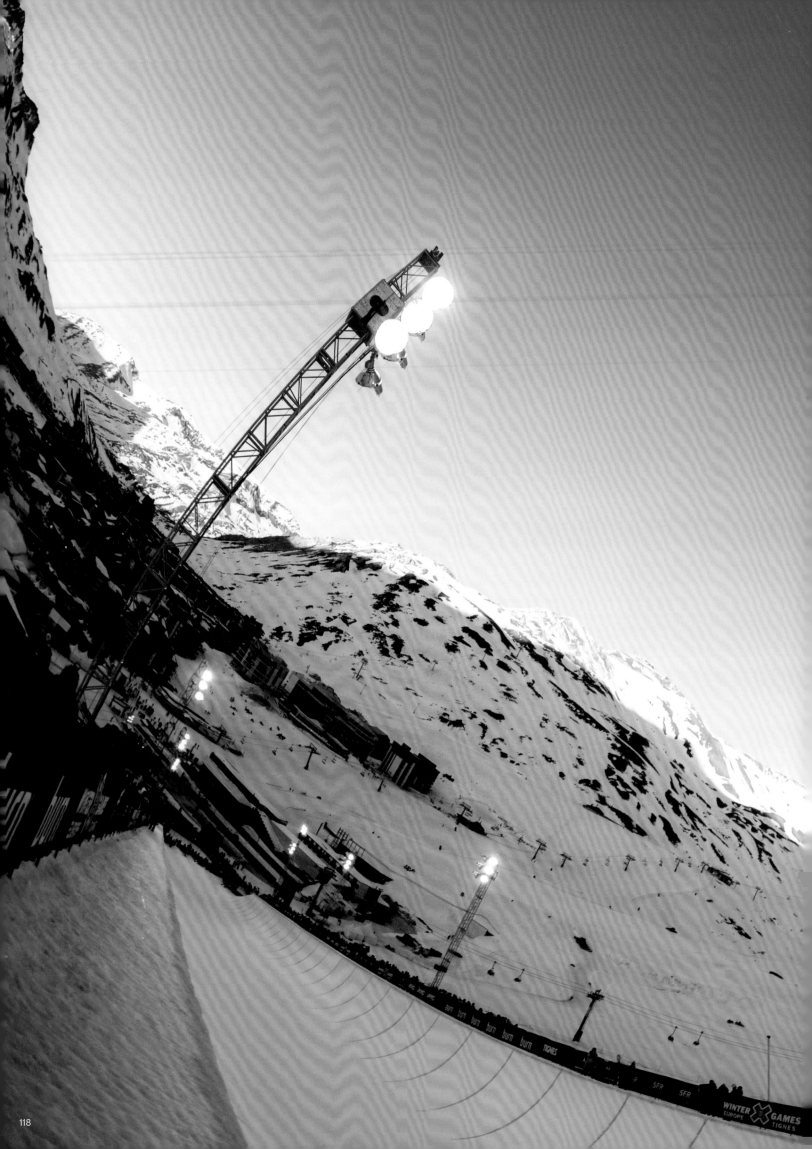

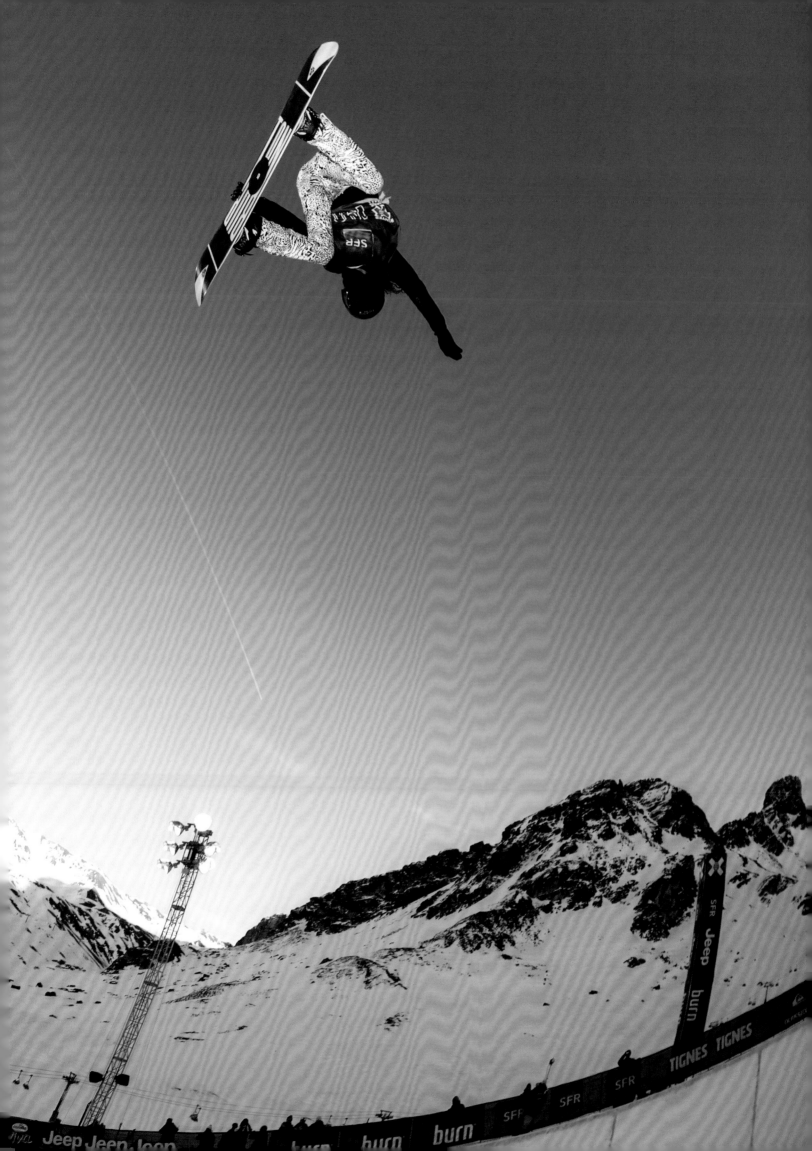

There are usually only a handful of Olympic-sized superpipes, so if you're on the professional training circuit, you spend a lot of time in those places. Breckenridge, Colorado; Park City, Utah; Copper Mountain, Colorado; Aspen, Colorado; Mammoth Mountain, California; and Vail, Colorado are some of the best places I've ridden and, at times, practically lived at because that's where the pipes were.

Park City Mountain Resort was the first resort in the United States to have the legitimate 22-foot superpipe. Training there was incredible. It started in the eighties with hand-dug halfpipes shaped with shovels and then the invention of the pipe cutter, a snow-shaving tool attached to a snowcat, which is used for grooming the mountain. It made an 8-foot halfpipe wall, then it turned into a 16-foot halfpipe, then 18-foot, and then it blew up into the 22-foot superpipes. Vancouver was the first Olympics that featured the 22-foot halfpipe.

Early on in my career, I was sponsored by Park City Mountain Resort. I worked with them for about nine years. The 22-foot pipe was the perfect training ground for me. I would either go there to learn new tricks or dial in my runs. It was at this superpipe where I landed the first-ever double McTwist 1260. Park City Mountain Resort was like my home away from home.

# Park City, Utah + Breckenridge, Colorado

*(OPPOSITE)* BRECKENRIDGE SKI RESORT, BRECKENRIDGE, COLORADO, 2013.
*(NEXT SPREAD)* PARK CITY SKI AREA, PARK CITY, UTAH, 2010.

PHOTOS BY GABE L'HEUREUX.

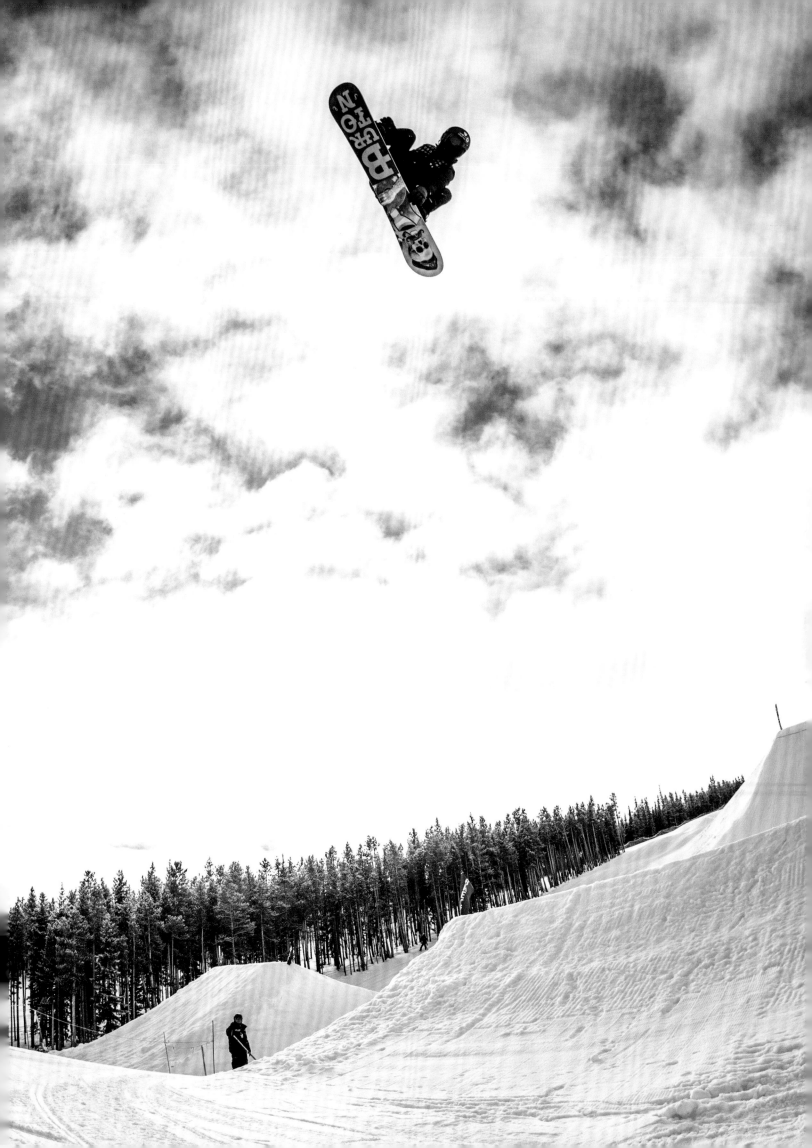

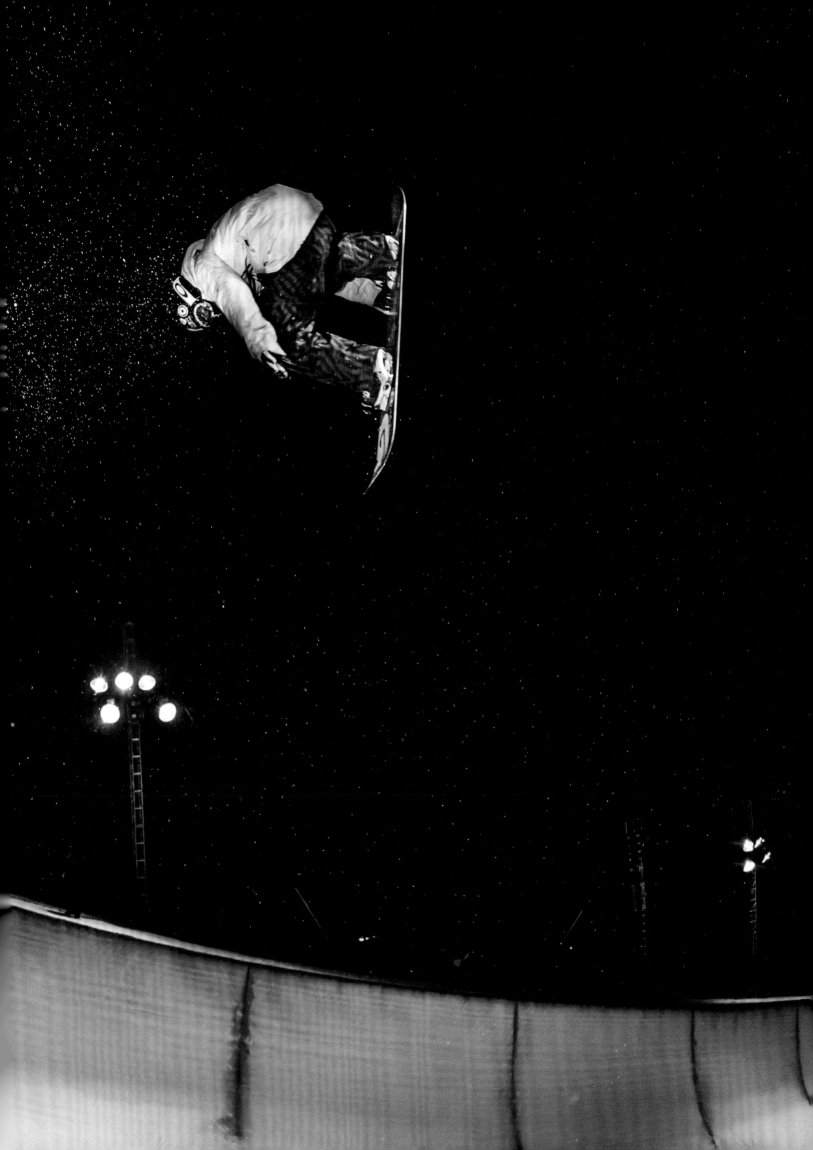

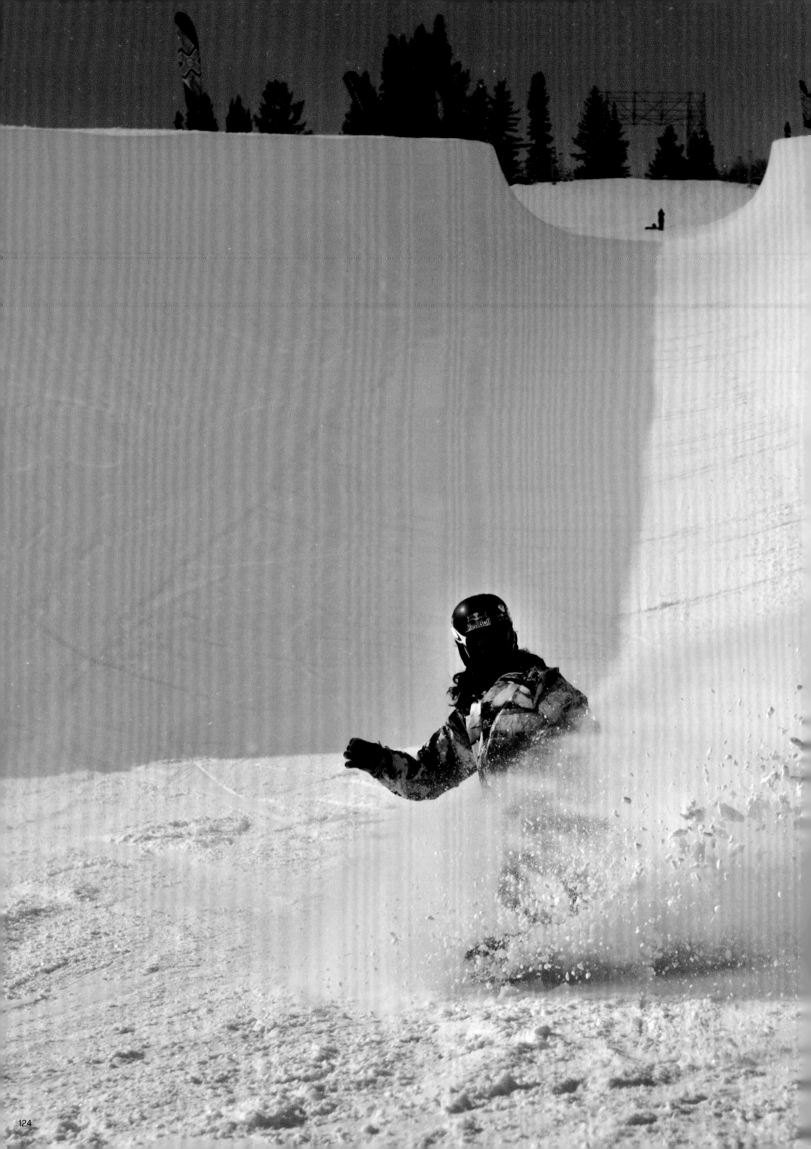

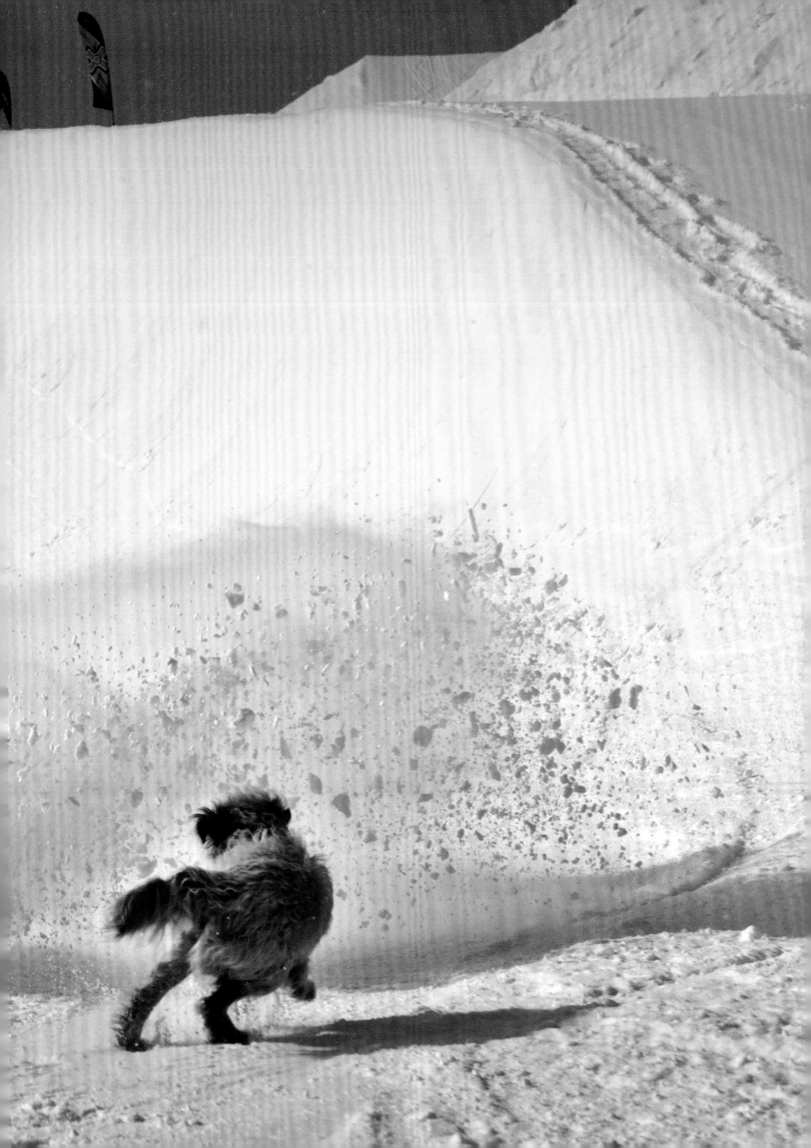

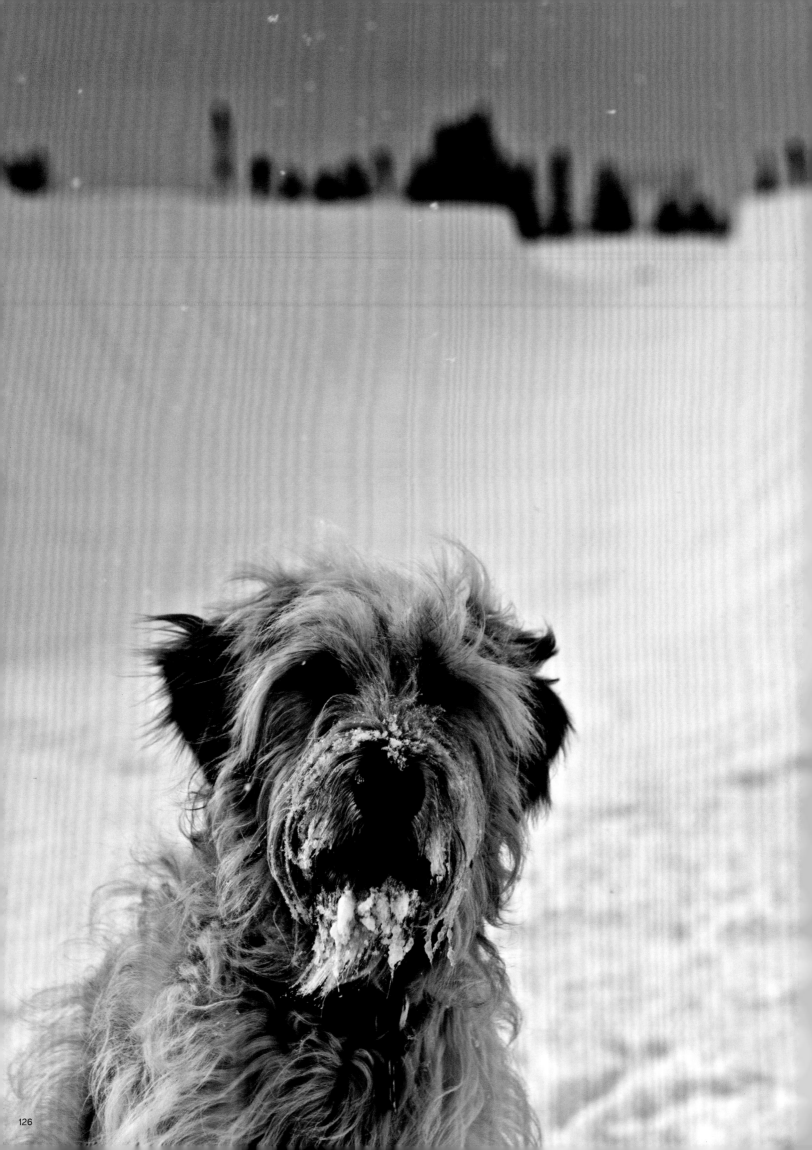

At Buttermilk Mountain in Aspen, I would do my run, get to the bottom, and one of the ski patrol dogs would rush up to me. Every time, I had to slow down so my board would throw up a wall of snow at the dog, who just loved it. He tried to eat all the snow chunks before they hit the ground. It became our little thing. Every time I got to the bottom, I'd throw a huge plume of snow at him, and he would gobble it up and come back for more. I just love this photo so much because you can tell that he got his daily fill of snow and seemed pretty happy with himself.

I also really love this image because, at times, this is how I see myself inside: just a weathered snow dog getting his fill. It's all about the little moments, and this one has always stuck with me.

(PREVIOUS SPREAD AND OPPOSITE) ASPEN SNOWMASS SKI RESORT, SNOWMASS VILLAGE, COLORADO, 2010.    PHOTOS BY GABE L'HEUREUX.

127

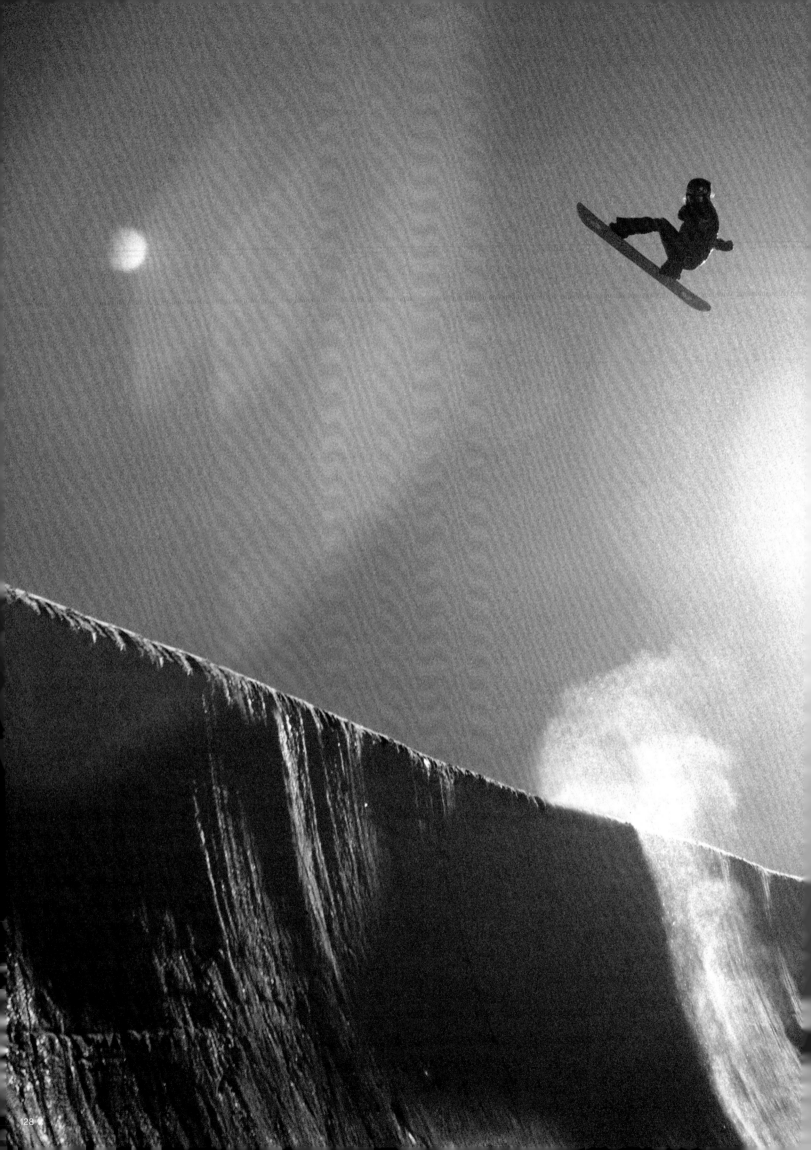

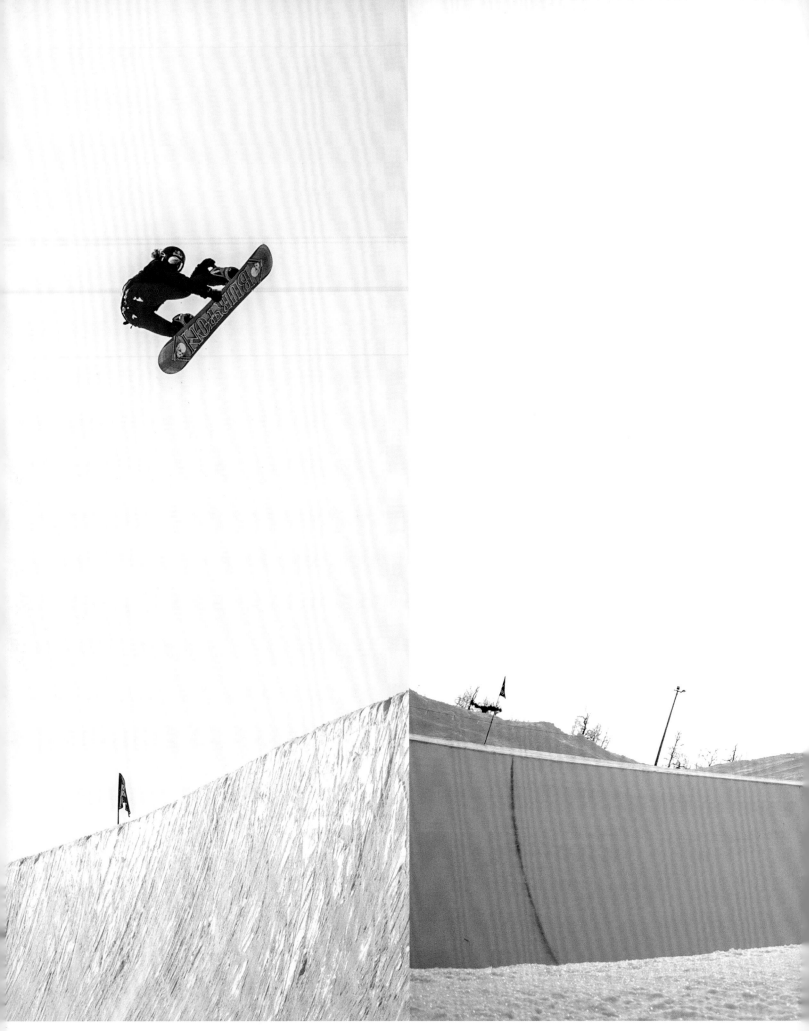

*(PREVIOUS SPREAD AND THESE IMAGES)* PARK CITY SKI AREA, PARK CITY, UTAH, 2011.

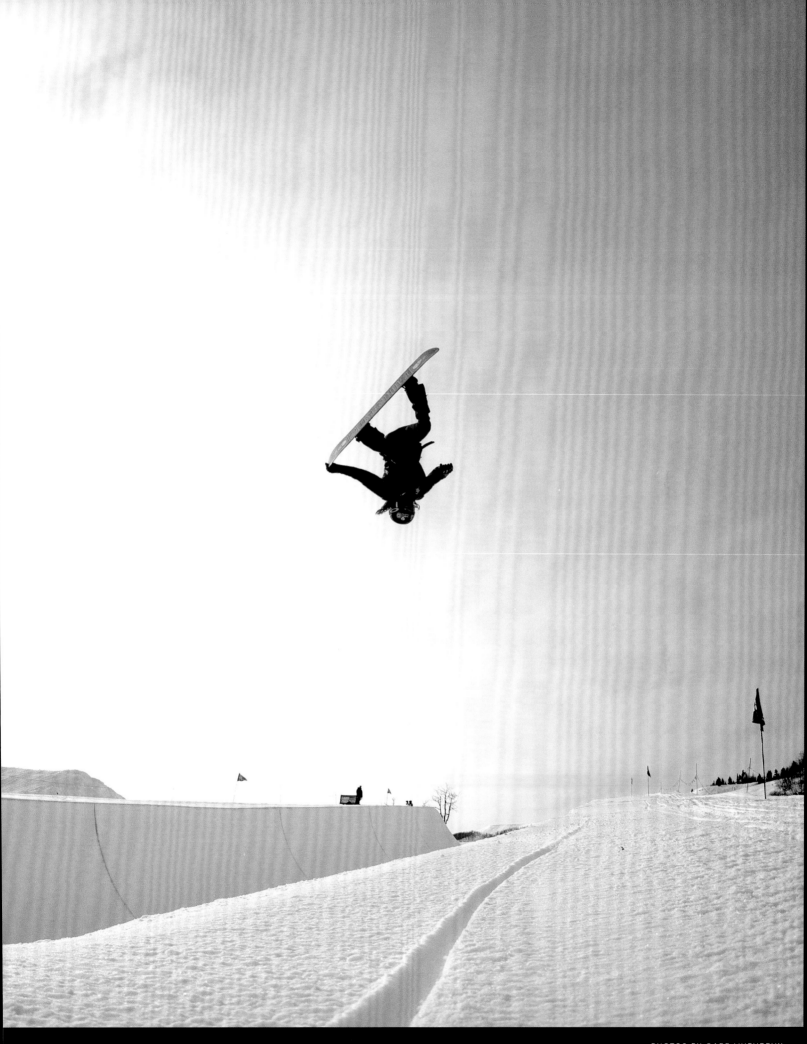

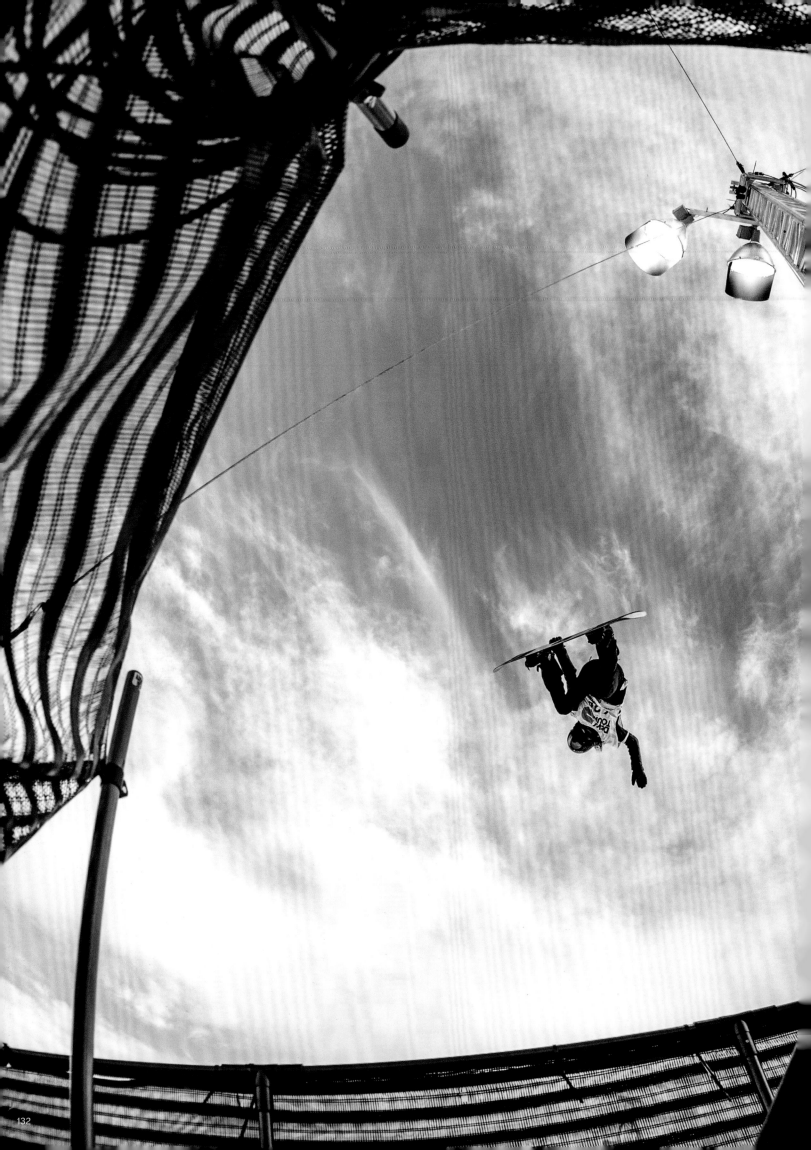

People mostly know me as a snowboarder because of the massive reach of the Olympics, but I would consider myself just as much a skateboarder as a snowboarder. At times, I even prefer skateboarding over snowboarding.

I started skateboarding at X Games in 2003, when I was sixteen years old. I won two gold medals, two silver, and one bronze on the vert ramp between 2005 and 2011. I was also the overall Dew Tour skateboard vert champion multiple years running.

The photos on this page and the next are from the second summer X Games that I won, in 2011. They had set up the vert ramp inside of the Staples Center in Los Angeles, and there was this huge crowd. I put down an amazing run on my last run to win it, and I ended the run with a trick that I had invented: the frontside body varial heelflip 540—basically, a spinning backflip where the board is also flipping. Halfway through my flip, I caught the board behind my back and pulled it under my feet from behind. It's a very complicated trick, and this was the best run I've ever done on a skateboard.

The photo on the next page captured the best feeling ever: sliding across the ramp after landing my run. The score hadn't come in yet, but I remember not really caring because I was so caught in the moment after pouring everything I had into that last run. I don't try to wait for the last run to pull things off for a win—I'd way rather coast into an easy win—but when I do manage to pull it off on the very last run, it makes for an eventful contest, which you can tell by all the arms up in the air and the cheering faces in the crowd!

Winning this event meant the world to me because I'd always wanted to be a pro skateboarder. I had set out to win summer and winter X Games in the same year, and now I had done it multiple times. I felt like I had made my mark on the world of skateboarding. So, when you hear some of my X Games stats, like my twenty-three career medals, remember they include the five skateboarding medals.

X Games

(OPPOSITE AND NEXT PAGES) 2011 X GAMES LOS ANGELES, STAPLES CENTER.

PHOTOS BY ERIC WILLIAMS.

134

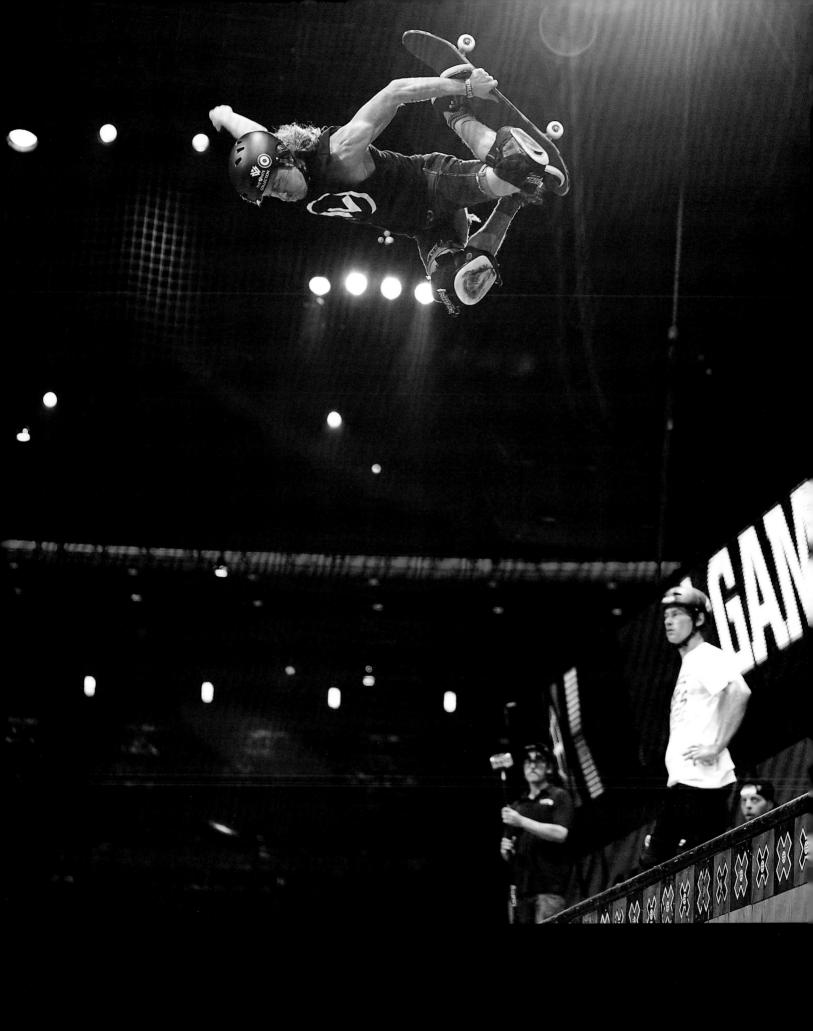

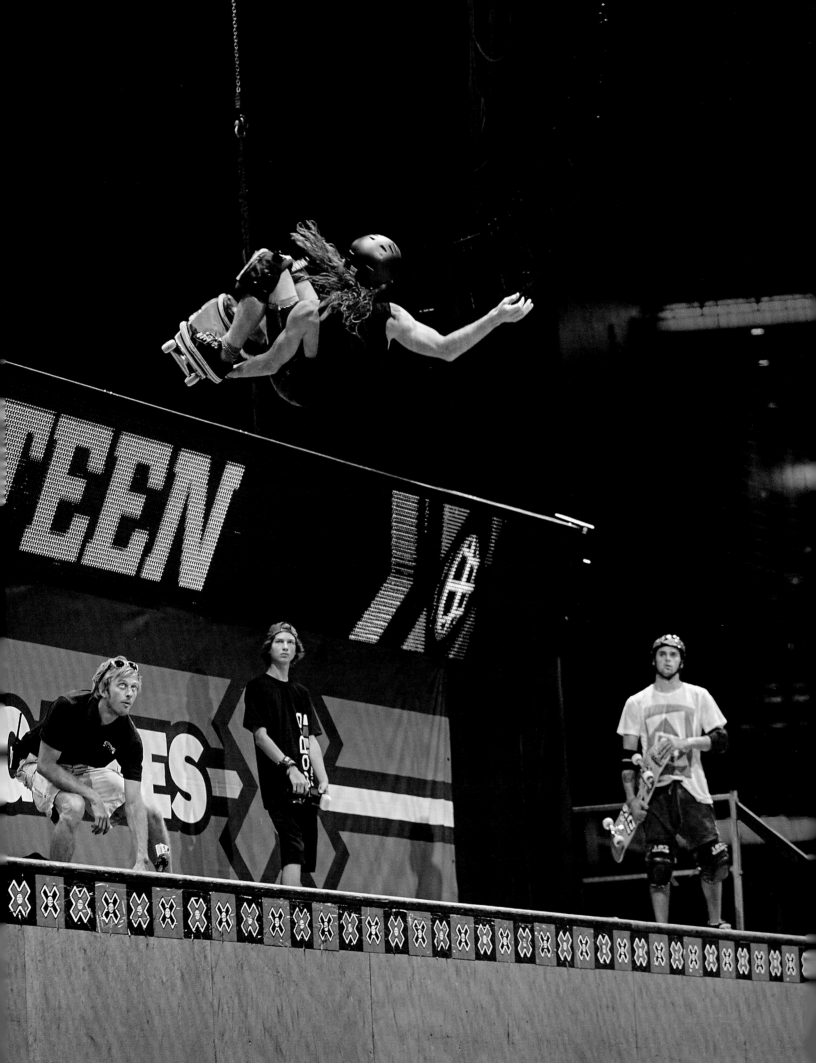

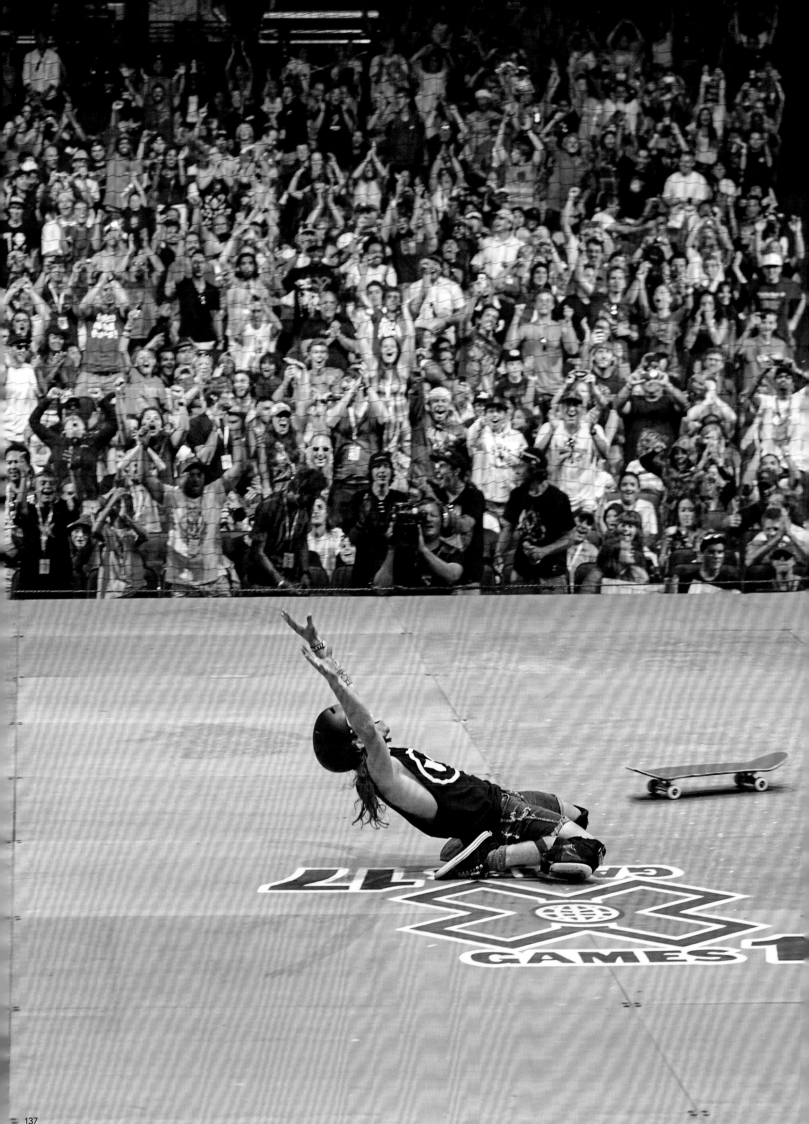

PHOTO BY ERIC WILLIAMS.

WITH KARA MASTERSON. 2011 X GAMES LOS ANGELES. STAPLES CENTER.

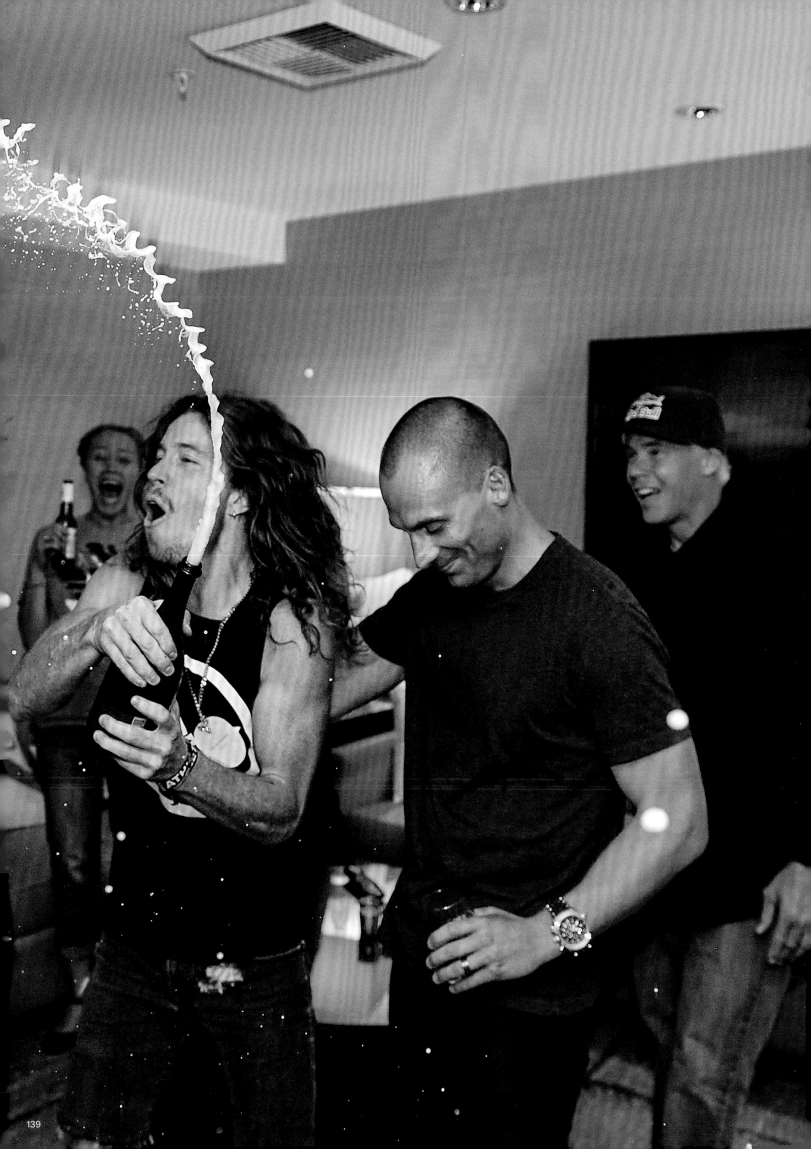

The Burton US Open was the longest-running contest in snowboarding and probably the most important for a long time. It started in 1982, a few years before I was born. They had a halfpipe in Vermont starting back in 1988. All the legends in the sport had won the US Open—people like Craig Kelly, Terje Haakonsen, Todd Richards, Peter Line, Rob Kingwill, Ross Powers, Danny Kass, Tina Basich, Janna Meyen, Tricia Byrnes, Shannon Dunn, Cara-Beth Burnside, Barrett Christy, Nicola Thost, and Natasza Zurek. It was the big contest.

(Opposite) This was one of my first few years attending the Burton US Open. I was barely taller than the banners lining the halfpipe! I felt like I was cursed at the Open. I could win all these major contests and then get to Vermont and just blow it.

The US Open in 2003 was the first big year for me: I won slopestyle and took second behind Travis Rice in the rail jam, a new event they added that year. And then, in 2006, I won both slopestyle and halfpipe. Once the curse was broken, I was unstoppable. I ended up winning a total of nine times: slopestyle in 2003 and 2006, and halfpipe in 2006, 2007, 2008, and 2012, when it was still at Stratton in Vermont, then in 2013, 2016, and 2017, after it had moved to Vail, Colorado. Burton Snowboards was my sponsor for nearly all my competitive career, so it always felt extra good to win that one and give Jake Burton a big hug at the finish.

(Next spread) This is the record-breaking 26-foot air at the 2013 US Open in Vail, Colorado.

US Open

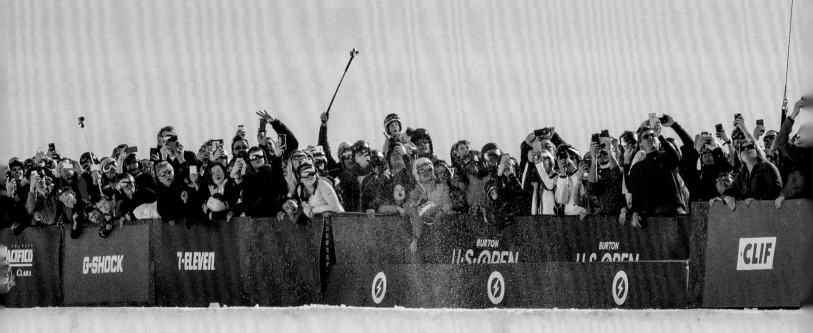

**25** FT

**20** FT **20** FT

**15** FT **15** FT

**10** FT **10** FT

BOXED WATER IS BETTER.

SHISEIDO
GINZA TOKYO

anon.

BURTON GIRLS.com

WORLD
SNOWBOARD TOUR

BURTON
U·S·OP
SNOWBOARDING CHAMPIO

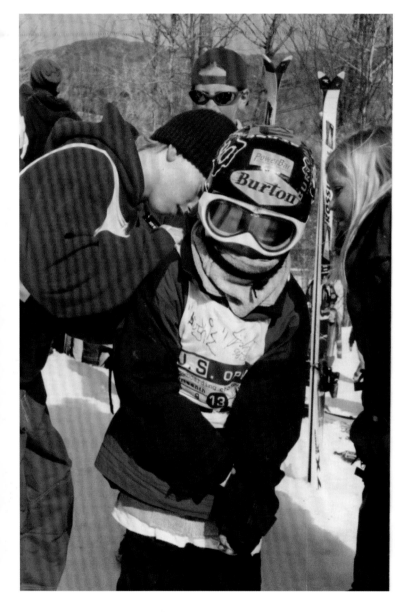

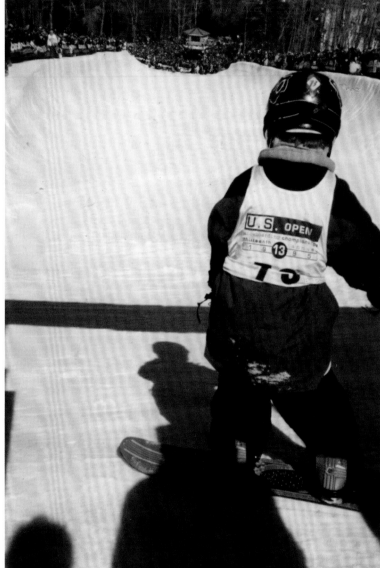

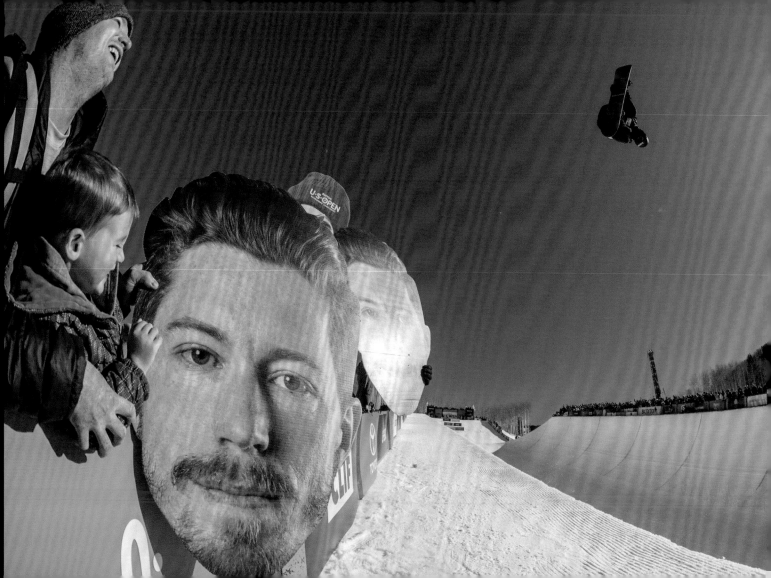

PHOTO BY GABE L'HEUREUX.

2013 US OPEN AT VAIL SKI RESORT, VAIL, COLORADO.

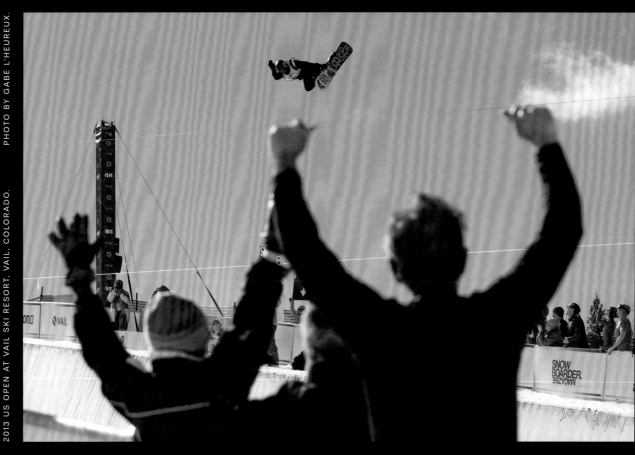

*(Above)* It's wild to look at these photos together and to see me go from the little kid I was at the front of this chapter to this. This photo is from 2013, the year that I broke the world record for highest air out of the halfpipe. I first set the record at X Games in 2010, by going 23 feet out, then I went 24 feet at X Games in 2013, and then I broke that record here by going 26 feet. The interesting part was I hadn't ridden for a month or two before setting the record. A friend of mine had passed away, and I was grieving. This was the first competition back, and I remember dropping in for my run and letting all that frustration out in my first hit. I went bigger than I had ever gone before.

*(Left)* Jake Burton was the father of the sport and gave me my start; his company, Burton Snowboards, sponsored me when I was probably six or seven years old. I was on the team since almost as far back as I can remember. Jake would always attend select events, like the US Open and the Olympics. To have him there at the bottom of the pipe in those huge moments was just so special. It was kind of like having your very first teacher who helped you out be there when you graduated. This happened multiple times over my career. Jake's the man, and he always will be. I hold a special place for him, for sure.

I always respected Jake because he was competitive like I was, just in a different way. You know, running a business and having one of the most prominent sports brands in the world is impressive, but I loved that he was still a very down-to-earth sort of guy. He lived in Vermont with his family and had a very nice house, but it wasn't the craziest house I'd ever been to. He lived a normal man's life, and he treated others with respect. I think that was what was so great about being around him: he never let all the success change him. We had a great relationship; he was my helping hand and my greatest champion. He gave me my first sponsorship and helped me travel to places and do things. He always had great advice for me when I needed it. I wish we had had more time together.

*(OPPOSITE)* 2016 US OPEN AT VAIL SKI RESORT, VAIL, COLORADO.
*(NEXT SPREAD)* 2013 US OPEN, VAIL SKI RESORT, VAIL, COLORADO.

PHOTO BY GABE L'HEUREUX.
PHOTO BY DEAN BLOTTO GRAY.

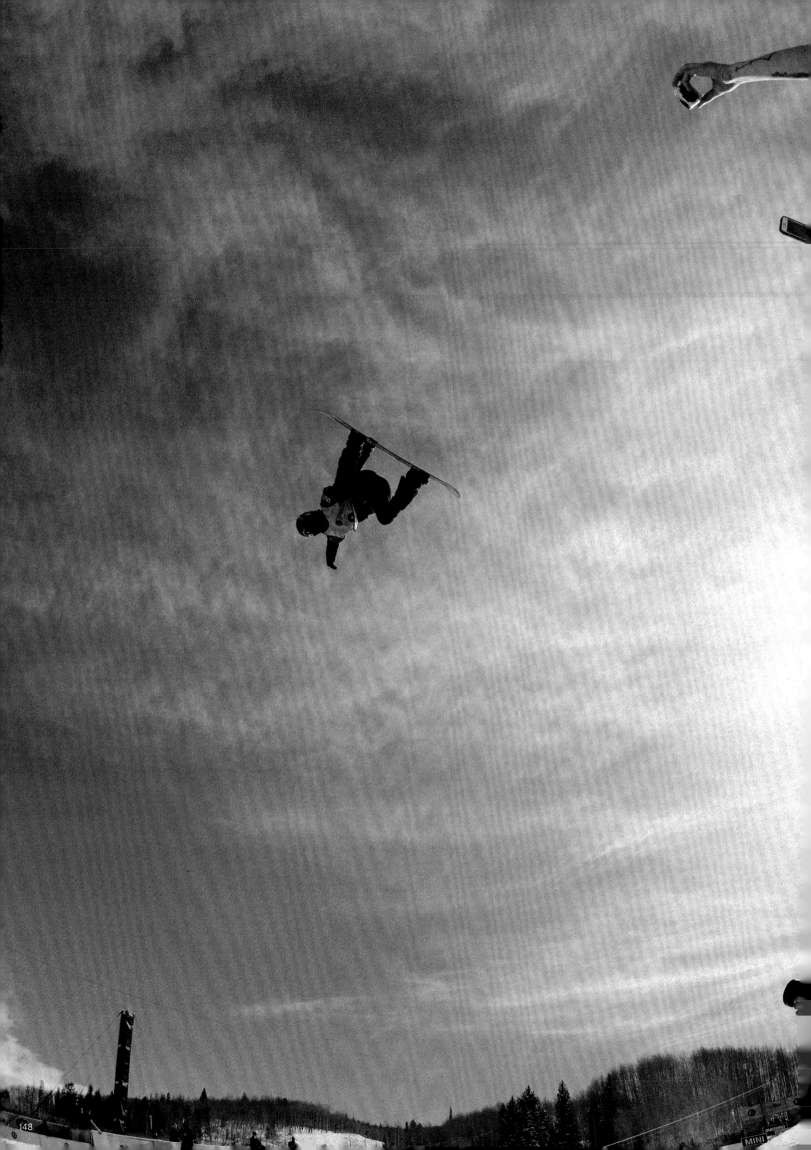

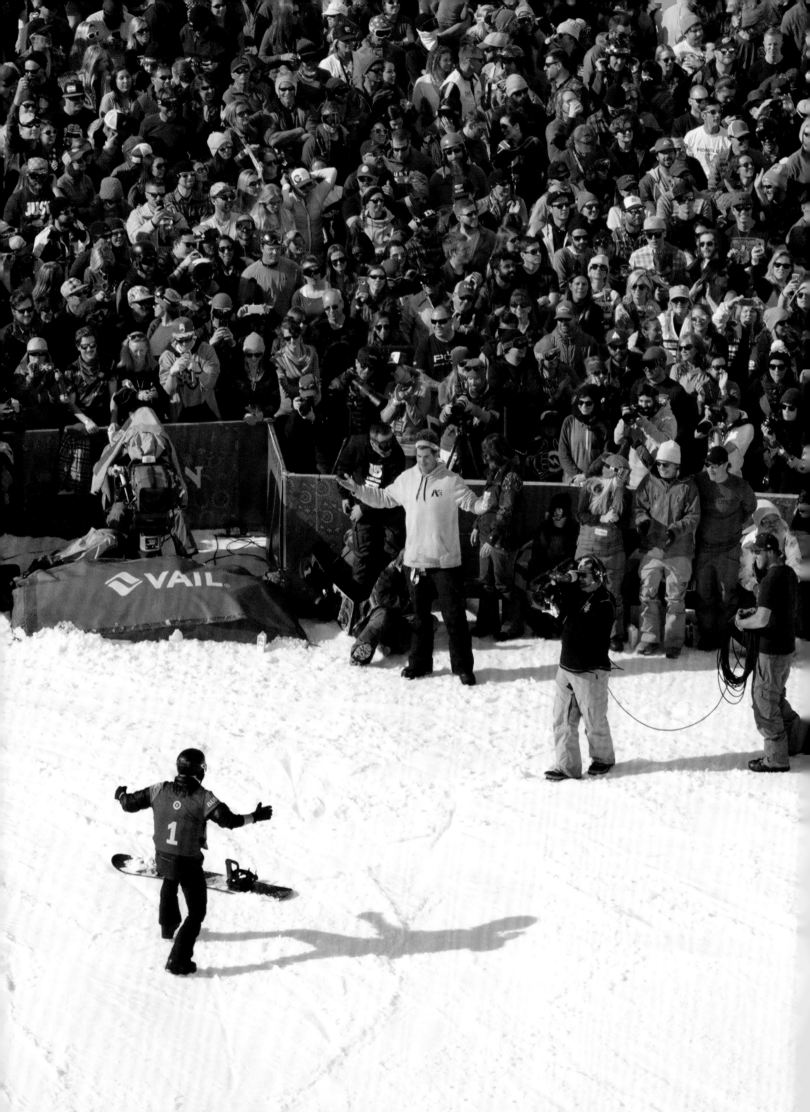

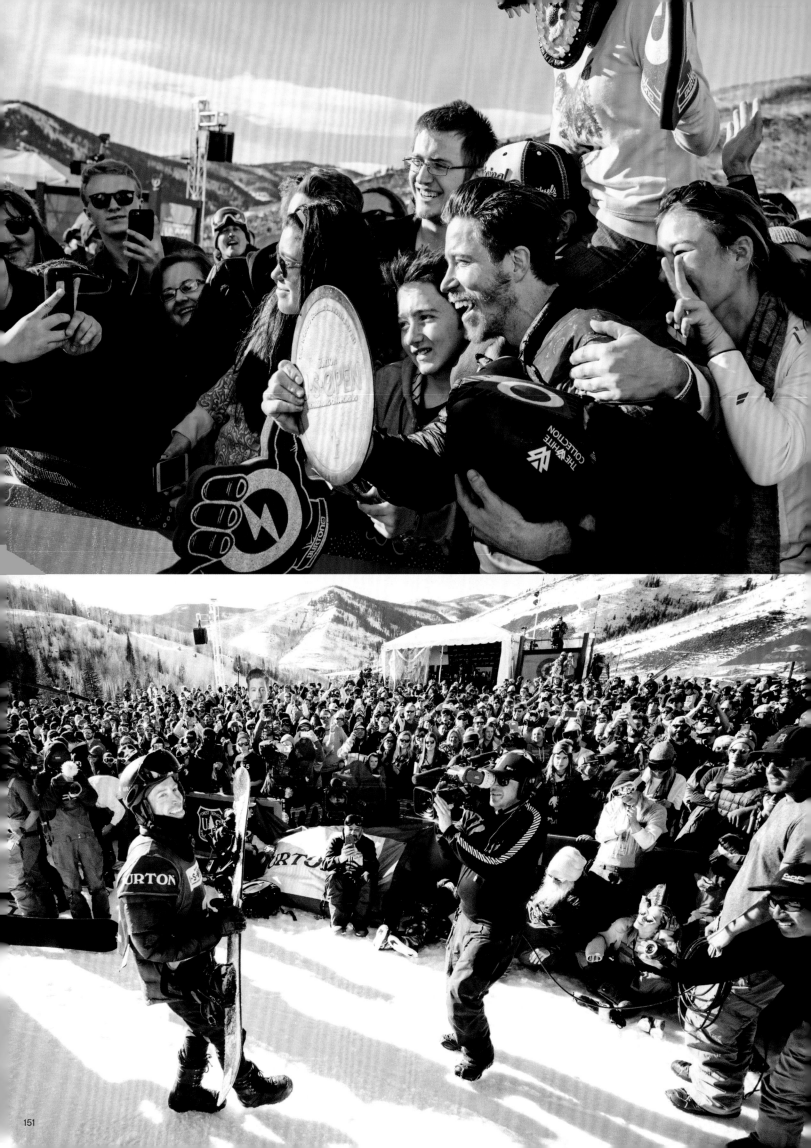

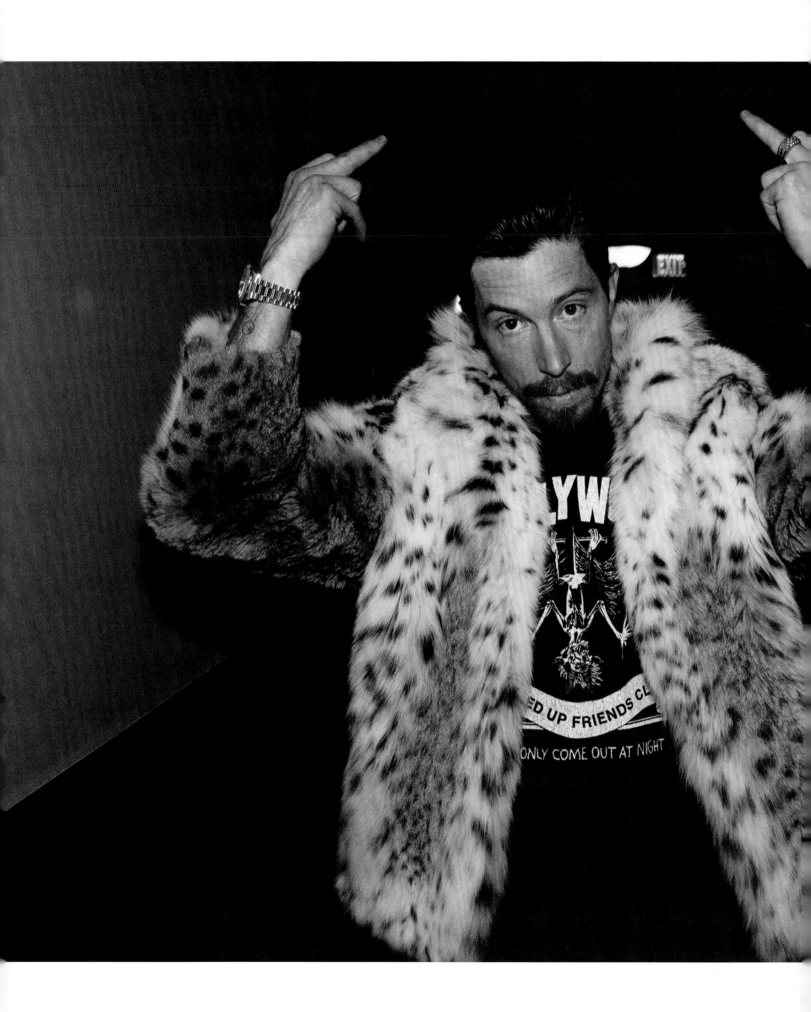

PHOTO BY GABE L'HEUREUX.

VAIL, COLORADO. 2016.

This photo was taken in my rock 'n' roll phase. I had just finished practice at the US Open at Vail, and I walked by a shop where this coat caught my eye. Looking through the shop glass, in a split second, I saw myself wearing it with a gold medal around my neck heading to the after-party concert, so I bought the coat!

This photo was taken the day after I had won the contest, on my way to collect the medal and watch the concert. Sarah Barthel, my girlfriend at the time, was in a band named Big Grams, which was performing that year.

A lot of things in my life start with an idea or mental road map. If I'm going to do something, I like to envision every little detail of it and then make it happen.

The 2014 Sochi Olympics was the first Olympics where I was really burning the candle at both ends. It was the first time the Olympics would have slopestyle, and I was planning to compete in both that discipline and halfpipe. I was excited to go to Russia; I had been to Moscow once before, so I thought this would be an interesting Olympics. But this is the one Olympics where everything seemed to fall apart. I got to the slopestyle event and the course was incredibly icy. Jumps were gigantic with super-long takeoffs. It seemed like the course had been designed to look good on TV, but it didn't ride well. I kept watching rider after rider get seriously injured on the course during practice. I felt unsafe.

I made the incredibly tough decision to pull out of that event and focus on the halfpipe. I took a lot of backlash from the media and other riders on social media for that decision. Growing up in a sport with risks, I've always followed my gut and, when I feel unsafe, I walk away. I would never let someone else pressure me into something I think is too dangerous or I feel uncomfortable doing, no matter how big the event. The only problem was I quickly found out the halfpipe had issues as well. The snow conditions were really warm, and the builders struggled to put a good shape on the walls. The whole thing was poorly built. After three discouraging days of practice, I know myself and many others just kind of gave up mentally before the event even started.

After finishing fourth in the halfpipe, I was devastated. But later, for me, Sochi became that super-important upset in my life that taught me a huge lesson, which was things don't always go your way but life goes on. It brought me to a place of appreciating the things that I do have.

I had lost that love for the sport that was driving me. I thought I could just check the boxes of what I needed to accomplish to get to the Olympics and everything would work out. It became more mechanical than a feeling. And then I found myself at the top of the course, and I had no heart to put into my performance. After I crashed, it was all over. I left Sochi with no medals and an empty feeling of "What now?"

Sochi, Russia

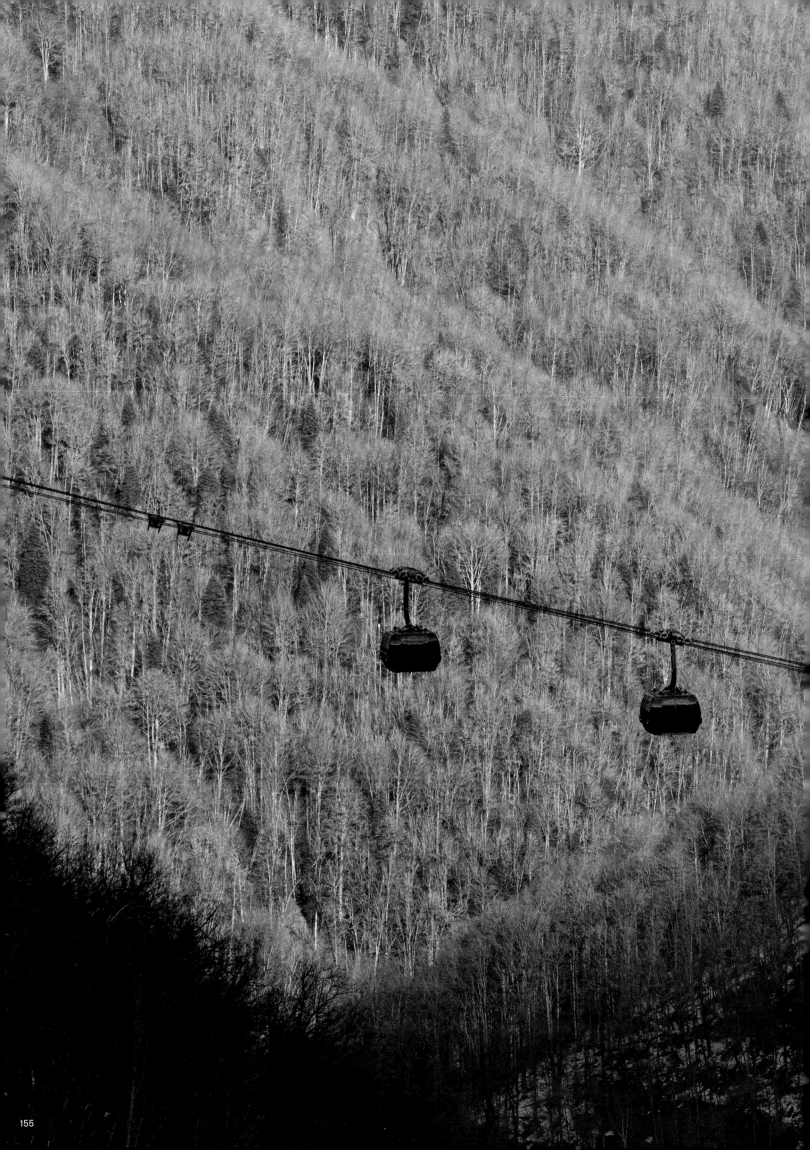

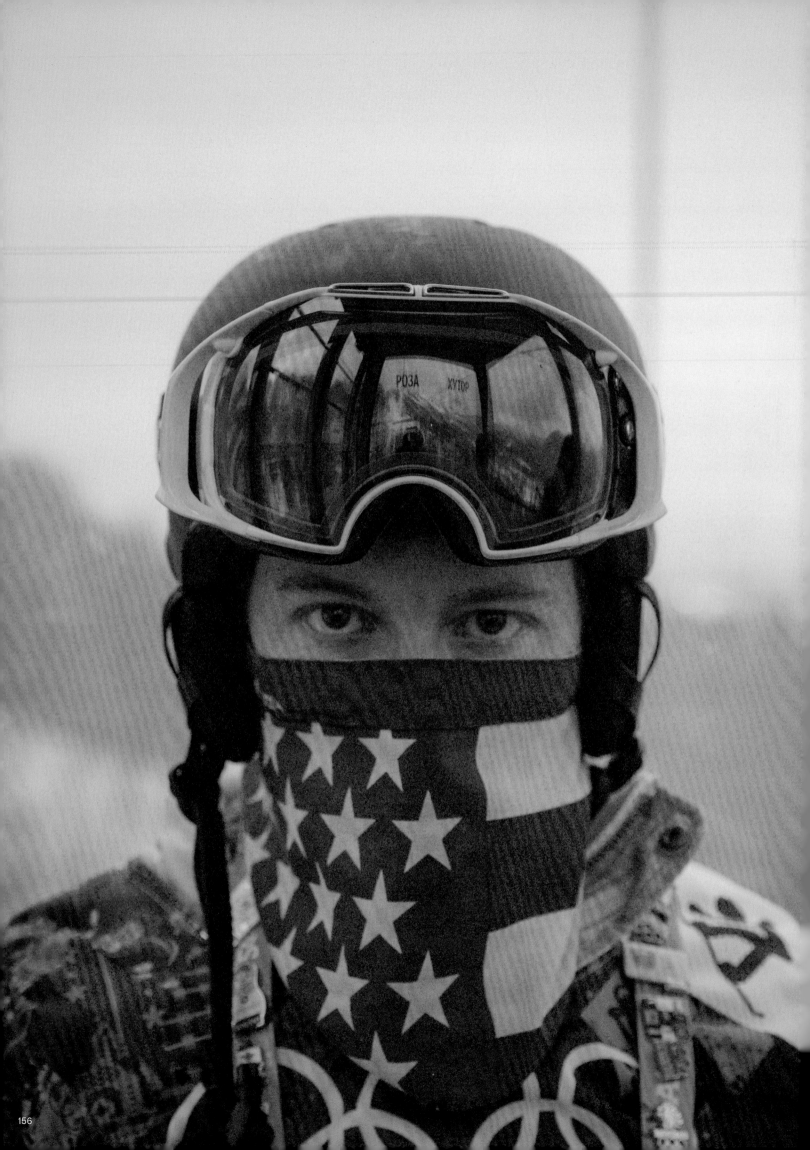

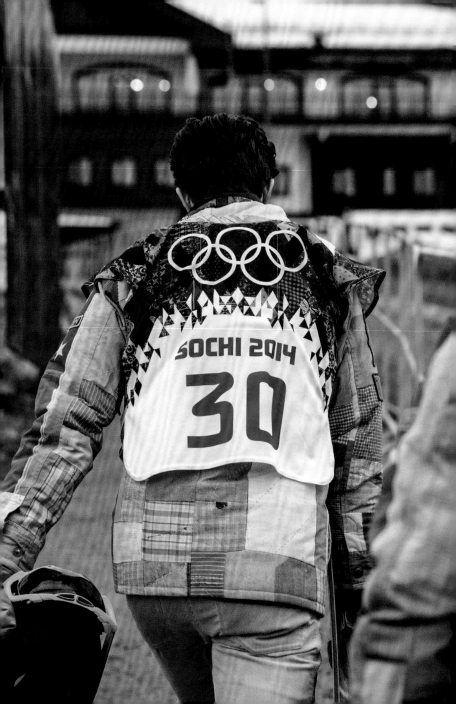

WITH KARI WHITE. ROSA KHUTOR EXTREME PARK, KRASNAYA POLYANA, RUSSIA, 2014.

PHOTO BY GABE L'HEUREUX.

This is me hanging with my family. The house that I had booked for them in Sochi wasn't finished being built, so my family ended up staying with me.

PHOTO BY G

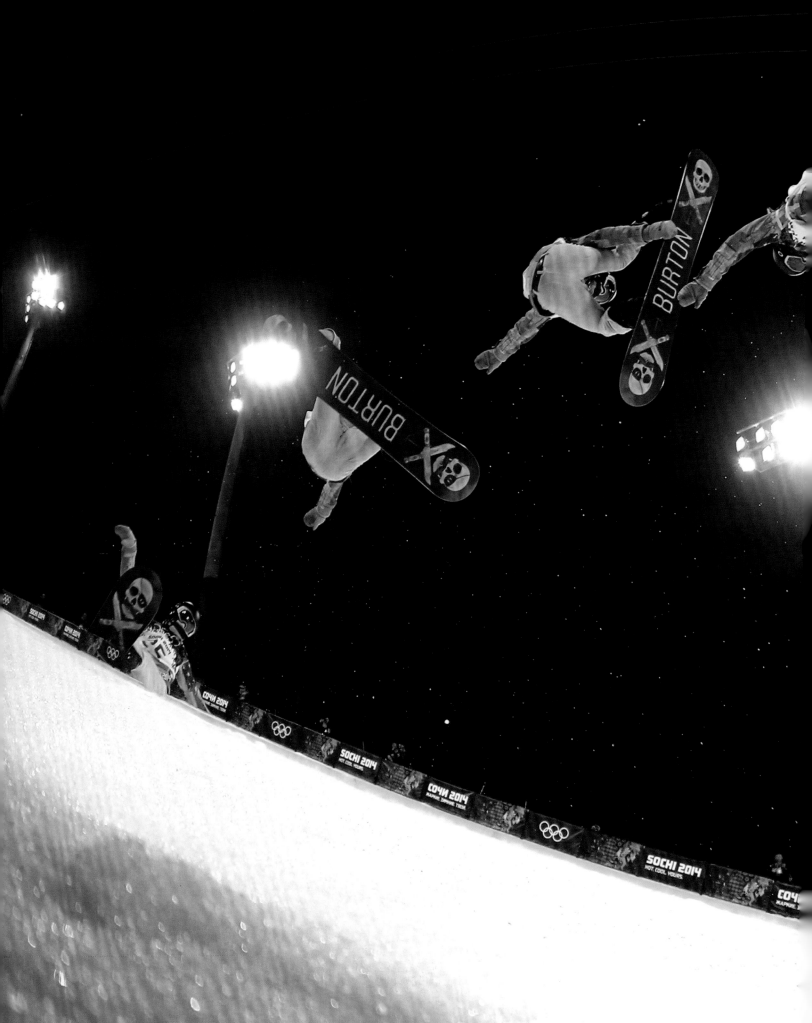

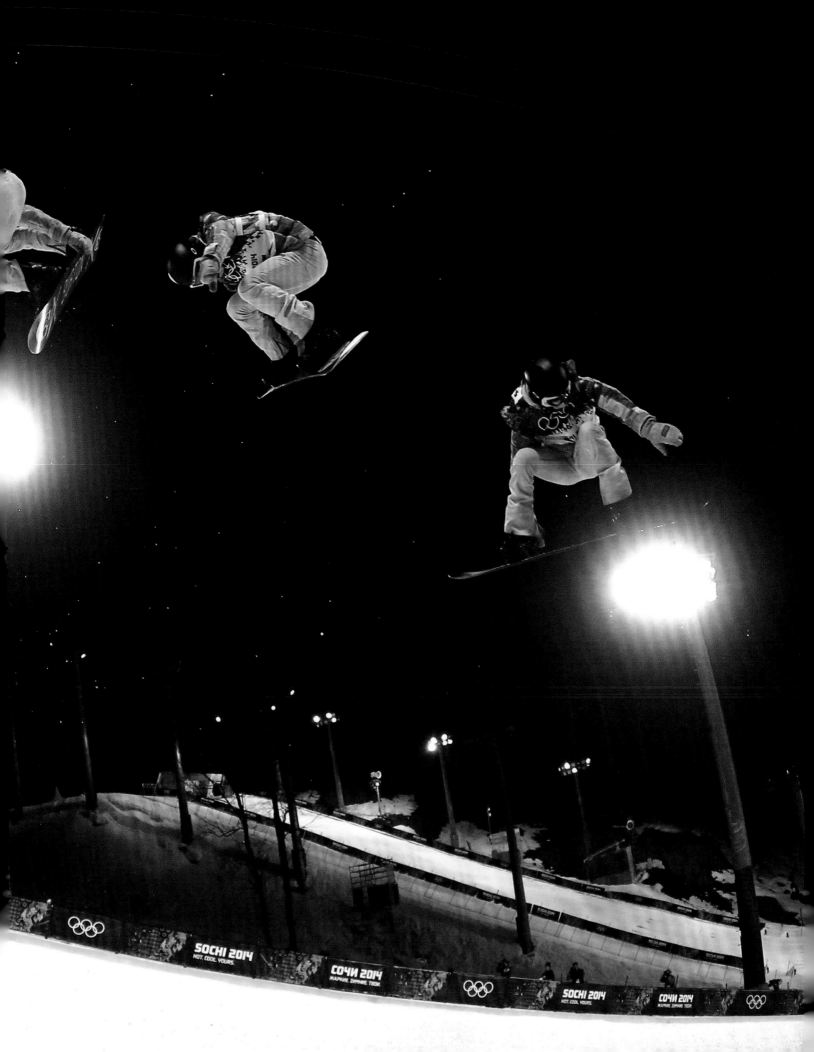

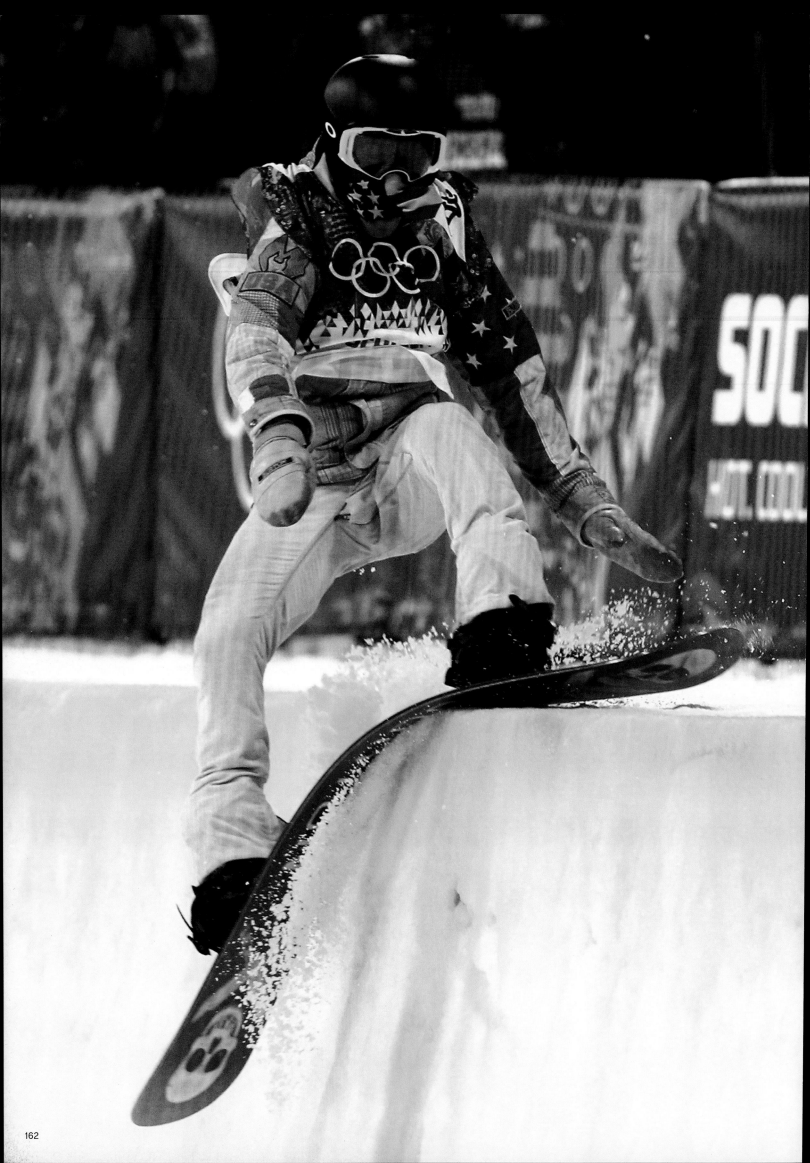

*(PREVIOUS SPREAD)* PRACTICING BEFORE
THE MEN'S SNOWBOARD HALFPIPE FINALS,
2014 SOCHI OLYMPICS, ROSA KHUTOR
EXTREME PARK, KRASNAYA POLYANA, RUSSIA.

PHOTO BY MIKE EHRMANN.

*(LEFT AND ABOVE)* MEN'S SNOWBOARD
HALFPIPE FINALS, 2014 SOCHI OLYMPICS,
ROSA KHUTOR EXTREME PARK,
KRASNAYA POLYANA, RUSSIA.

PHOTOS BY CAMERON SPENCER.

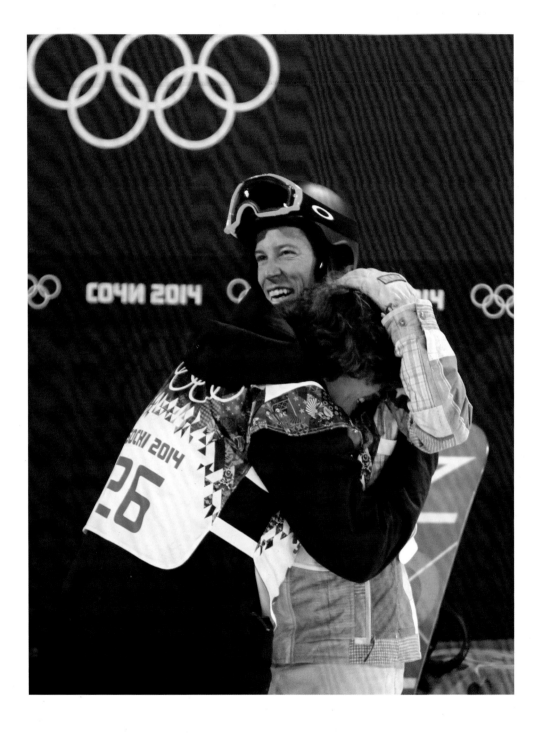

This is me hugging Iouri Podladtchikov after he won. I've always felt like this was the Olympics that slipped through my fingers, but I was still happy for Iouri. I was considering retiring after this Olympics if I won a third gold medal, but I lost and didn't want to end my career like this.

So, I had to do a lot of soul searching after this to figure out what to do next. It felt like I was running toward the finish line of a marathon, only to cross the finish, see another marathon ahead, and wonder if I had the strength to keep running.

New Zealand always felt like summer camp. It was our summer in the United States, but winter in New Zealand. It became that meet-up place for everyone chasing winter.

Besides training, we would test new boards and shoot photos for the upcoming winter-season catalogs. New Zealand is an amazing place to go snowboarding, but it's also an adventure destination. We'd always take advantage of things like swimming in the lake, bungee jumping, skateboarding, and taking little road trips. I always just seemed to have so much fun when I was down there.

# New Zealand

*(OPPOSITE AND NEXT SPREAD)* WANAKA, NEW ZEALAND, 2012.

PHOTO BY GABE L'HEUREUX.

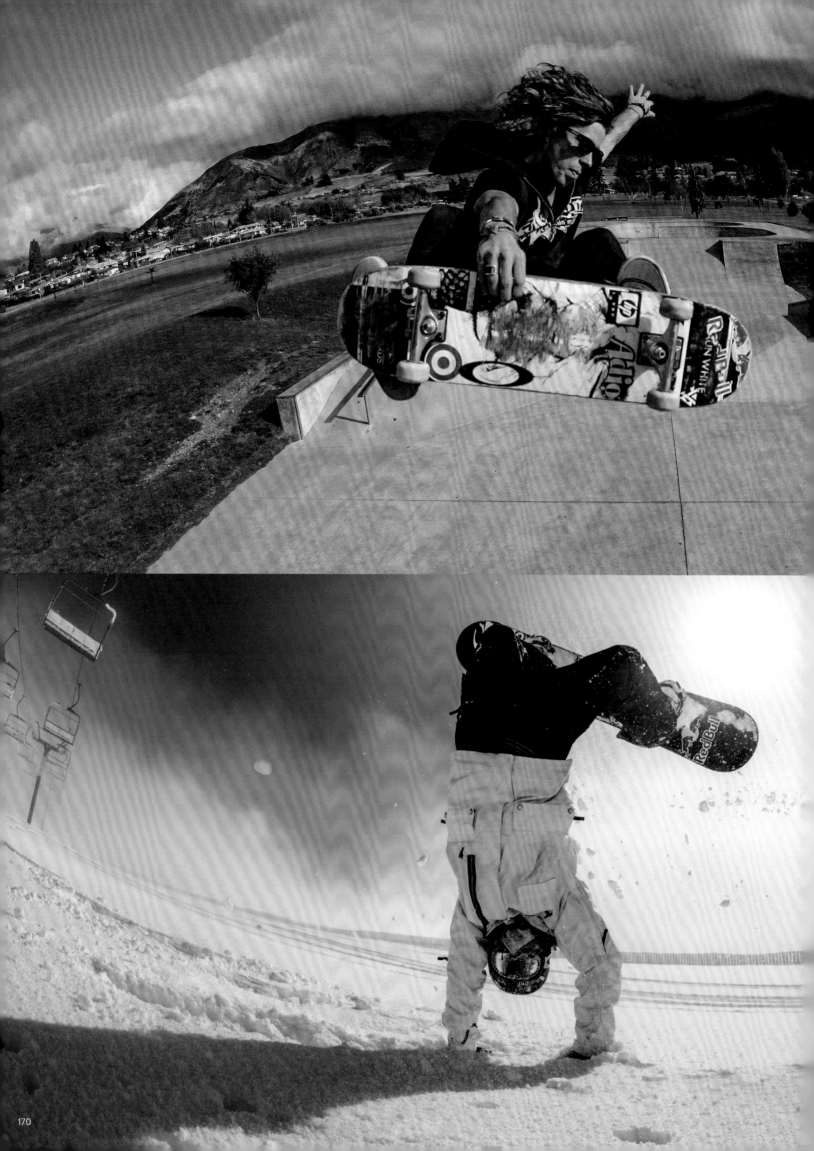

The New Zealand landscape is one of the most beautiful in the world. Every twist and turn makes you want to jump out of your car and snap a picture.

This is me and my friends heading to a waterfall we had heard about somewhere deep in the mountains. One thing is for sure: we always got the extra coverage on our rental-car insurance.

WANAKA, NEW ZEALAND, 2012.    PHOTO BY ADAM MORAN.

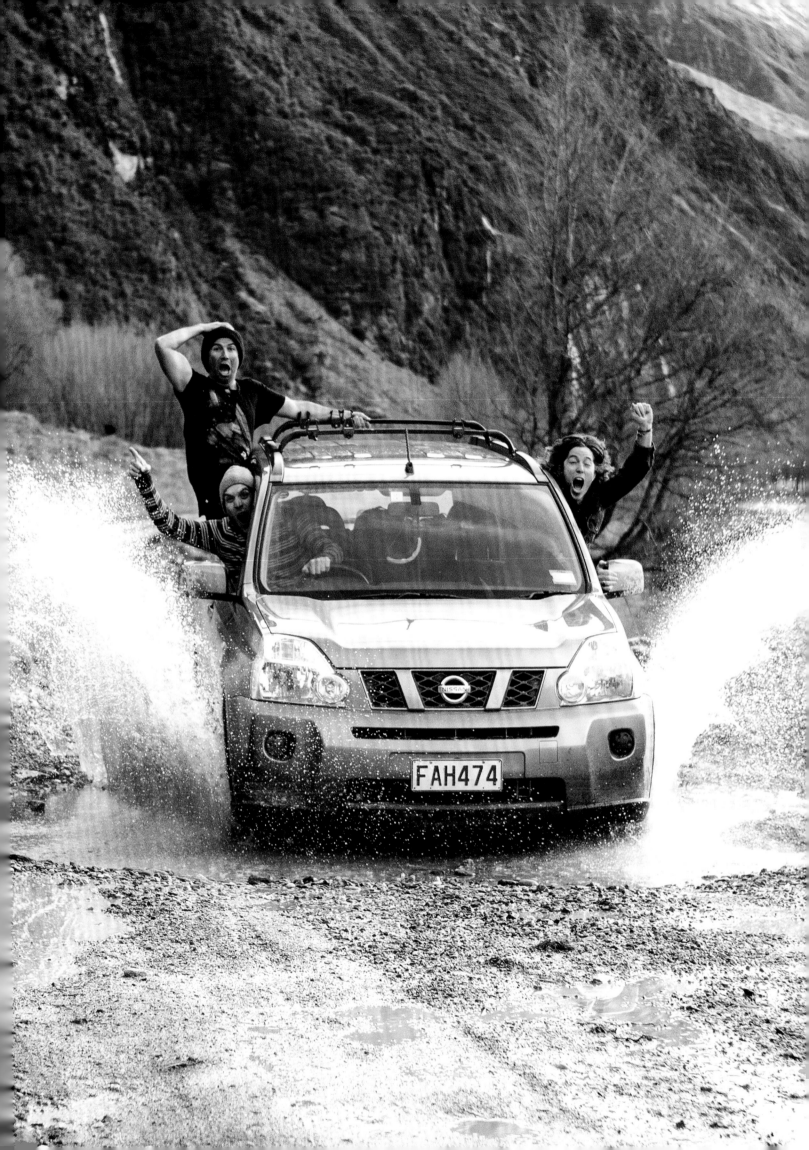

PHOTO BY GABE L'HEUREUX

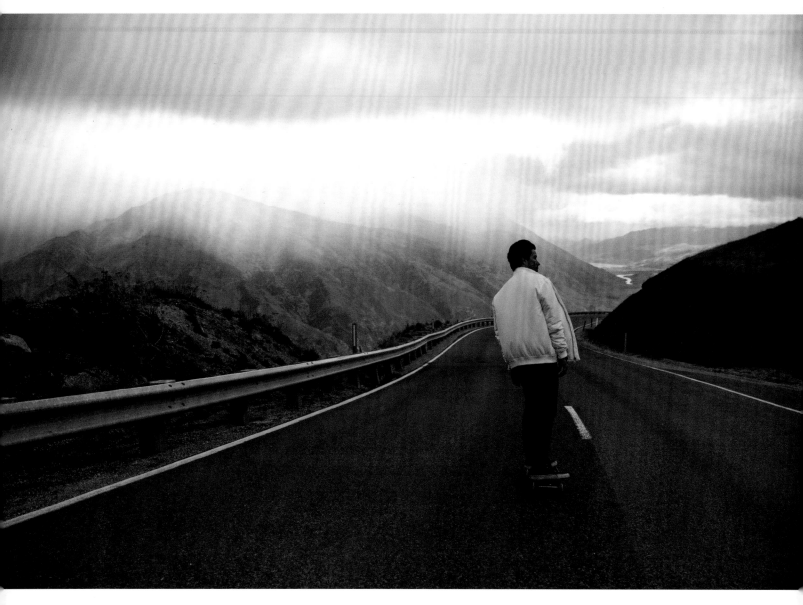

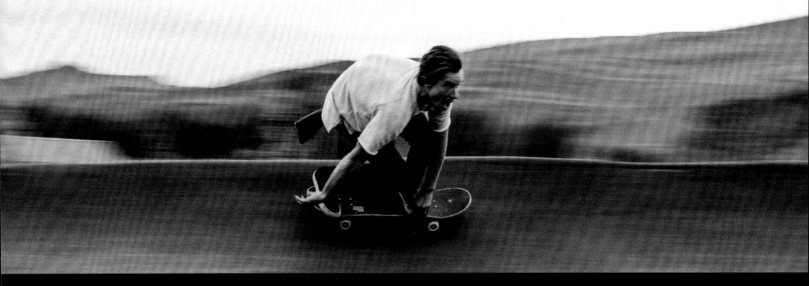

QUEENSTOWN, NEW ZEALAND, 2016.

PHOTO BY GABE L'HEUREUX

WANAKA, NEW ZEALAND, 2016.

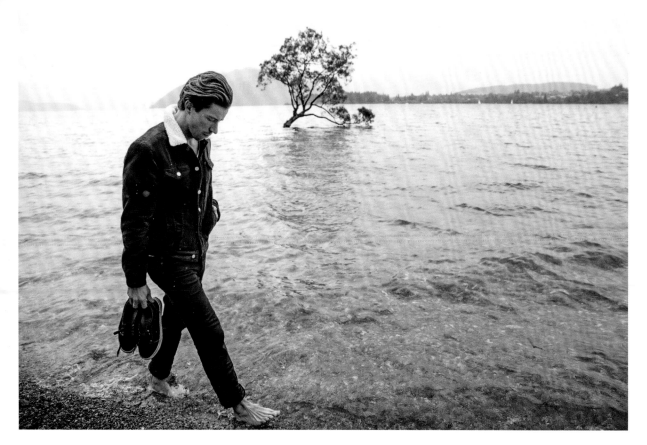

PHOTOS BY GABE L'HEUREUX.

(*Above*) This is a special spot in Lake Wanaka, where this tree is actually growing out of the middle of the lake. It's bizarre. But there's something serene about this place, and it's one of my favorites to visit.

(*Opposite*) After training, instead of doing an ice bath at the house for recovery, we would go jump in Lake Wanaka because it was freezing. JJ Thomas, my coach, made us stay in the water for a full eight minutes. The water was freezing but, more important, it was full of eels to avoid!

JJ Thomas became my coach right after I didn't medal in Sochi. He helped bring back the fun element of snowboarding that I had lost along the way. Some people don't know this, but when I was fifteen, I missed the cut for the 2002 Salt Lake City Olympics. JJ beat me by a few points for the fourth and final spot on the team and ended up getting a bronze medal. He always jokes that he was there to help me with some tough love in the beginning of my career and give me the push that I needed. He is now helping me finish my career.

(ABOVE AND OPPOSITE) WANAKA, NEW ZEALAND, 2016.

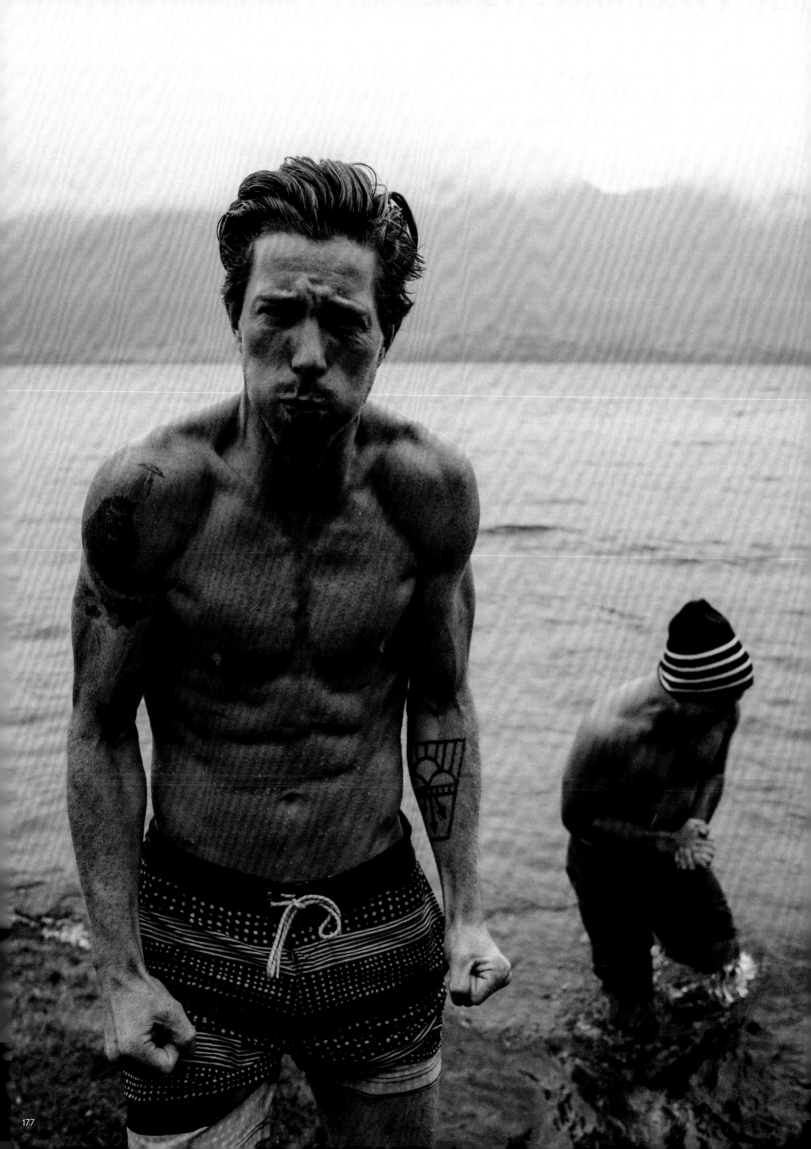

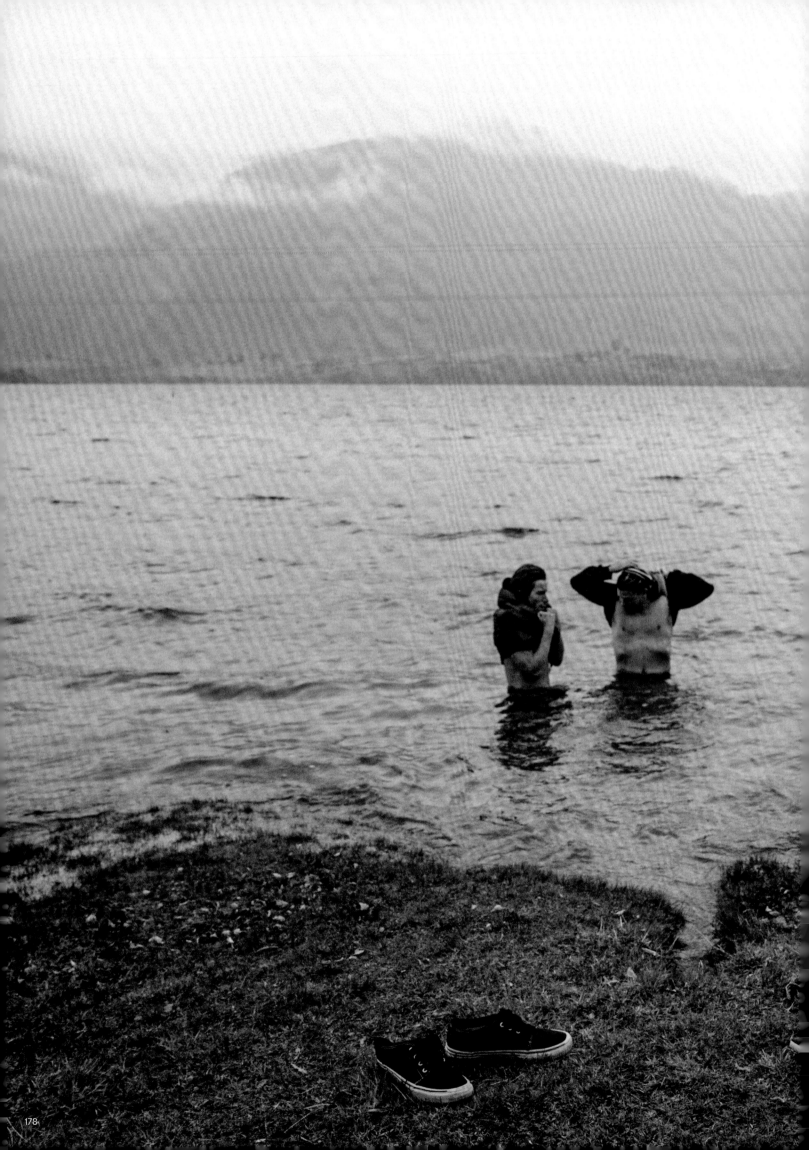

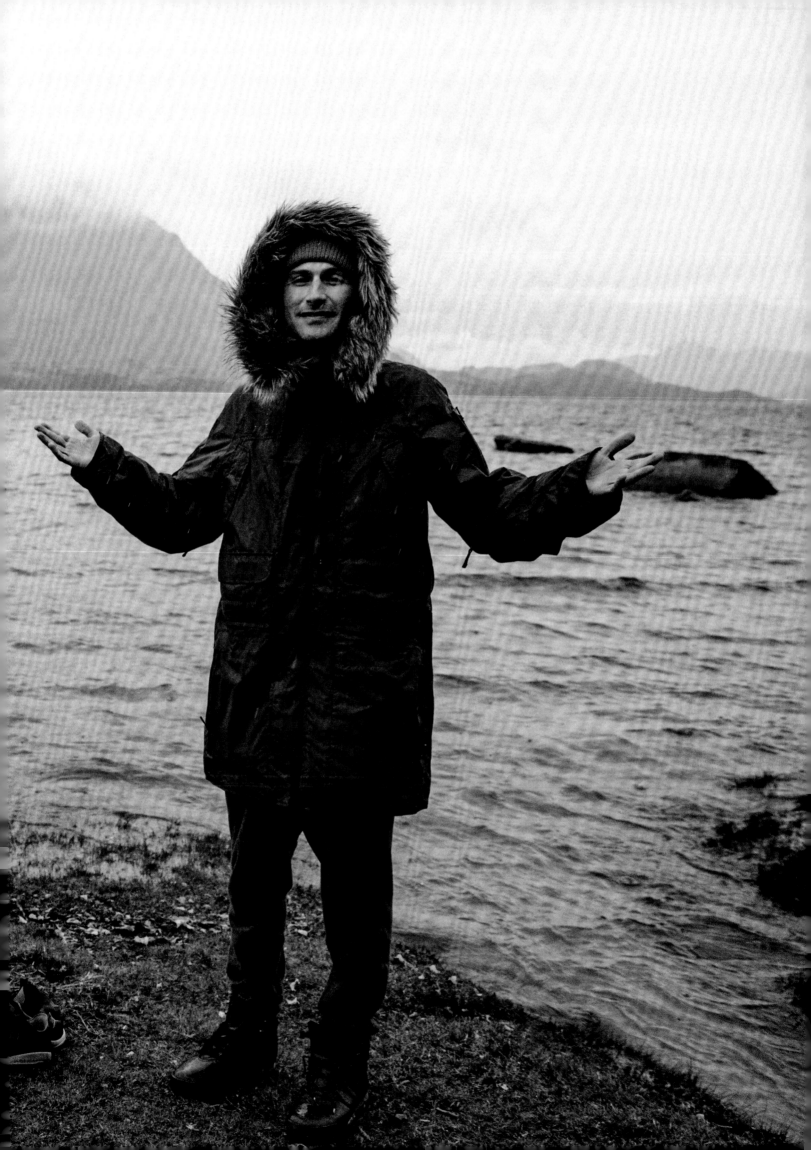

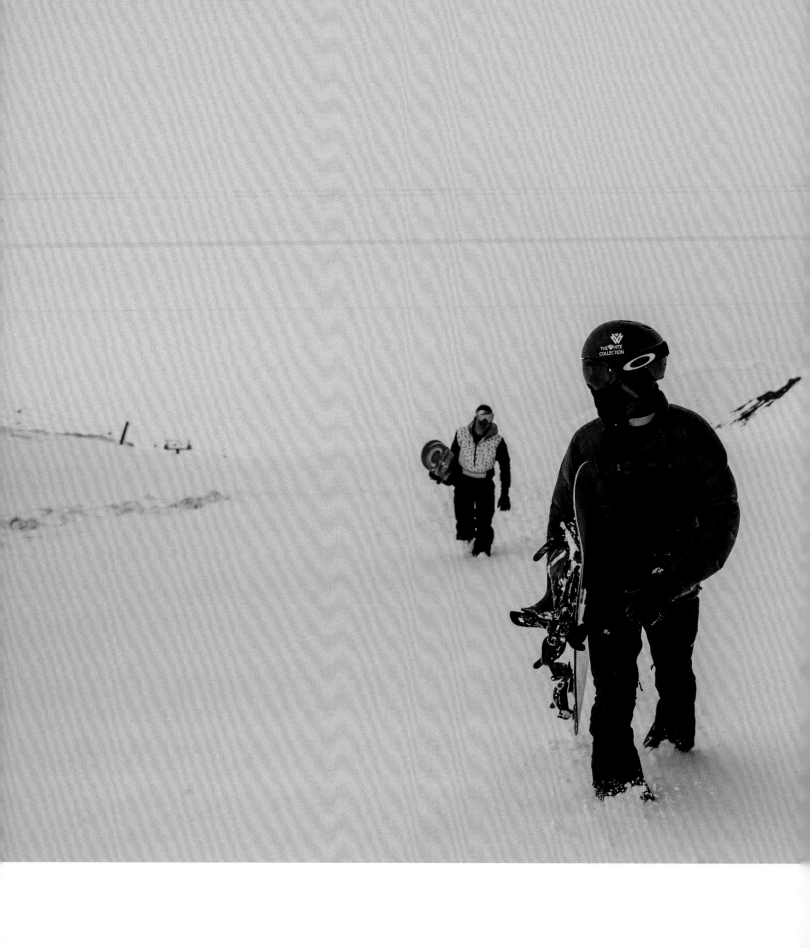

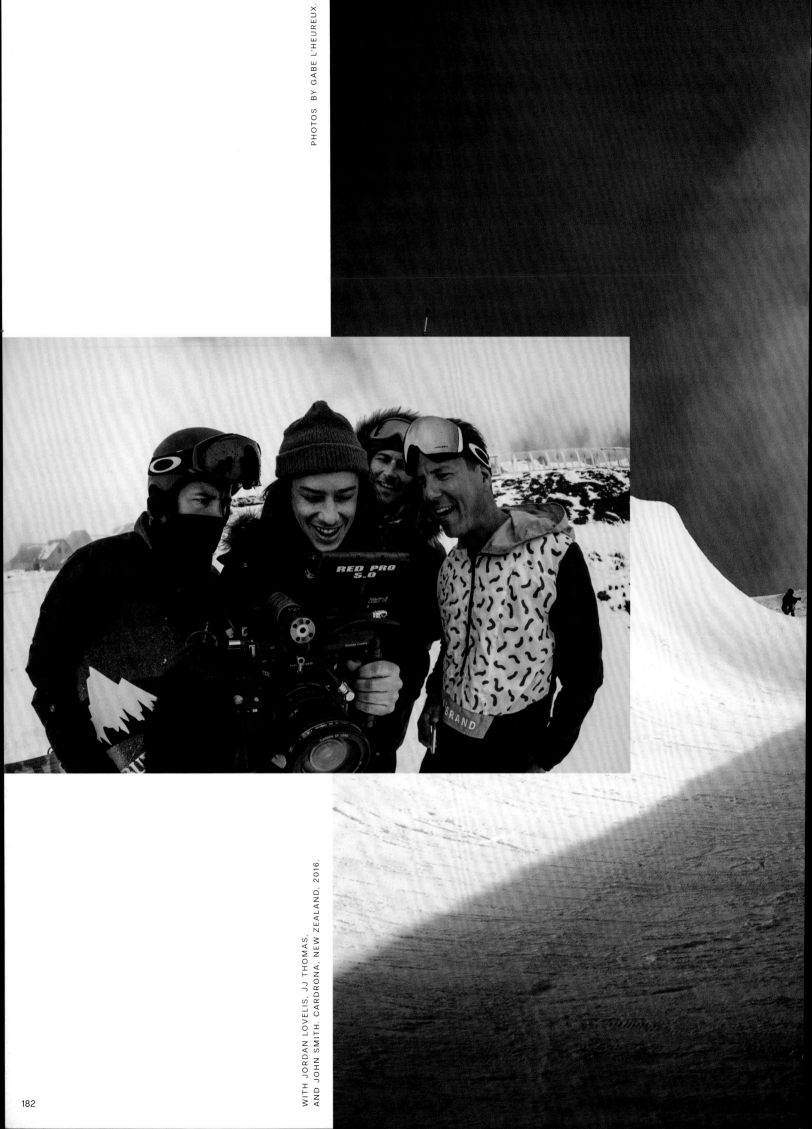

WITH JORDAN LOVELIS, JJ THOMAS,
AND JOHN SMITH. CARDRONA, NEW ZEALAND. 2016.

PHOTOS BY GABE L'HEUREUX.

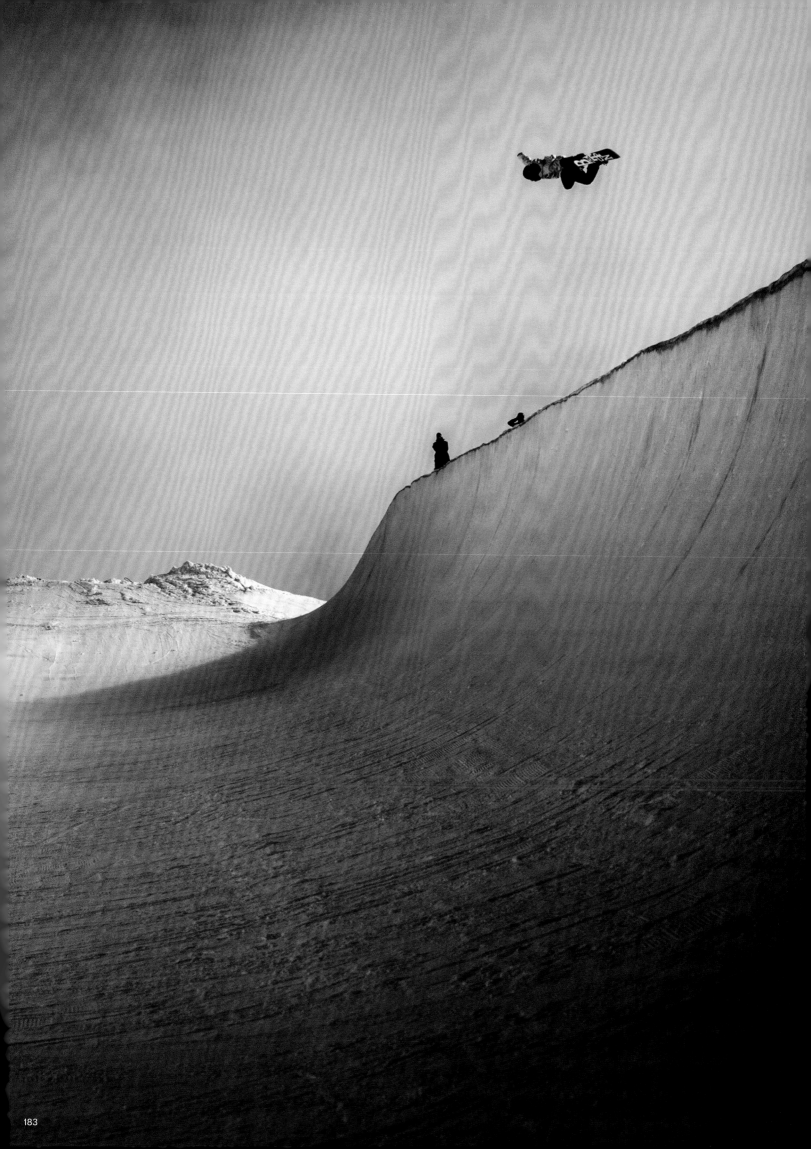

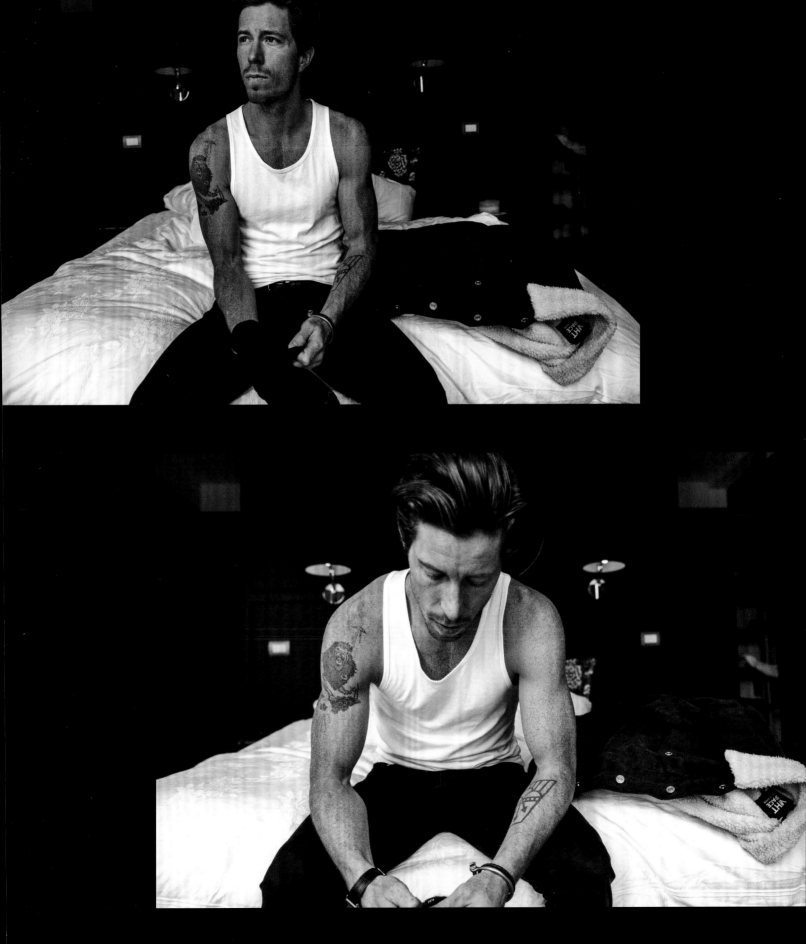

(PREVIOUS SPREAD) CARDRONA, NEW ZEALAND, 2016.

PHOTO BY GABE L'HEUREUX

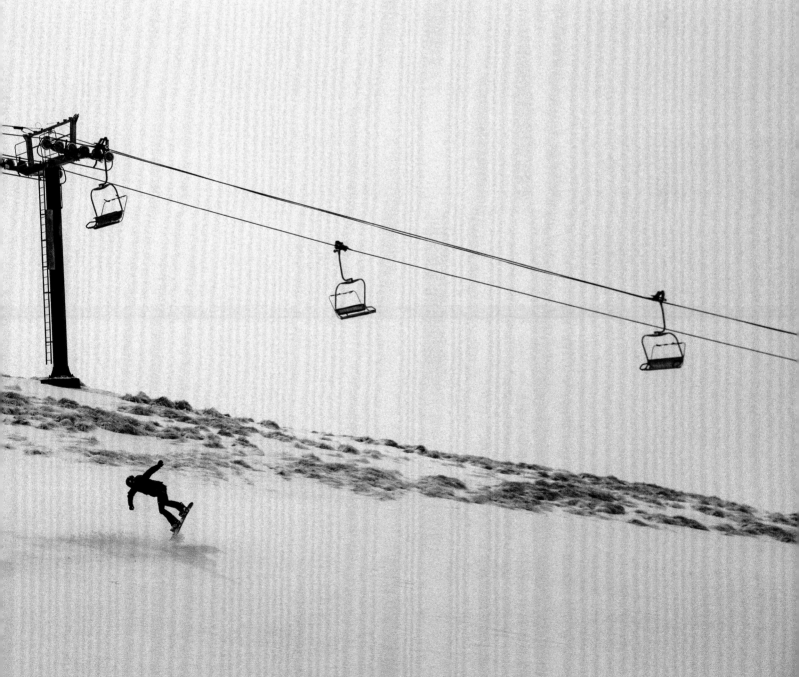

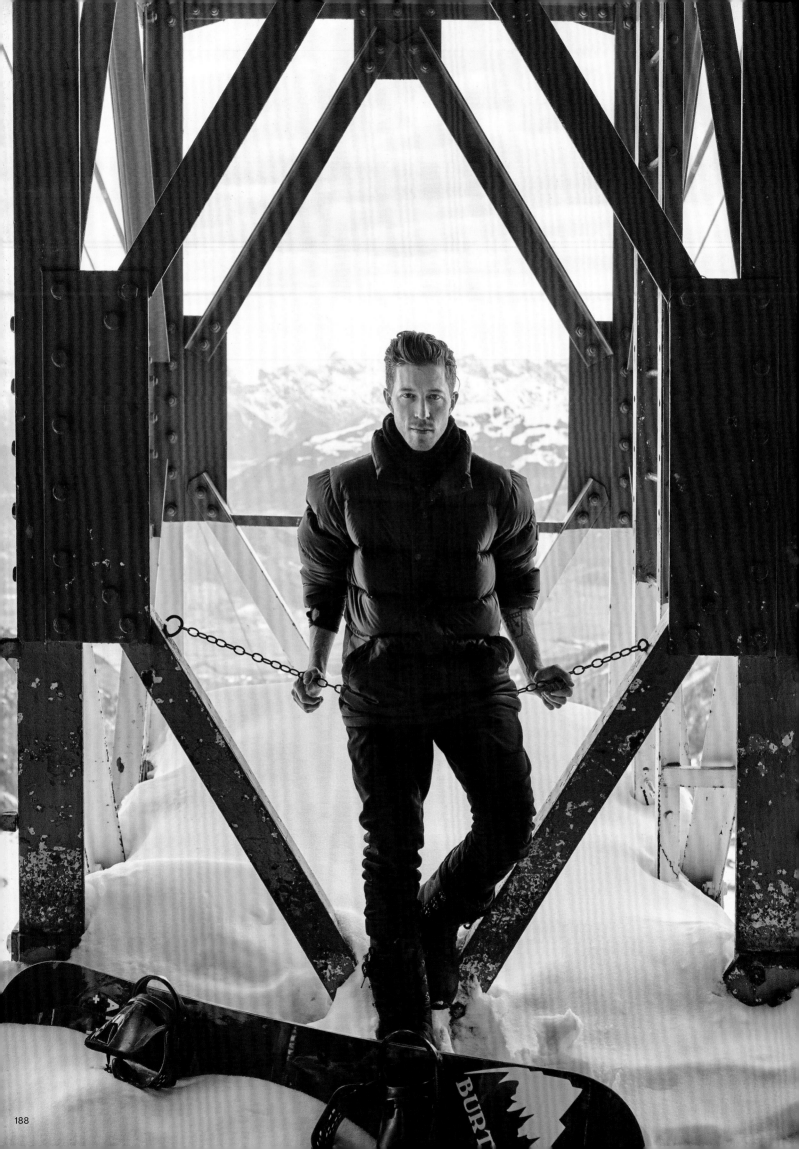

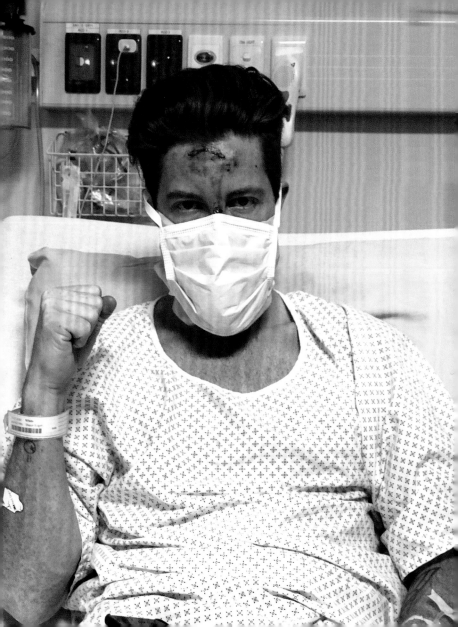

It wasn't a physical journey to get from the Sochi Olympics to the PyeongChang Olympics; it was a mental and emotional journey. At the PyeongChang Games, I knew it wasn't going to be an easy win and that I'd have to fight just to get on the podium. I loved that feeling of being back in the fight. I was fired up!

After the crash, I had made another pact with myself that I wouldn't try the Cab double cork 1440 unless it was in perfect conditions. But I kept running into all these roadblocks and never put the trick in a full run until I got to the Olympics.

So, I basically flew to South Korea thinking, "I'll just do it when I get there." Fast-forward to the contest: I'm in first place until Ayumu Hirano beats my score by one point. I'm thinking, "It's now or never. I have to do a run I've never done before with the trick that put me in the hospital in order to win it."

For my third and final run, I was the last rider to drop, and everything started to click into place. The flags were blowing to show the wind was down, a little bit of sun started to peek out, and a song came on that I recognized. Everything shifted into this sort of weird daydream. I started my run with a big first hit, and it all came down to this second move: the Cab double cork 1440. And I nailed it! After that, all the other tricks seemed to fall into place. I slid to the bottom, trying to hold my composure, and hoped for a great score.

I had probably the best run of my life. When the score came in and I had won for the third time, I burst into tears. It had all been worth it and my comeback was complete. I love looking back on this moment in my life and thinking about all the circumstances that led me to that exact moment.

PyeongChang, Korea

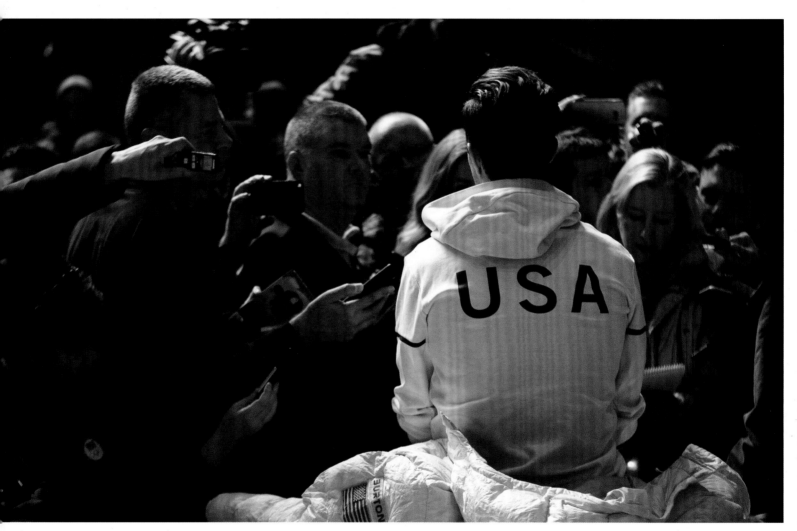

MEETING WITH REPORTERS INSIDE THE MAIN PRESS CENTRE, KNOWN AS THE MPC, AT THE PYEONGCHANG OLYMPICS, 2018.                    PHOTO BY TOBY MILLER.

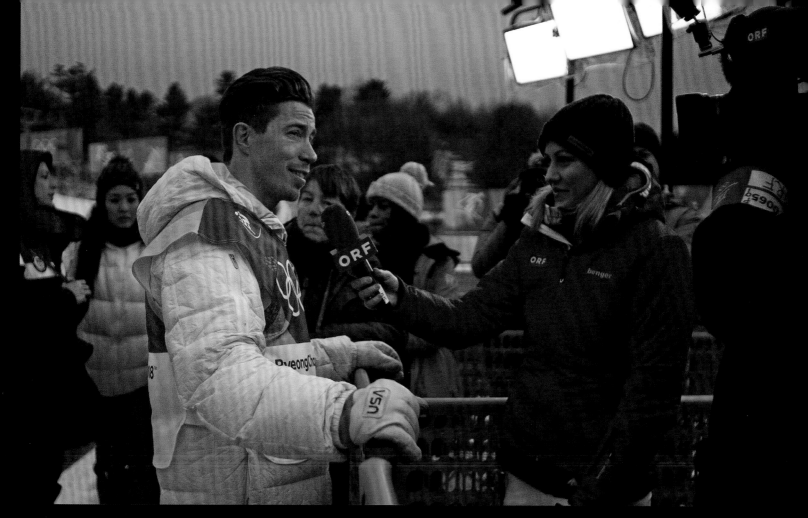

INTERVIEW WITH A REPORTER FROM ORF, THE AUSTRIAN BROADCAST
CORPORATION, AT THE BASE OF THE HALFPIPE AT PHOENIX SNOW PARK
AFTER WINNING GOLD AT THE PYEONGCHANG OLYMPICS, 2018.

PHOTO BY TOBY MILLER.

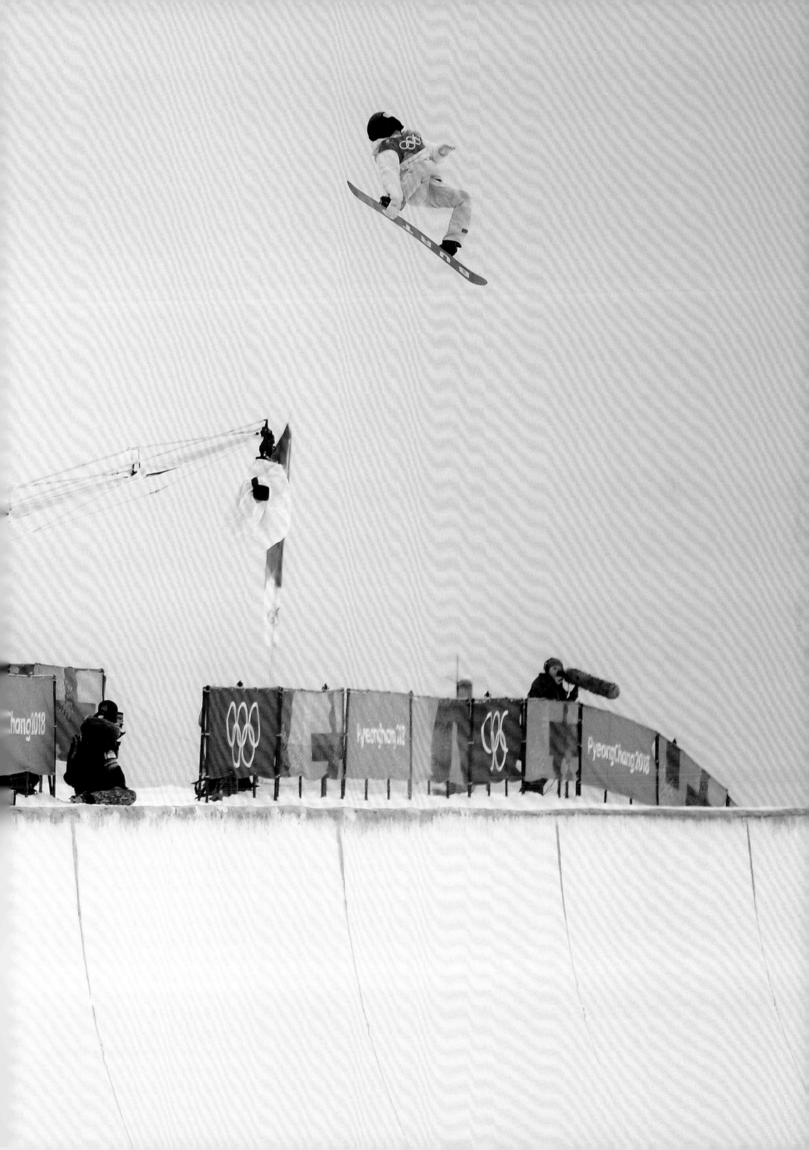

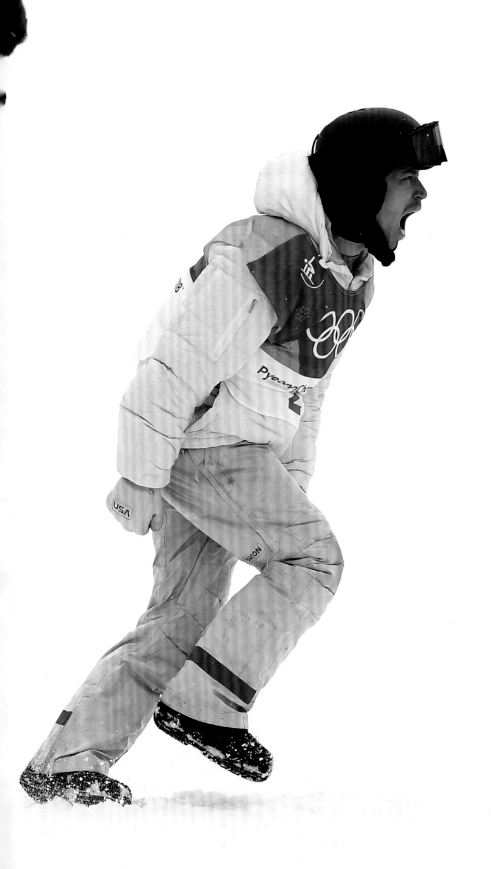

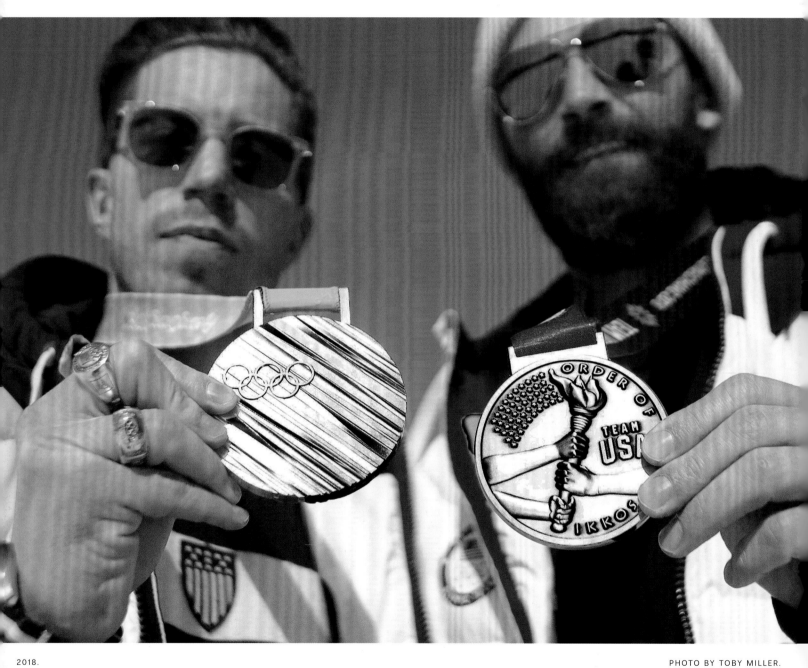

PHOTOS BY DAVID RAMOS.

This is me wearing my gold medal in PyeongChang and my Olympic rings from my previous wins in Torino and Vancouver. More important, this is just after giving my coach, JJ Thomas, the Order of Ikkos medal. It's a tradition the US Olympic and Paralympic Committee started to help athletes recognize the efforts of our best coaches, and it's named for the first known Olympic coach in ancient Greece.

It's kind of crazy to think back on all the adventures JJ and I have shared, from being competitors to his becoming one of my closest friends. This photo is a good reminder that even though snowboarding is an individual sport, it takes a team to get to the top.

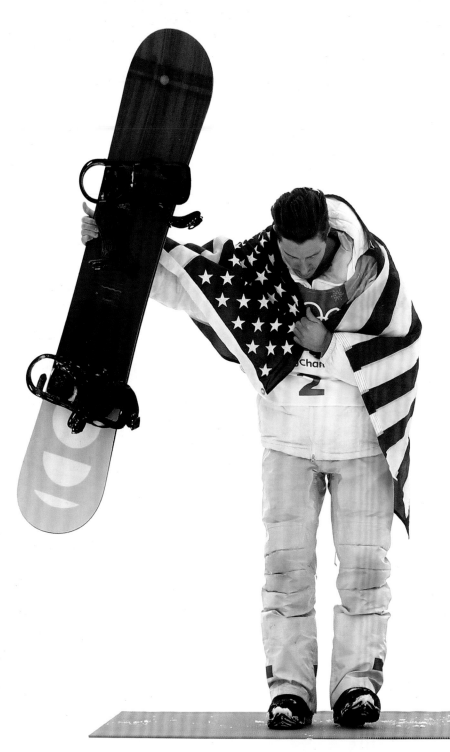

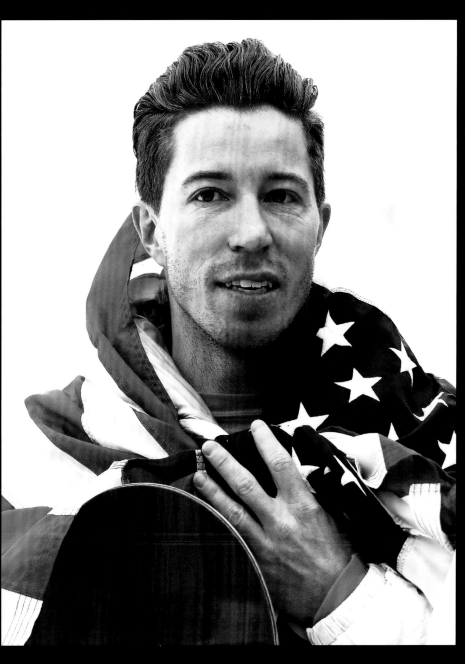

This is one of the most intense, emotional moments of my life, which I shared with Jake Burton at the bottom of the pipe in South Korea.

This man lived for snowboarding. This is so hard to even think back on now, because he passed away the following year. This was one of our last big moments together. I remember he came up to me here and said, "I'm so fucking proud of you! How do you do it? Every time! You're just incredible. I'm so proud!"

Jake was one of the originators of snowboarding. He built the sport from the ground up. He was always one of my biggest supporters, so it was always special to have him in the crowd cheering.

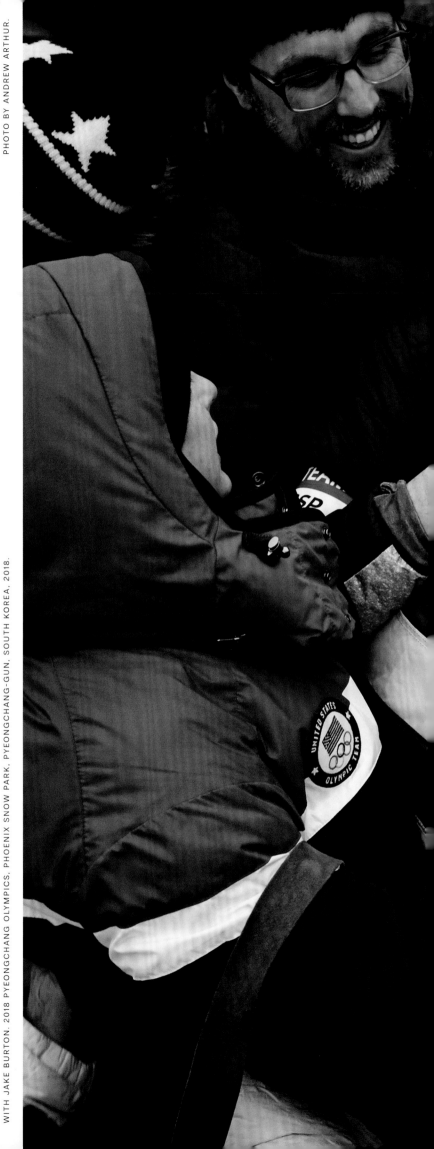

WITH JAKE BURTON. 2018 PYEONGCHANG OLYMPICS, PHOENIX SNOW PARK, PYEONGCHANG-GUN, SOUTH KOREA, 2018.    PHOTO BY ANDREW ARTHUR.

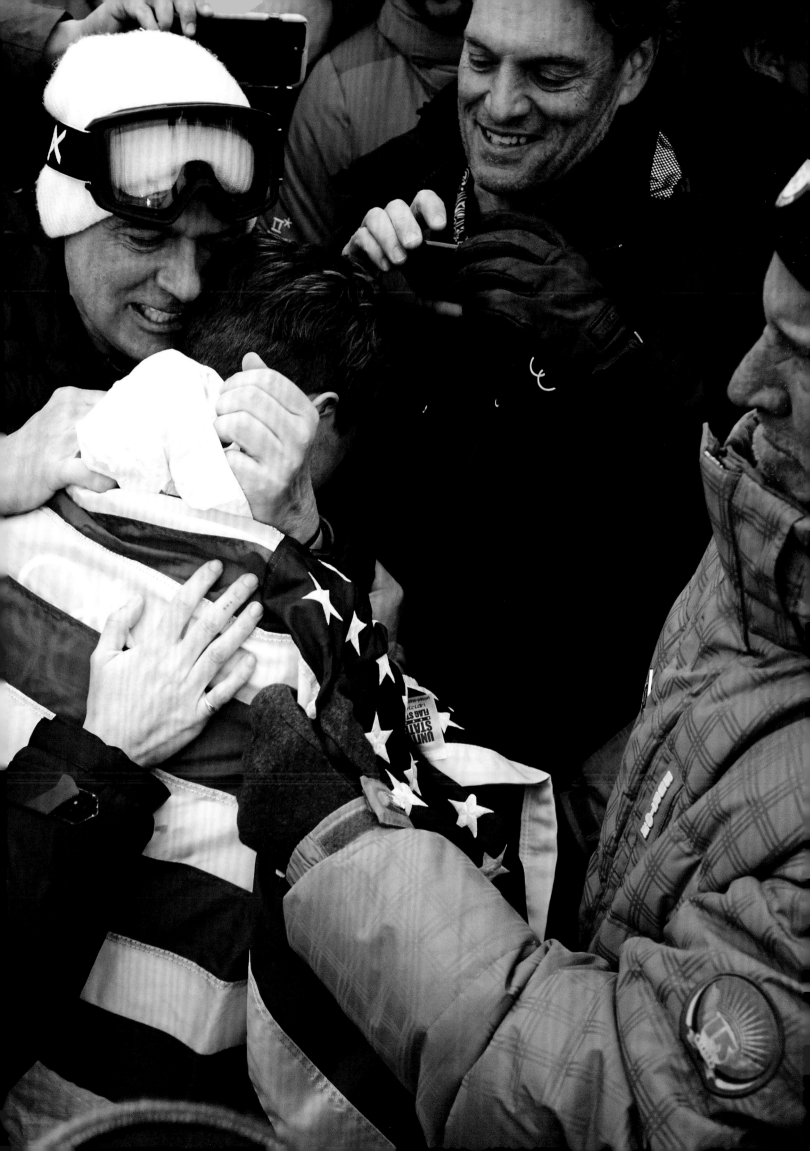

One year, I won a guitar at X Games. I kind of forgot about it until a bunch of my friends started playing, and then I thought, "Wait, I have a guitar!" It was an American-made Fender Stratocaster that was meant to be a trophy, but it was a really nice guitar.

I picked it up with the goal of learning one song, hoping maybe I could impress a few friends at a party if a guitar was in the room. I learned "Seven Nation Army" by The White Stripes. It's literally one string for most of the song. After that, I was hooked. I had always thought music was so complicated and that I would need to study and learn to read music. Learning to play guitar seemed like a daunting task. But here, within minutes, I was playing a song! It dawned on me that music isn't about being technical. It's about conveying a message or a feeling. And some of the best songs are quite simple.

I just fell in love with music and started taking a guitar with me everywhere. I'd put my small travel amp and pedals in my board bag and set up at every hotel. It became my obsession for a while and still is a big part of my life.

*(Opposite)* This is from when my band, Bad Things, played Lollapalooza at Grant Park in Chicago in 2013.

The Lollapalooza gig was especially insane because, at that point, even though I had a name as a snowboarder and skateboarder, I knew that didn't earn me any credibility in the music world. We wanted to show that we were down to hustle and ready to play whatever gigs we could get. They invited us to play Kidzapalooza, which is the family-friendly kids' stage at Lollapalooza. And what happened—it was like out of a movie—was one of the main acts on the Grove Stage dropped out last minute and the word went out: "We need a band to fill the time slot." So I said, "We're a band!" and just like that we got a huge break playing the best time slot on that stage. We went on after the band Haim and played one of our best shows. The crowd started chanting, "One more song!" It was an amazing feeling and that show opened a lot of doors for us.

(OPPOSITE) BAD THINGS PERFORMS DURING LOLLAPALOOZA, GRANT PARK, CHICAGO, AUGUST 3, 2013.          PHOTO BY SETH MCCONNELL.

204

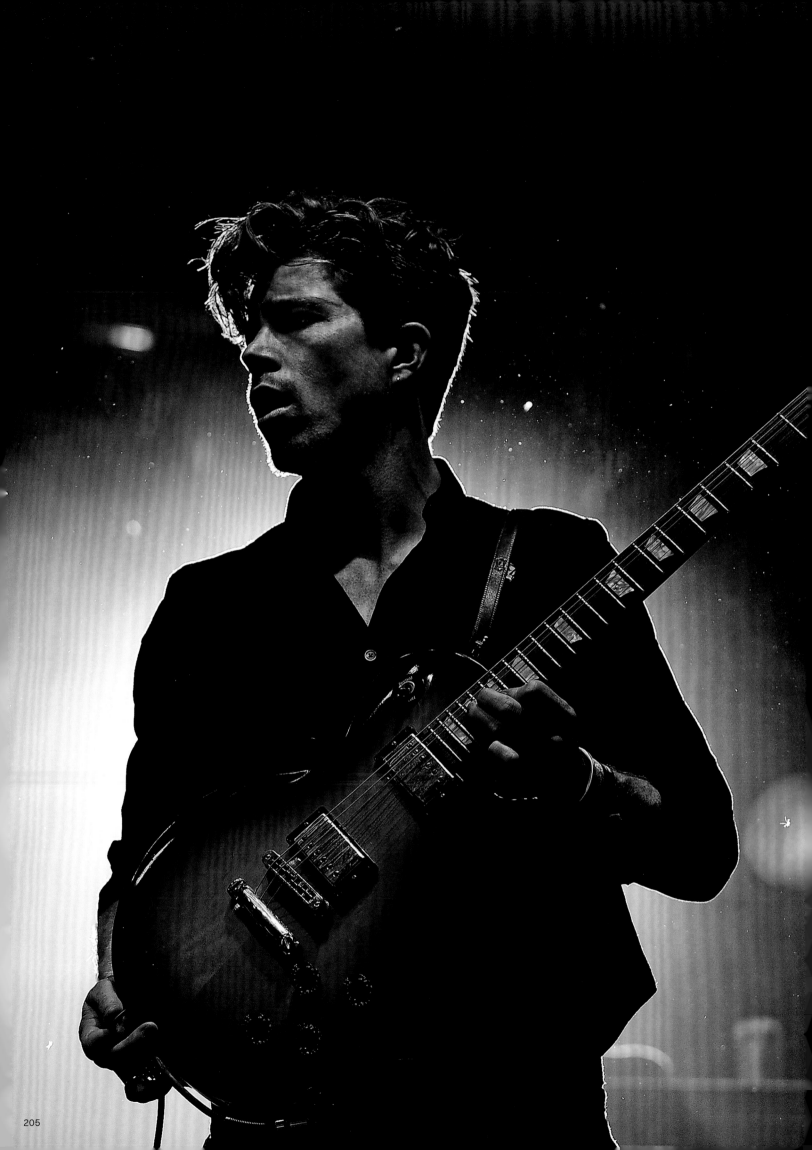

Any time I was waiting at an airport, bus station, hotel, or photo shoot—anywhere I had a spare second—I was playing guitar.

Playing guitar became an outlet from snowboarding and skateboarding because it was so unique and different. Whereas snowboarding can be isolating, music offers a lot more camaraderie. You need to come together in a joint effort to make a song. I've always loved that aspect.

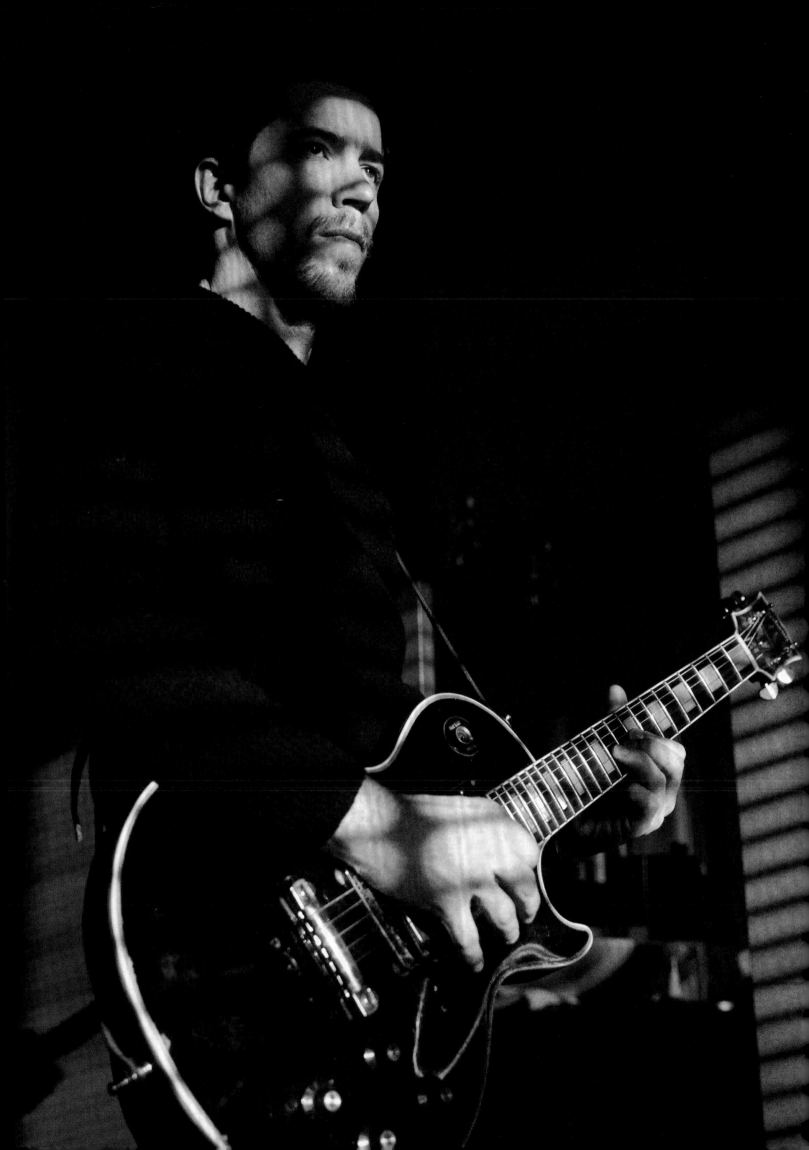

Air+Style is a great European snowboard contest series with a lot of history. After competing at the event for many years, I became its majority stakeholder in 2014, with the idea to have a bigger footprint, bigger crowds, more music, add skateboarding, and bring it to the United States for the first time as a sports and music festival. I had been an athlete and a musician, and Air+Style just seemed like a great opportunity to put all those parts of my life together into one big festival wrapped around the culture of action sports.

These pictures are from when we brought Air+Style to Los Angeles, where I got to put together a dream music lineup: Kendrick Lamar, Diplo, Phantogram, Black Lips, Metz, Steve Aoki, The Flaming Lips, Edward Sharpe & The Magnetic Zeros, Sleigh Bells, Cults, and Surfer Blood. Being able to have my whole wish list of bands, with all of my winter-sports friends, was just amazing.

BACKSTAGE AT AIR+STYLE IN LOS ANGELES, 2015.

PHOTO BY IOURI PODLADTCHIKOV.

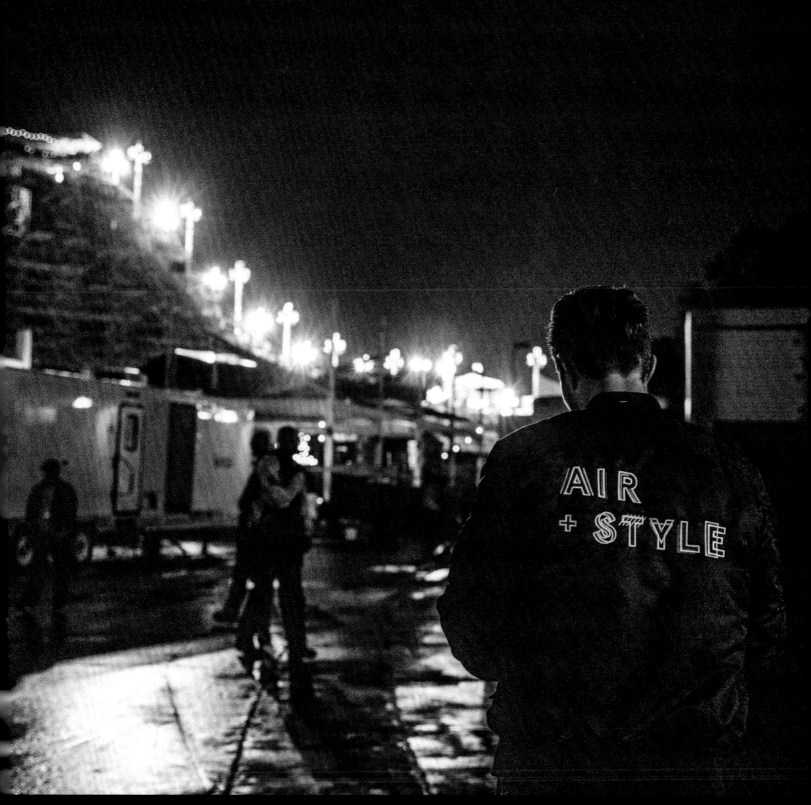

LOS ANGELES, 2017.                                                    PHOTO BY GABE L'HEUREUX.

Like everything during the pandemic, we had to shut down our Air+Style tour stops in Austria, China, and Los Angeles, but I'm working on relaunching it as the world opens up again.

(TOP) LOS ANGELES, 2018.
(BOTTOM) SARAH BARTHEL AND JOSH CARTER OF PHANTOGRAM PERFORM ON FEBRUARY 21, 2015, AT SHAUN WHITE'S AIR & STYLE MUSIC FESTIVAL, ROSE BOWL, PASADENA, CALIFORNIA.

PHOTO BY GABE L'HEUREUX.

PHOTO BY SCOTT DUDELSON.

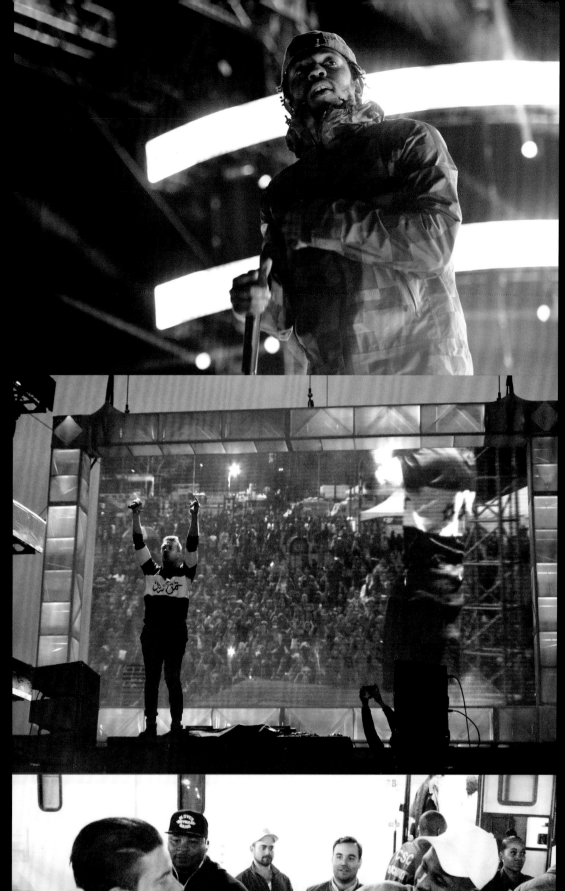

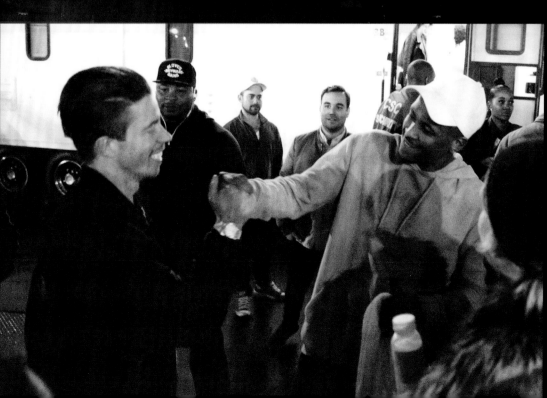

*(TOP)* KENDRICK LAMAR PERFORMS ON FEBRUARY 21, 2015, AT SHAUN WHITE'S AIR & STYLE MUSIC FESTIVAL, ROSE BOWL, PASADENA, CALIFORNIA. PHOTO BY SCOTT DUDELSON.
*(MIDDLE)* DJ DIPLO PERFORMS ON FEBRUARY 21, 2015, AT SHAUN WHITE'S AIR & STYLE MUSIC FESTIVAL, ROSE BOWL, PASADENA, CALIFORNIA. PHOTO BY SCOTT DUDELSON.
*(BOTTOM)* LOS ANGELES, 2017. PHOTO BY GABE L'HEUREUX.

After the 2018 PyeongChang Olympics, I took a year off from riding in the halfpipe. Then it turned into two years. After Jake Burton passed away, word went out that there was going to be a big tribute ride for him at the Burton US Open that next year. I showed up for Jake and got to say my goodbyes with everyone in the snowboard community. I found myself back in the halfpipe with a renewed excitement.

I decided I was still feeling solid on my board at my age, so I set out to qualify for Beijing. Then, going into my fifth Olympics, I announced it would be my final Olympics and farewell tour. After the announcement, I was able to really enjoy every single moment going forward because I knew it would be my last. The workouts, the early morning practices, the pressure of competing, the fans in the crowd—everything had an extra glow to it.

# Beijing, China

(OPPOSITE) 2022 BEIJING OLYMPICS, BEIJING, CHINA.
(NEXT SPREAD) 2022 BEIJING OLYMPICS, BEIJING, CHINA.

PHOTOS BY MIKE DAWSON.

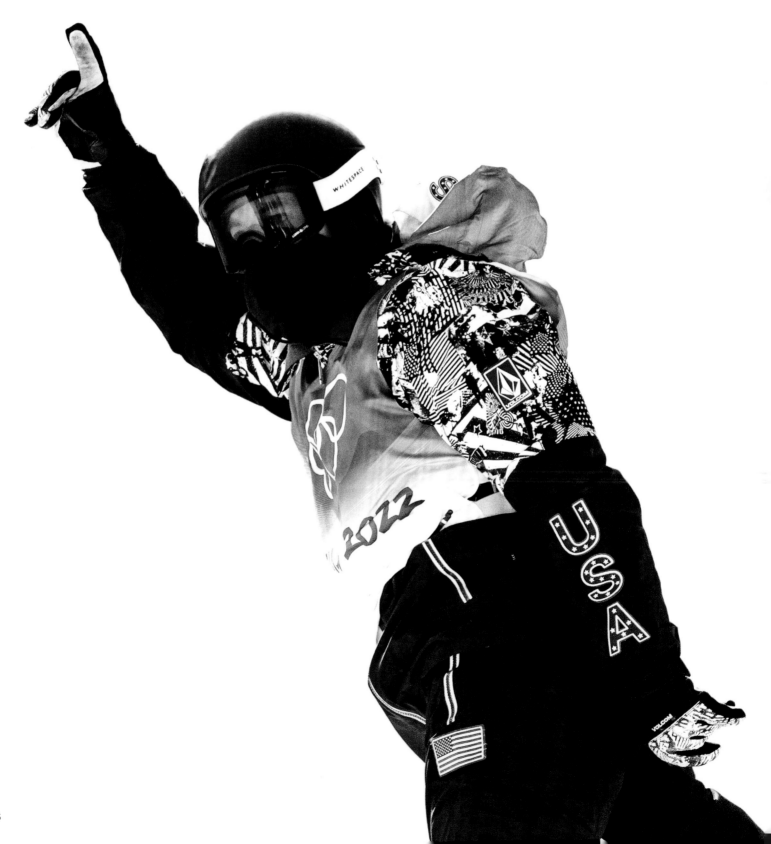

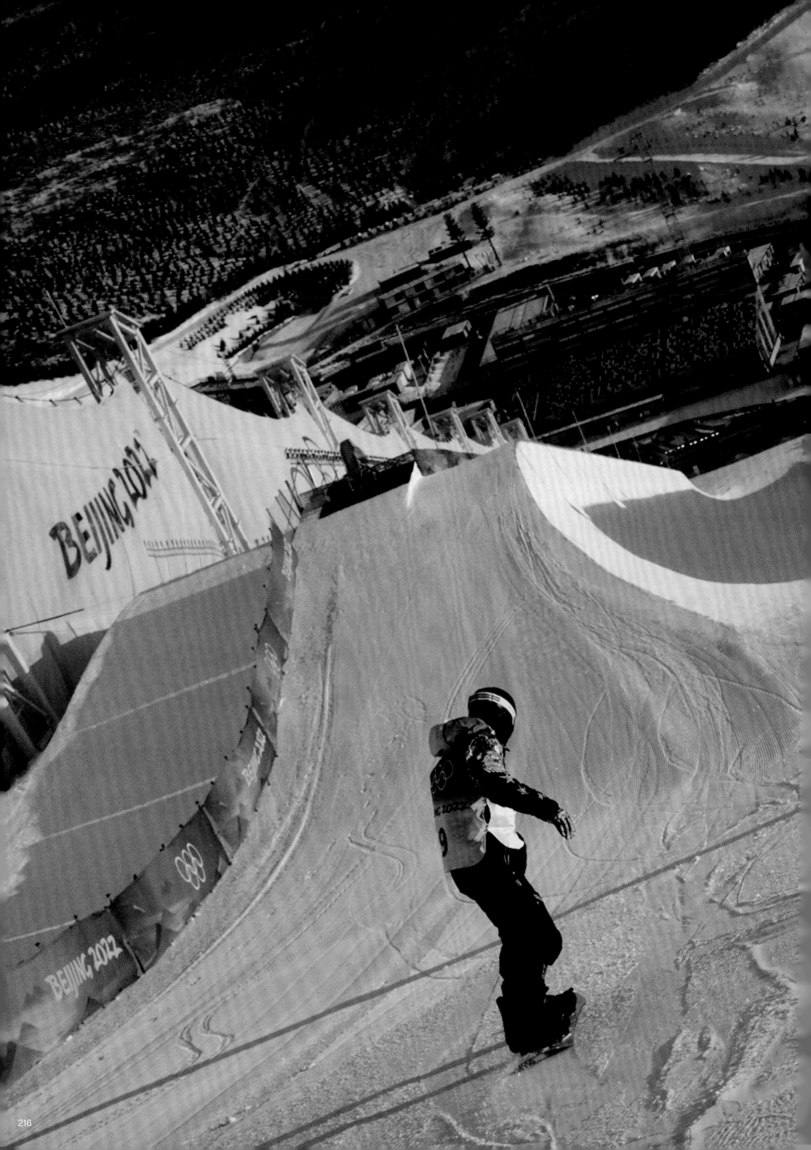

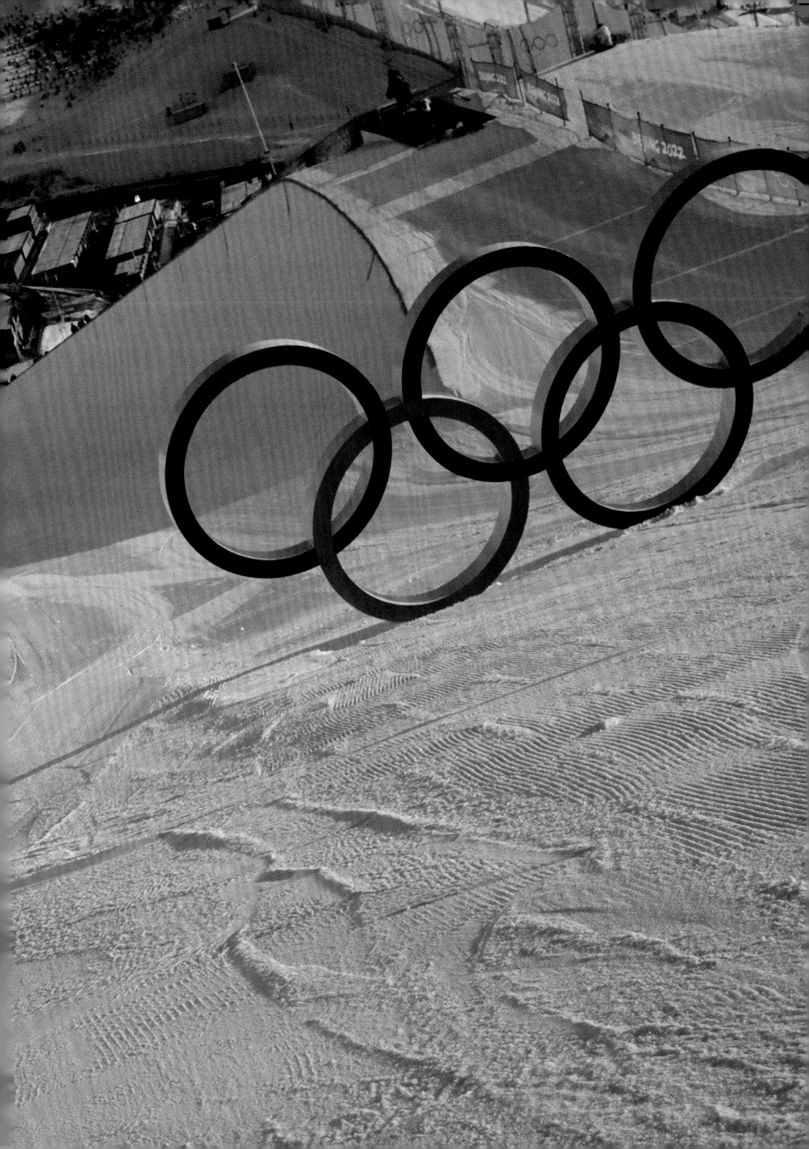

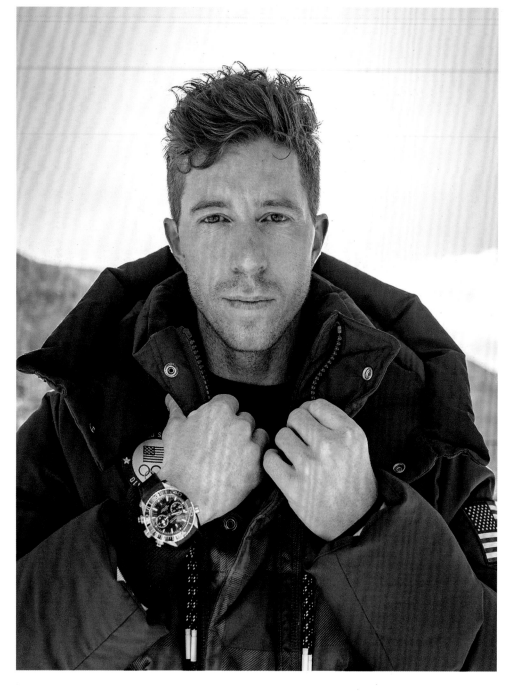

Snowboarding is such an individual sport. I almost never got to feel like part of a team. I almost never wore a uniform. Most of the time, I wanted to wear the exact opposite of what everyone else was wearing. But the Olympics, especially the opening and closing ceremonies, offers such cool opportunities to be out there rocking the red, white, and blue and just celebrating it all. It has been fun to be an Olympian among other Olympians, to represent my sport and Team USA in front of the whole world, and to see everyone else out there representing, flags everywhere, stadiums full of fans, millions of people watching at home. It's such a cool thing to be a part of that you can't help but get swept up in it all.

This photo shows me wearing the 2022 Beijing closing-ceremony uniform by Ralph Lauren for Team USA. It was a great look—classic puffer jacket with a little flannel flair. I got to model some of the team swag for a Ralph Lauren campaign before the Games, alongside Jamie Anderson and a bunch of other athletes.

There's some flexing on the wrist here too. At home, I have a whole fistful of Olympic rings— one for every finger—and three gold medals for around my neck. For my last Olympics, some gold on the wrist felt right. This is the OMEGA Seamaster Planet Ocean 600M Co-Axial Master Chronometer Chronograph—just a big ol' watch from a Swiss watchmaker that has Olympic history going back to the 1932 Los Angeles Games.

It feels unreal to me to have made it to five different Olympics over a span of twenty years and to be a part of Olympic history.

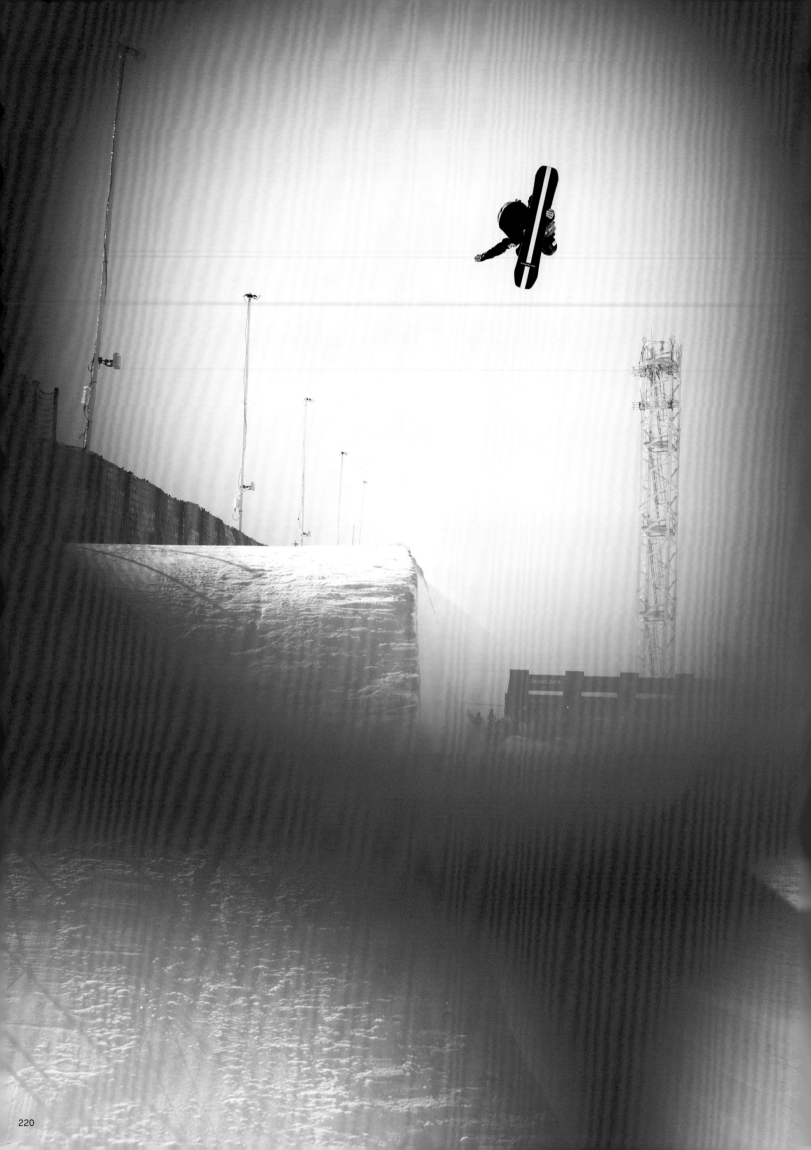

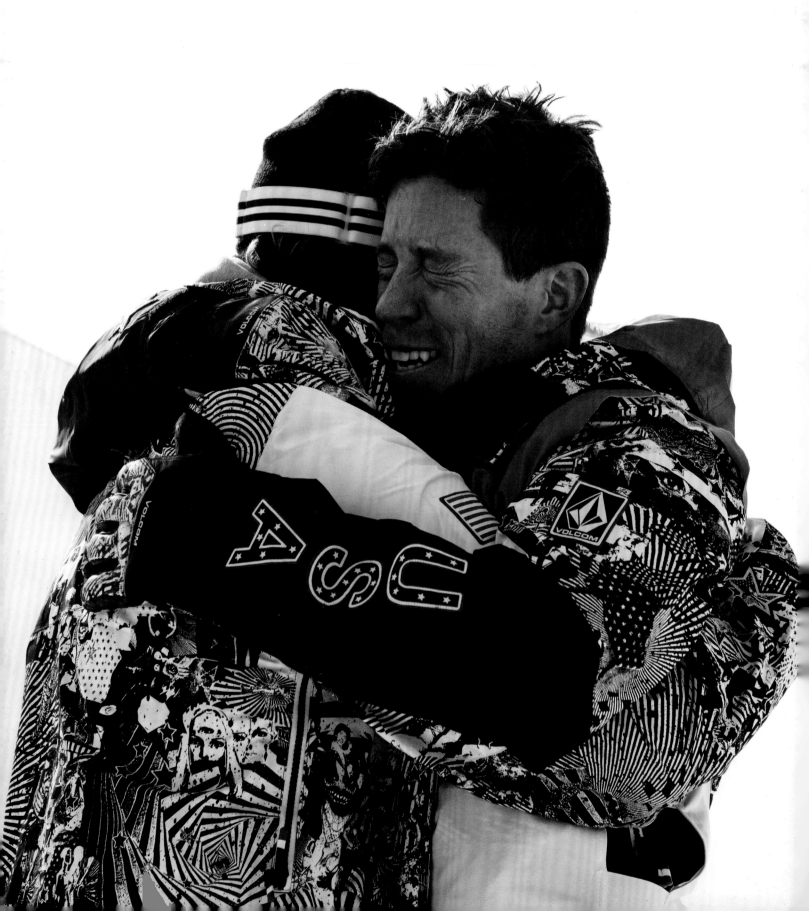

I love the emotion, intensity, and vulnerability in this photo. It's not tears over missing the podium. It's just that moment of having the feelings all at once about this twenty-five-year journey as a competitor coming to a close. I was thinking about how I had gone from being the youngest guy in the game to the oldest and how I had made it to the highest pinnacles of sport with so much to show for it. The wins, the losses, the injuries, the fans, the media—all of it.

All these memories started flooding back to me, and it was incredibly emotional saying goodbye to something that has been a major part of my life since I can remember. In a strange way, my whole career flashed in front of me, and I was just taking it all in.

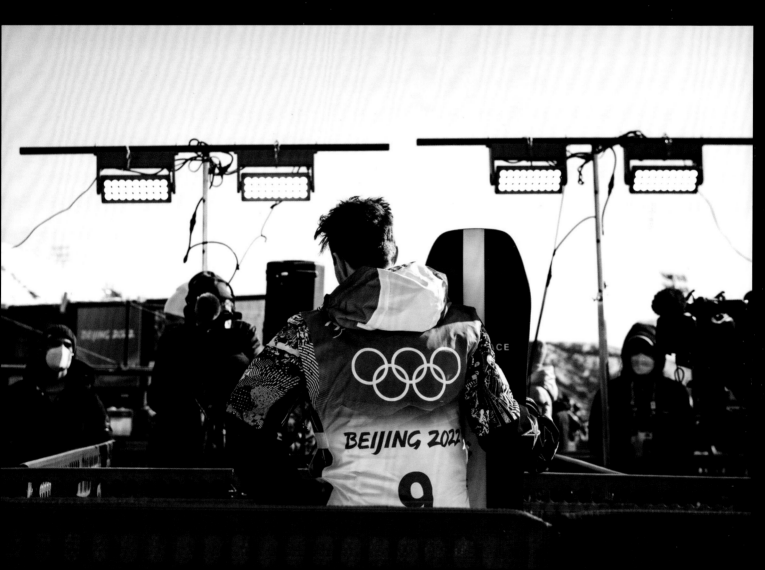

I was recently asked, "Could you imagine meeting yourself as a nine year old right now? What would your younger self think of you?" When I was nine years old, I was absolutely obsessed with snowboarding. Becoming a pro was at the top of my wish list in life. If I traveled back in time and met myself, I'd be able to say, "Hey, bud. You do it! Everything you're dreaming of, and more, you're gonna go do it."

It's a rarity to have your dreams as a kid come true, and I'm so fortunate to have accomplished that.

(PREVIOUS SPREAD, OPPOSITE, AND ABOVE) 2022 BEIJING OLYMPICS, BEIJING, CHINA.    PHOTOS BY MIKE DAWSON.

223

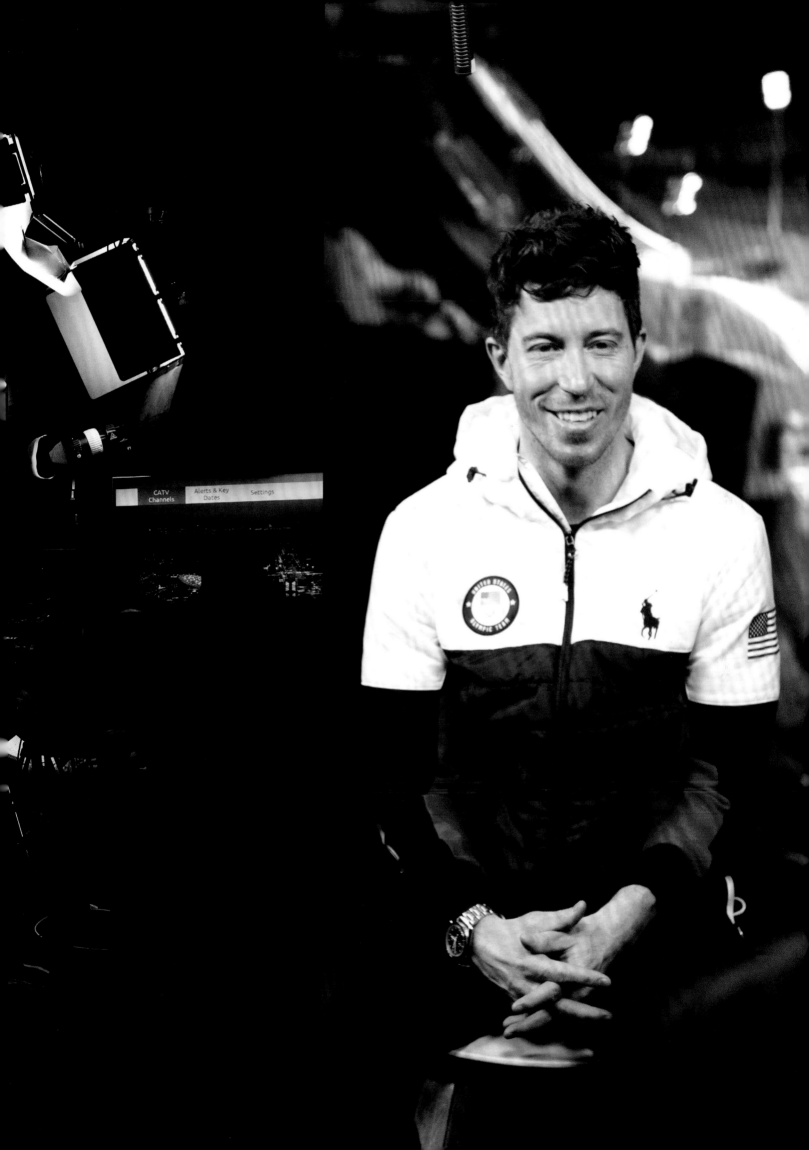

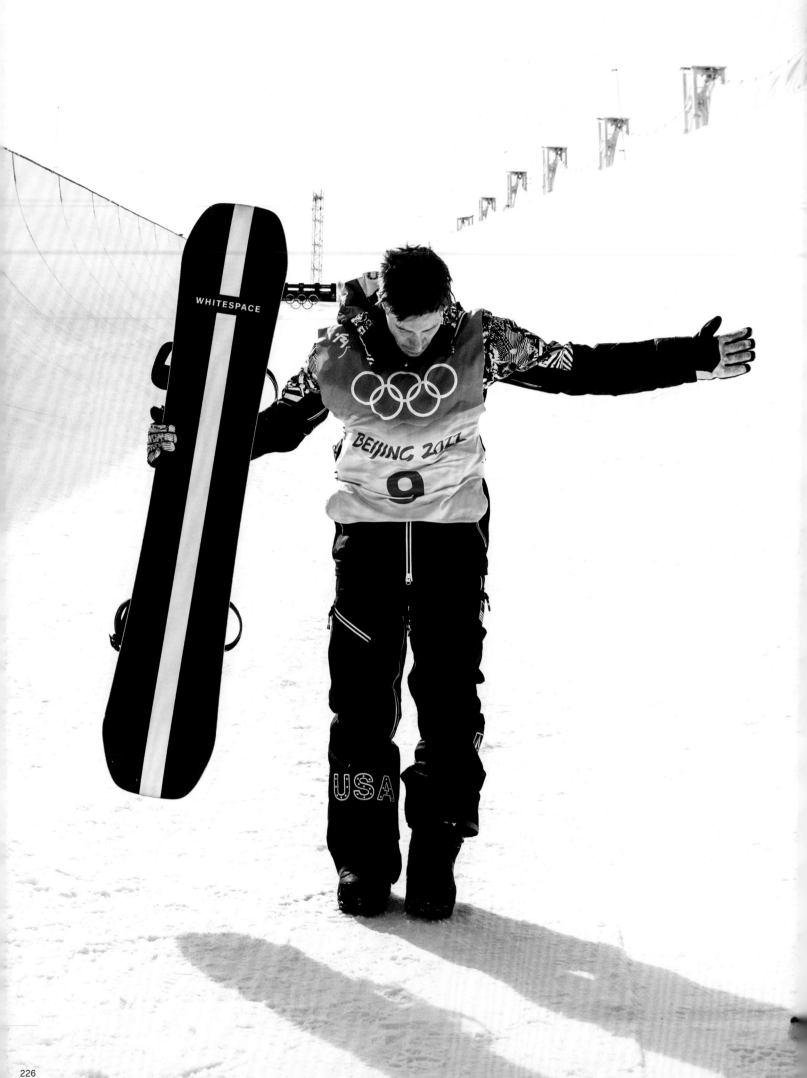

It would be impossible to articulate everything snowboarding has given me and how it changed my life forever. This photo shows me taking a moment to say thank you and goodbye.

I always tell people that my greatest accomplishment wasn't one contest or trick; it was the ability to stay at the top of a sport that is ever-changing, almost like how fashion changes overnight. Learning to navigate the waves of new competitors, trick inventions, and changes in technology within the sport, and overcoming struggles within myself are what kept me challenged for so many years and brought me all the way to my fifth Olympics.

A few months before the Beijing Olympics, I launched my own snowboarding brand, Whitespace, whose name was inspired by the board I was riding on that season. I was developing my perfect competition board with a factory in Switzerland, and I decided to take it one step further and create a line of snowboard products.

I wanted to take everything I've learned from the brands that I've worked with over the years, and all my expertise in the sport, and pour all of it into Whitespace. My goal is to inspire and mentor the next generation of riders by building a team and making products that shape the future of the sport.

When we were designing my board, the factory suggested I use an all-blacked-out base. Something about that color was running the fastest with the new waxes. I wanted something different, but I still wanted to be fast. So, early in the design process, I asked them to put a big white racing stripe down the middle so that I would stand out on the mountain and my coaches could spot me. The majority of the board would still have the fastest material.

When the name Whitespace came about, I felt it was perfect on many levels. Besides starting with my last name, it also conveys a space to be creative—a blank canvas, a gap in the market, or a void waiting for something new. And that's what my whole career has been based off of: not looking at what my competitors are doing but instead asking myself, "What are my competitors *not* doing? And how can I find my own path?"

Whitespace

(OPPOSITE) I SIGNED EACH OF THE FIRST FIFTY WHITESPACE SNOWBOARDS BEFORE OUR LAUNCH EVENT, 2022.
(NEXT SPREAD) COPPER MOUNTAIN, COLORADO, 2022.

PHOTO BY WHITESPACE.
PHOTO BY MIKE DAWSON.

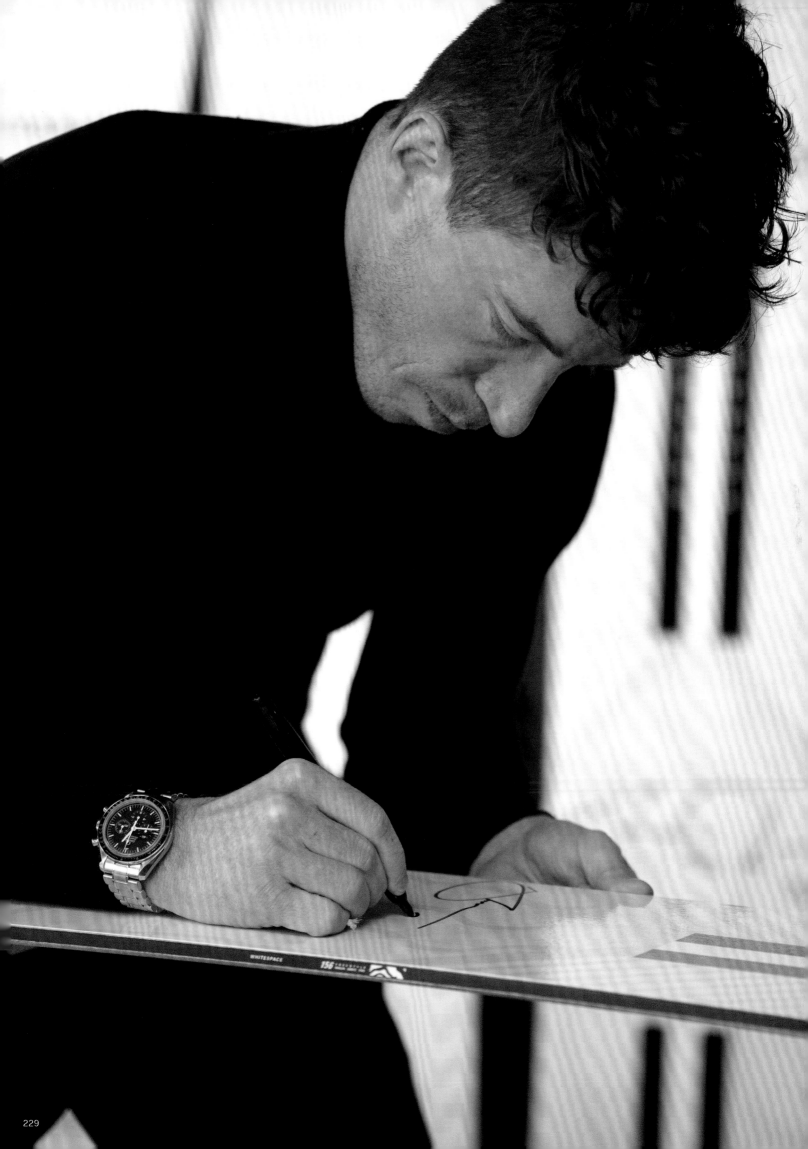

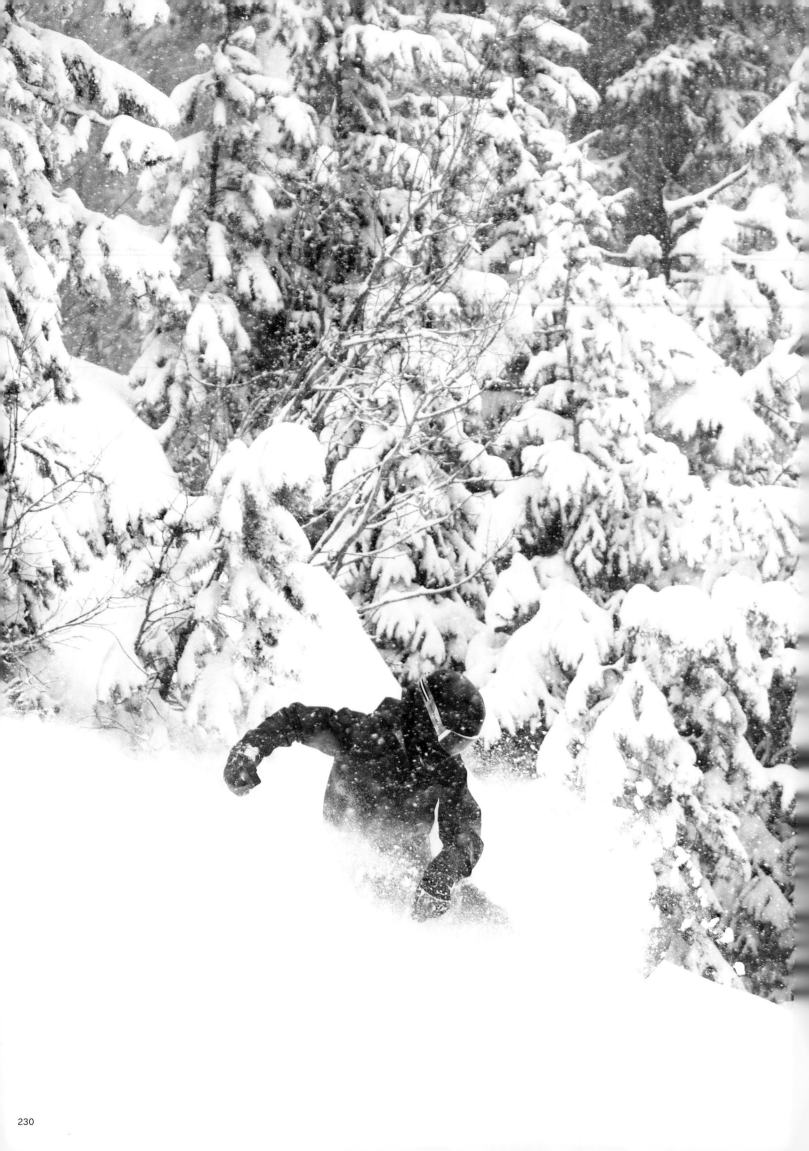

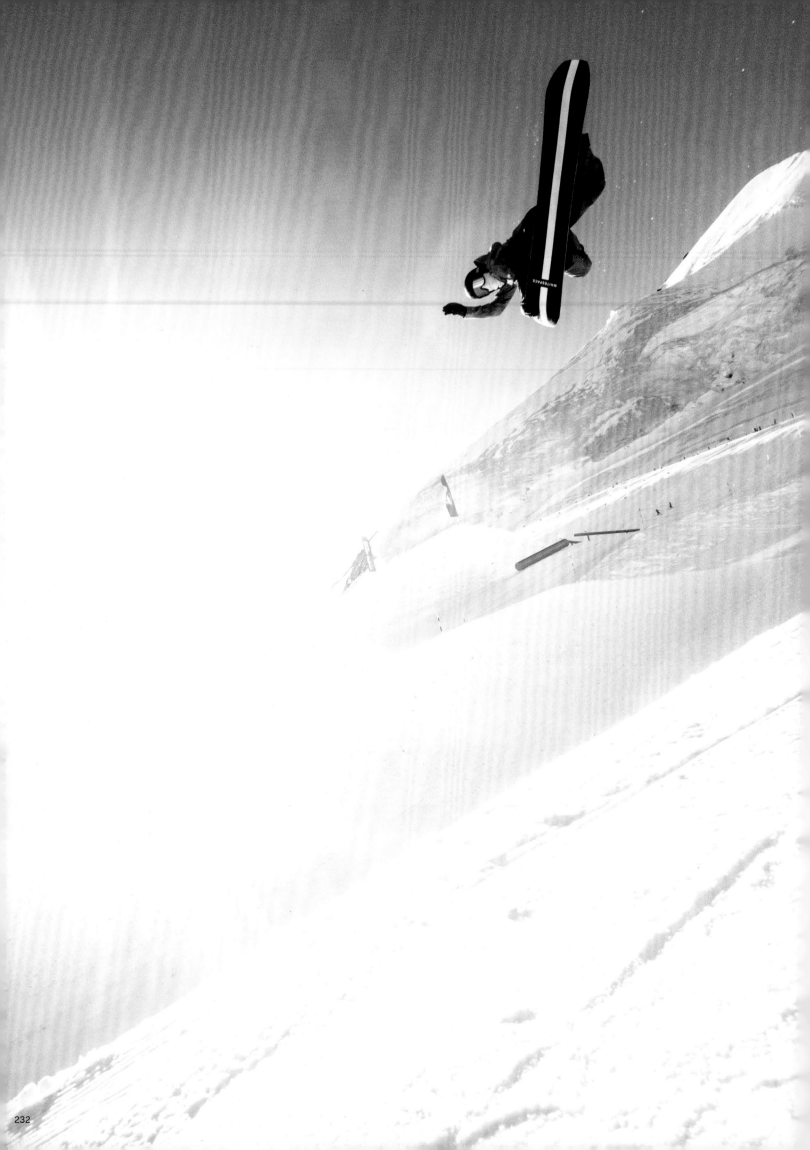

COPPER MOUNTAIN, COLORADO, 2021.

234

SAAS-FEE, SWITZERLAND, 2022. PHOTO BY MIKE DAWSON.

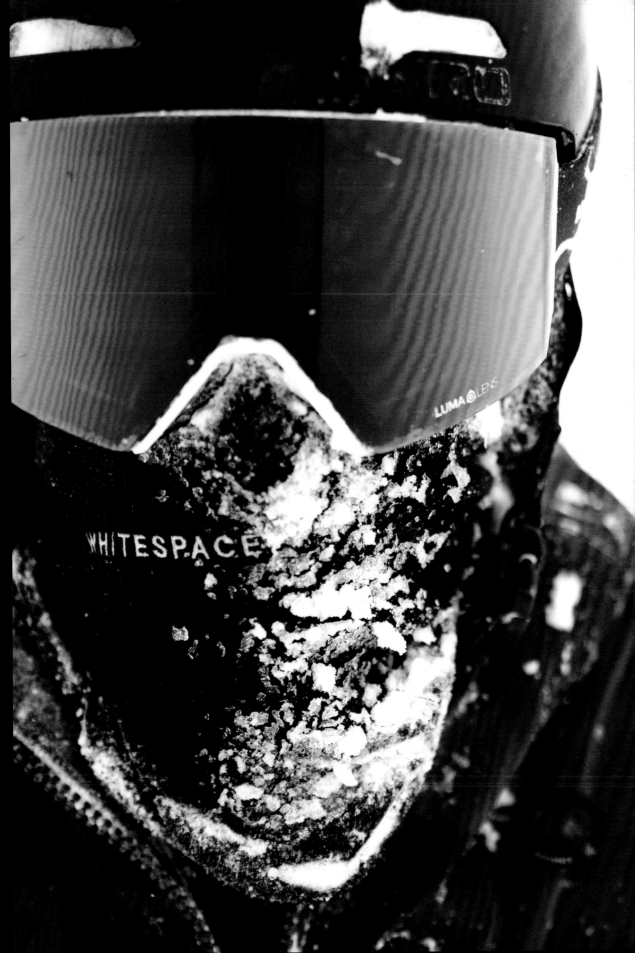

WHITESPACE

LUMA LENS

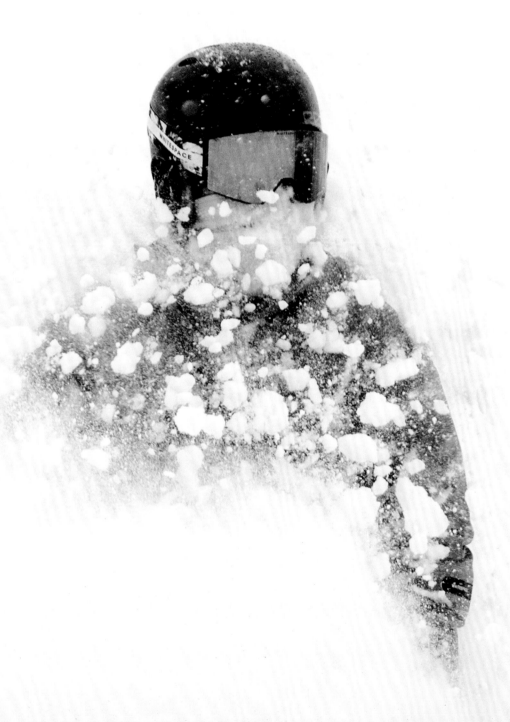

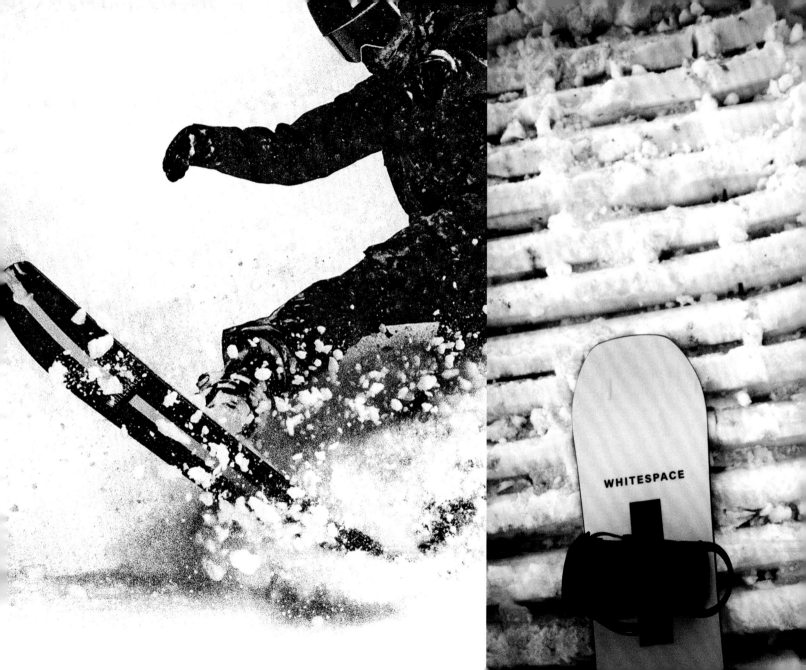

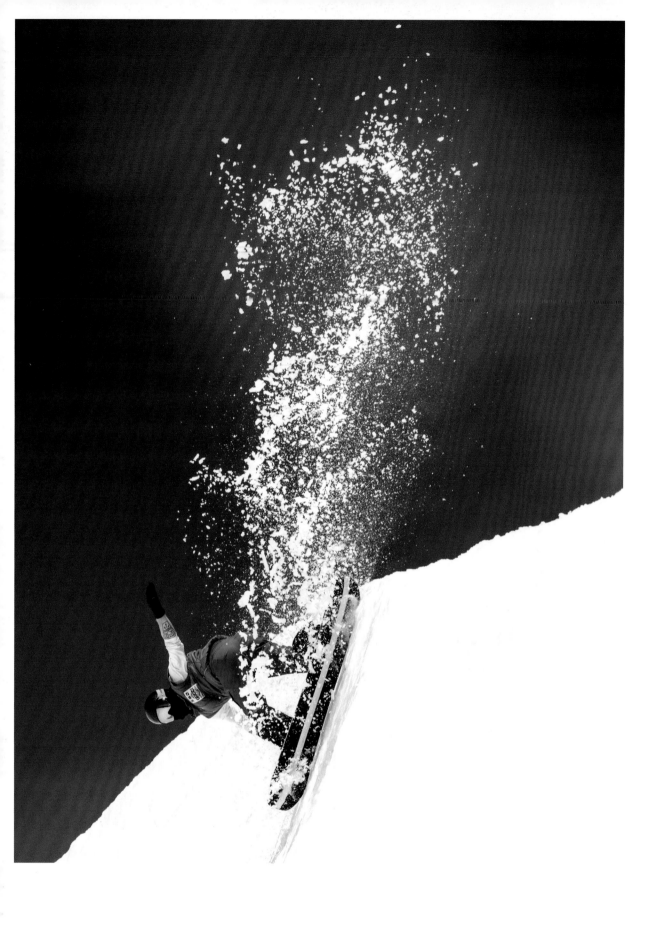

MOUNT HOOD, OREGON, 2021. PHOTOS BY MIKE DAWSON.

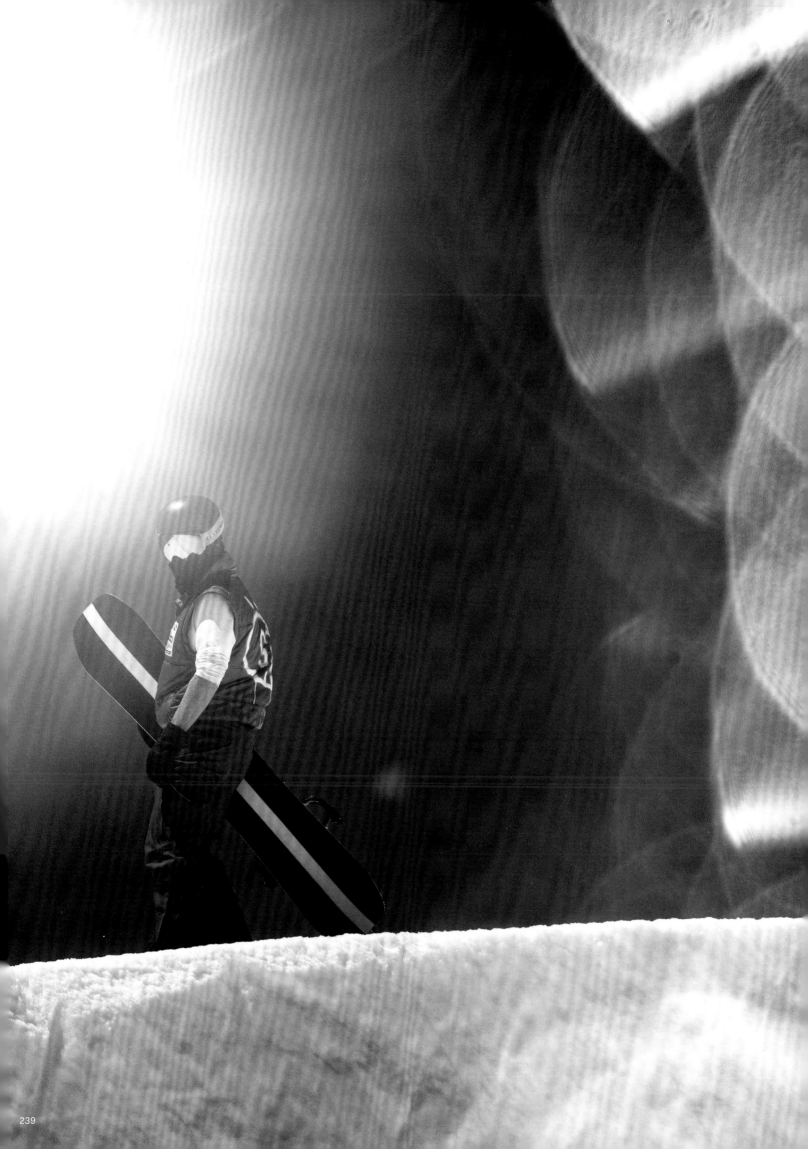

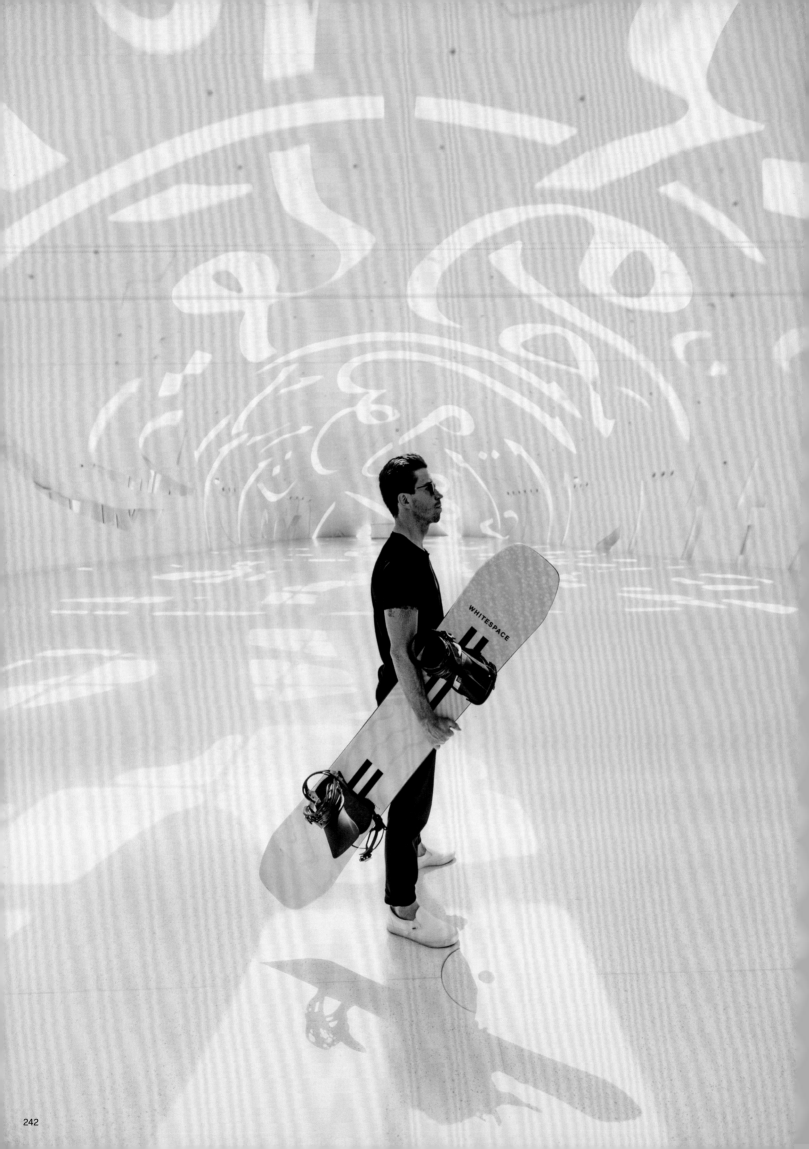

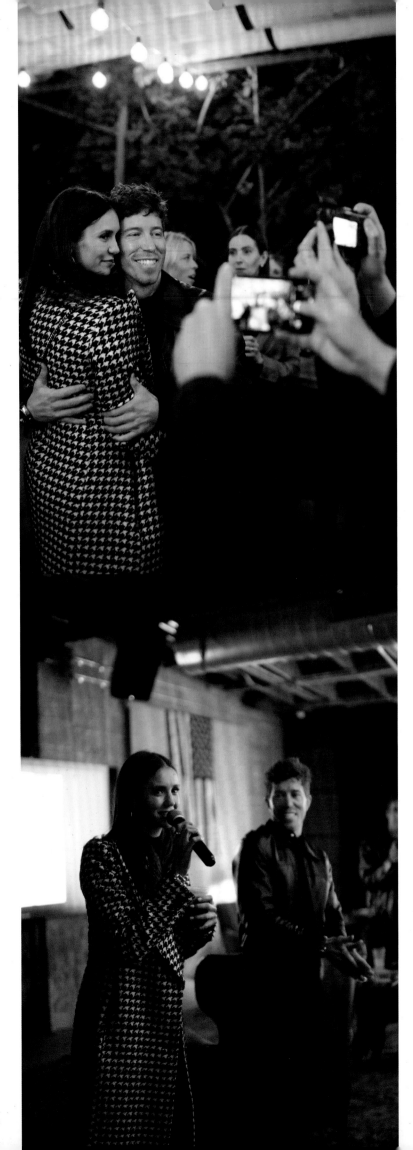

PHOTOS BY JACK PLATNER.

(THIS PAGE AND OPPOSITE) RETIREMENT PARTY, CULVER CITY, CALIFORNIA, 2022.

244

This is me at my retirement party with my girlfriend, Nina Dobrev. She has been such an amazing support through this whole transition from competing athlete to retirement. She put this party together for me a few days after I arrived home from China.

We had a great group of people come through—everybody who has been in my life, from family to business to friends and fellow athletes—to share stories and talk about the good old days. The good, the bad, the ugly—all of it. And it was just awesome. Mark Ervin, the first agent with whom I ever worked, was there. He said, "You were so young when I signed you that, when I took you to lunch, you ordered a milk."

This cake was great. They used the old-age FaceApp on it. Looking at it, I thought, "This is what you're going to look like if you decide to make a big comeback someday."

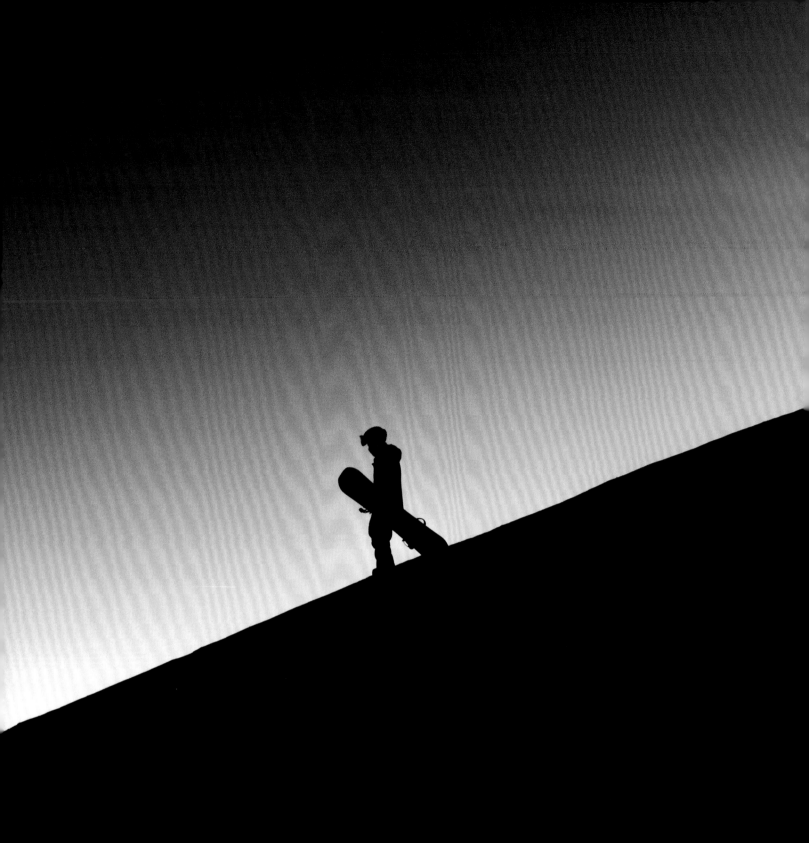

SAAS-FEE, SWITZERLAND, 2022.    PHOTO BY MIKE DAWSON.

PHOTO BY MIKE DAWSON.
PHOTO BY BENJAMIN LOWY.
PHOTO BY GABE L'HEUREUX.
PHOTO BY GABE L'HEUREUX.
PHOTO BY KEVIN ZACHER.
PHOTO BY CAMERON SPENCER.

(FOLLOWING SPREADS) SAAS-FEE, SWITZERLAND, 2022.
BAND THINGS, BACKSTAGE.
BURLINGTON, VERMONT, 2014.
SNOWY MOUNTAINS, AUSTRALIA, 2013.
VANS TRIPLE CROWN, BRECKENRIDGE SKI RESORT, BRECKENRIDGE, COLORADO, 2000.
MEN'S SNOWBOARD HALFPIPE FINAL, 2018 PYEONGCHANG OLYMPICS, PHOENIX SNOW PARK, PYEONGCHANG-GUN, SOUTH KOREA.

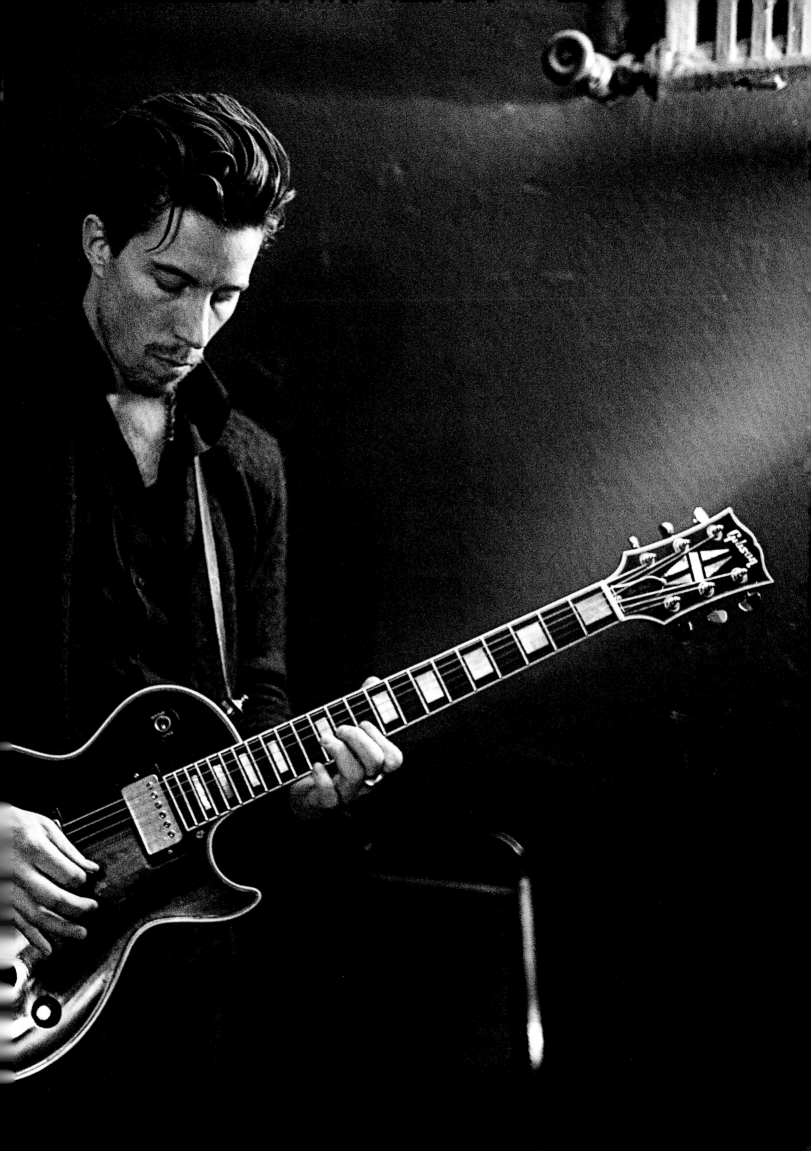

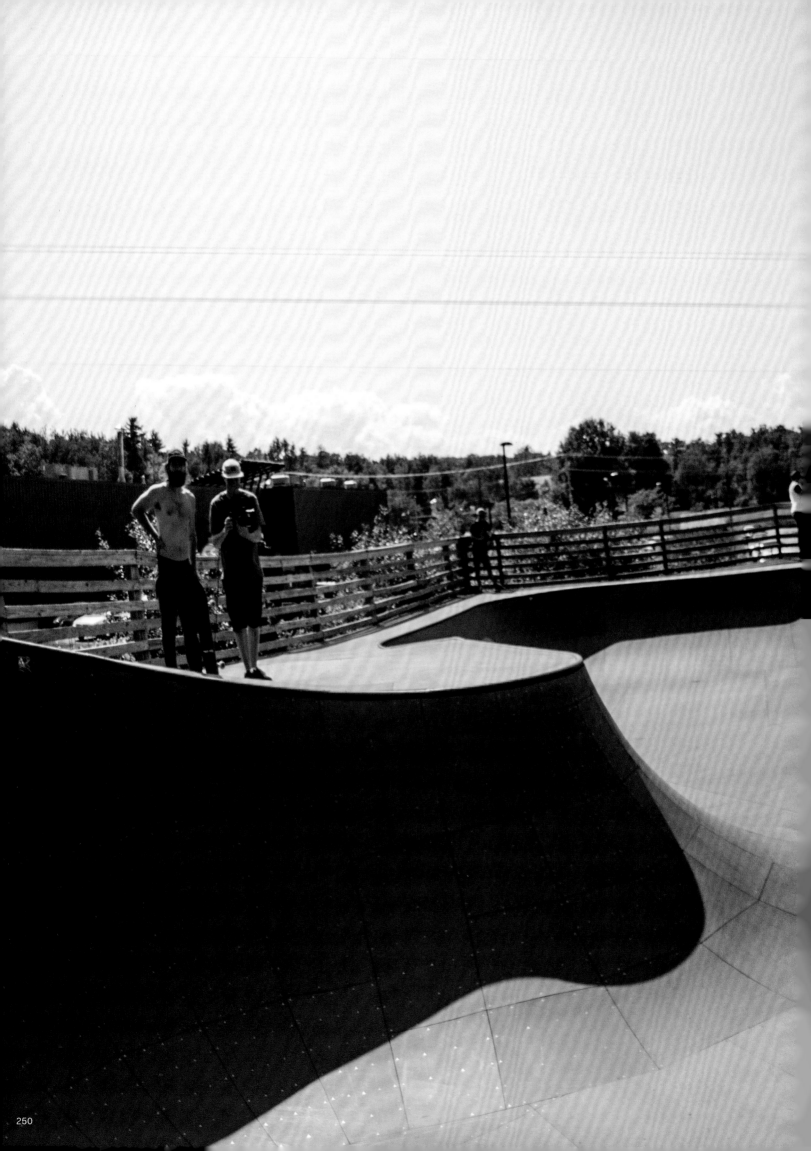

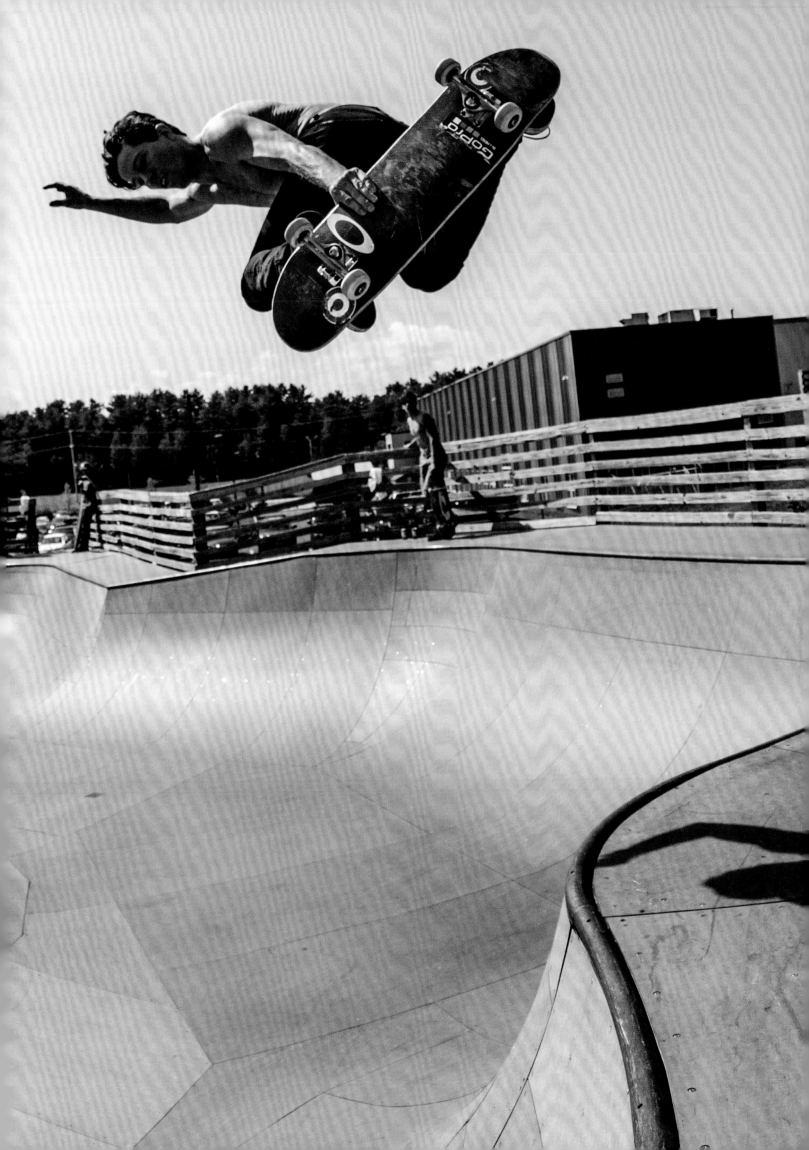

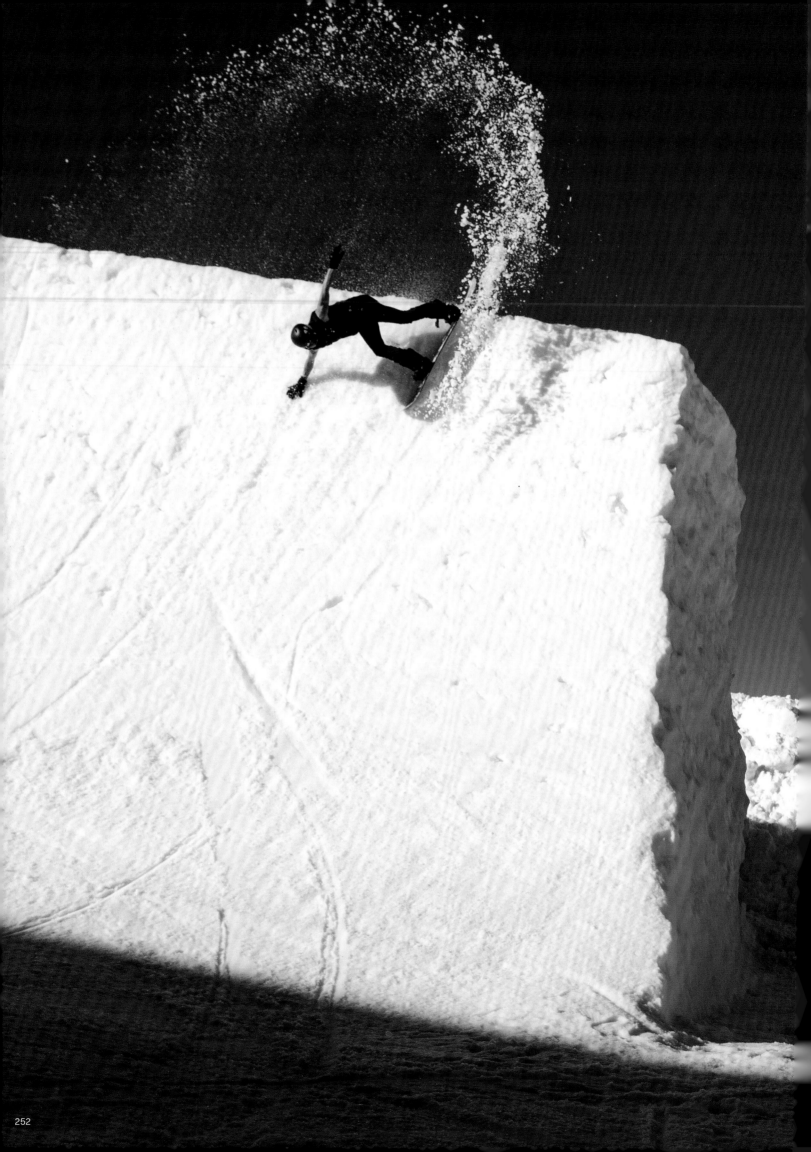

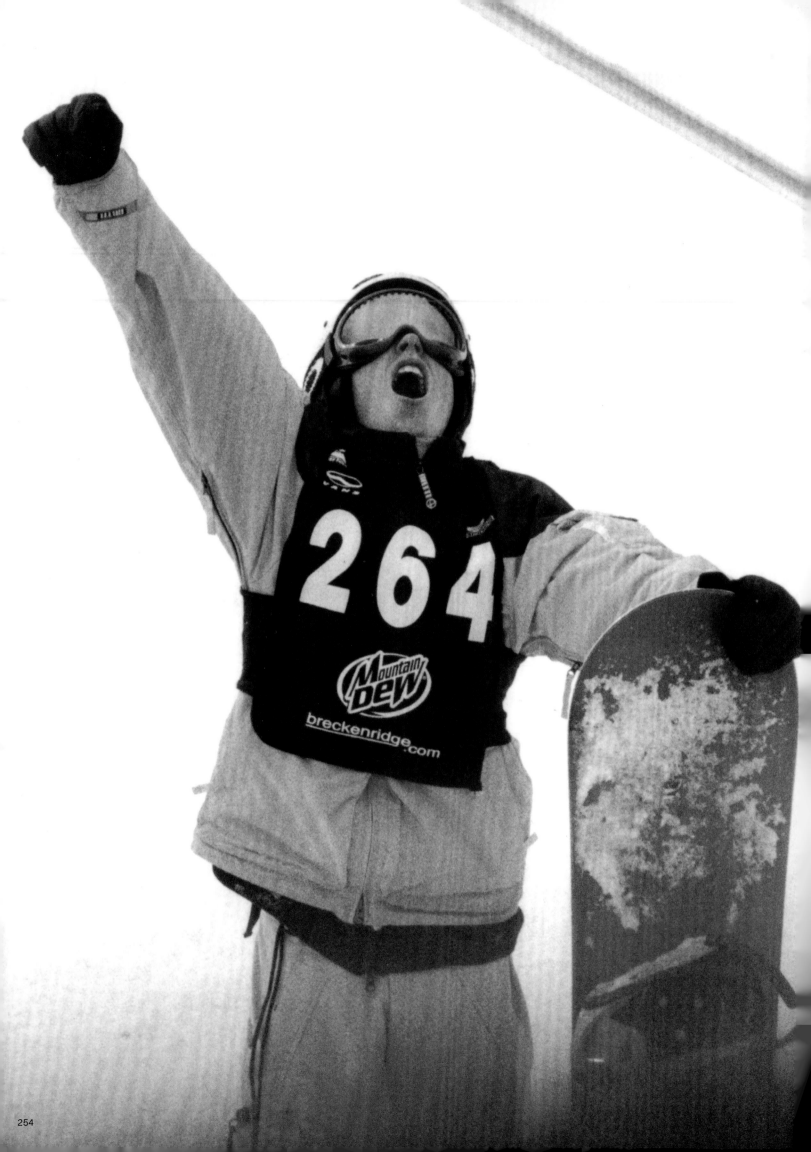

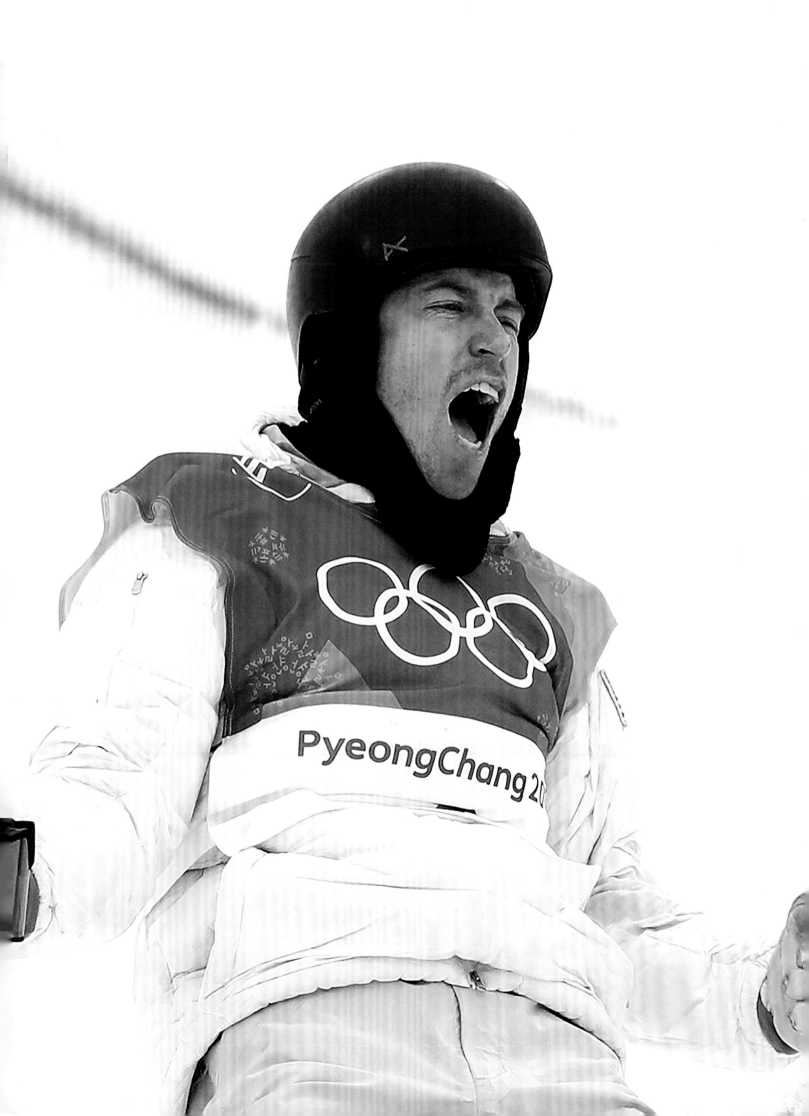

I would like to dedicate this book to my parents, Roger and Cathy White, and to my brother Jesse and my sisters Kari and Jessica, for being my biggest supporters and for inspiring and encouraging my passion for snowboarding from the beginning.

I would like to acknowledge and thank the photographers who contributed to this book. Many of them are my good friends. For these photographers—especially Adam Moran and Gabe L'Heureux—it was never just a gig. They shared in a lot of the adventures and know what it is to be out in the cold, aiming for perfection. They baited me to go bigger by saying, "One more hit!" and always encouraged me to get it just right.

I thank Jake Burton Carpenter and Donna Carpenter and the whole Carpenter family at Burton Snowboards for their support.

Thank you to Tony Hawk for being my friend and mentor.

I appreciate and thank my coaches, especially JJ Thomas, Bud Keene, and my first coach, Jesse White.

Thanks to my many competitors for always keeping the pressure on so that we could push each other to be the best. Our epic showdowns are what I will miss the most.

Thank you to my team, including my assistants over the years and my current assistant, Nathan Fisher.

I would like to acknowledge and thank Mark Ervin, my agent from a long time back, for helping to keep my career and personal life on track when so many things could have derailed it.

Thanks to Esther Lee, my physical therapist and friend, for keeping my body and mind in great shape.

Thank you to Toby Miller for always being there. Never change, bud!

I would like to thank Dr. Jan Fronek, for putting me back together, and Dr. John Lamberti, for patching the holes in my heart as a baby so I could live this amazing life.

I have a message for Joe Prebich: "Send lawyers, guns, and money. They'd get me outta this."

Thank you to my girlfriend, Nina Dobrev, for seeing the world with me and for helping me see a world beyond snowboarding.

Thank you to Selema Masekela, for writing the foreword of this book and for always supporting me throughout my career.

I thank Michael Spencer, Amen Teter, Colin Bane, Mackey Saturday, Amanda Sia, Kim Stravers, and the entire team at Rizzoli, especially Martynka Wawrzyniak and Charles Miers, for helping me pull this book together.

Thank you to everyone who has helped me tell my story at every step of this journey.

And, most of all, thanks to the fans—everyone who ever lined up along the deck of the halfpipe or at the corral at the bottom to cheer me on, watched me on TV, posed for a picture, asked for an autograph, or otherwise supported me and my dream. My deepest thank you!

Thank you, skateboarding. Thank you, snowboarding. Thank you.

—Shaun White

# Acknowledgments